Mirrors of Stone

Mirrors of Stone

Fragments from the Porcupine Frontier

Charlie Angus

photographs by
Louie Palu

Between the Lines
Toronto

Mirrors of Stone

First published in Canada in 2001 by
Between the Lines
720 Bathurst Street, Suite #404
Toronto, Ontario
M5S 2R4

National Library of Canada Cataloguing in Publication Data

Angus, Charlie, 1962–
Mirrors of stone : fragments from the Porcupine frontier

Includes bibliographical references.
ISBN 1-896357-49-0

1. Porcupine (Timmins, Ont.)—History.
2. Porcupine (Timmins, Ont.)—Biography.
3. Immigrants—Ontario—Porcupine (Timmins)—Biography.
4. Frontier and pioneer life—Ontario—Porcupine (Timmins)
I. Palu, Louie II. Title.

FC3099.P67A54 2001 971.3'142
C2001-901904-1 F1059.T56A54 2001

Cover design and text design by Margie Adam, ArtWork

Printed in Canada by union labour

Between the Lines gratefully acknowledges assistance for its publishing activities from the Canada Council for the Arts, the Ontario Arts Council, and the Government of Canada through the Book Publishing Industry Development Program.

THE CANADA COUNCIL | LE CONSEIL DES ARTS
FOR THE ARTS | DU CANADA
SINCE 1957 | DEPUIS 1957

Canada

ONTARIO ARTS COUNCIL
CONSEIL DES ARTS DE L'ONTARIO

For Jenny Angus who waits on the other side

Photographer's Preface

I WAS FOUR YEARS OLD the first time I saw what my grandfather looked like. It was during a family trip to my father's home town in Italy. We made our way to the local cemetery and I saw my grandfather's face staring back at me from an oval photo on a gravestone.

The memory of this experience was very much with me when I set out to photograph the graveyard landscapes of the Porcupine. As a child of working-class Italian parents I felt an immediate kinship with the families who erected these stones. It made me realize that the issue of the past and remembrance is an integral part of immigrant identity. How much to hold on to? How much to discard? In many ways, this tension between memory and identity is a fundamental theme of this book.

For me, the stones tell the story of time. Lives pass on, the photograph fades, even the rock is eventually worn down. In the end nature claims everything. As I documented these fading testimonies to the northern pioneers I couldn't help but think of J. Russell Smith's observation about the Great Plains, another vast landscape which devoured the hopes of so many settlers:

> This battlefield... is not marked by tablets, monuments, and the usual signs of victory. A lion does not write a book, nor does the weather erect a monument at the place where the pride of a woman was broken for want of a pair of shoes, or where a man worked five years in vain to build a home and gave it up, bankrupt and whipped, or where a baby died for the want of good milk, or where the wife went insane from sheer monotony and blasted hope.

The photographs were taken in three graveyards—Timmins, Tisdale Township, and Dead Man's Point, South Porcupine. The placement of these photographs in the text does not in any way imply a relationship between the lives of the people in the photographs and the stories being presented in the text. The photographs are intended to provide a distinct but complementary narrative—narratives that allow you to look deeper into these remnants of the past.

Louie Palu
Toronto, November 2001

Author's Acknowledgements

THANKS TO JOHN ANGUS for a thorough (and non-romantic) eye when it came time to check the facts. Thanks to the MacNeil clan—Anne-Marie, Margaret and Rod, Kathy and Nik, Jennette and my late uncle Lindsay—for providing the context and the colour over the years. A special thanks to Moses Sheppard of the USWA Thunder Bay for sharing his extensive files on industrial illness in gold mining. Thanks to Andrew Elgee and the staff of the Timmins Museum. Thanks to Brownie and Nancy for the hospitality and the crowd at the Welcome for so many ideas. Thanks to Lois Chetalet, Keith Draper, Red Phillips, Guy Gaudreau, Albert Ristimaki and Bruce McCleod for sharing their pieces of the history. Thanks to Vivian Hylands, Gilles Bisson, Rick Stowe, the late Michael Farrell, Dorothy MacCleod, Aarne Hannikainen, Susan Meurer, Andy King, and Bill Miller. Thanks above all to Brit, Mariah, Siobhan, and Lola, for everything.

Special mention needs to be made of the BTL team for backing this project with wholehearted enthusiasm from the beginning. Thanks especially to Paul Eprile, Robert Clarke, and Margie Adam. Any mistakes in the text or in the interpretation of historical record are, of course, my own.

This book was made possible through a grant from Canada Council.

Photographer's Acknowledgements

ELLIE RICCI, FIORINA & GIUSEPPE PALU, the Visentin family, the Angus family for always giving me a place to stay in Northern Ontario, all the staff at the Timmins Cemetery, Carla Picotti, Dan Guiho, Paul Talan, Andre and Dianne Laredo at Dmax Black and White Lab, Jan Wong, Leisa Ugarte, Renata Trogrlic and family, Branko Mustafovic and family, Erin Elder.

Milan Delich
1905—1947
Crushed in the McIntyre Mine

I'm convinced that the mines killed more Canadians than all the wars combined. It's just that the miners died—one on Monday, two on Wednesday and nobody noticed and nobody ever gave a rat's ass.

—Moses Sheppard, Steelworker staff rep

Contents

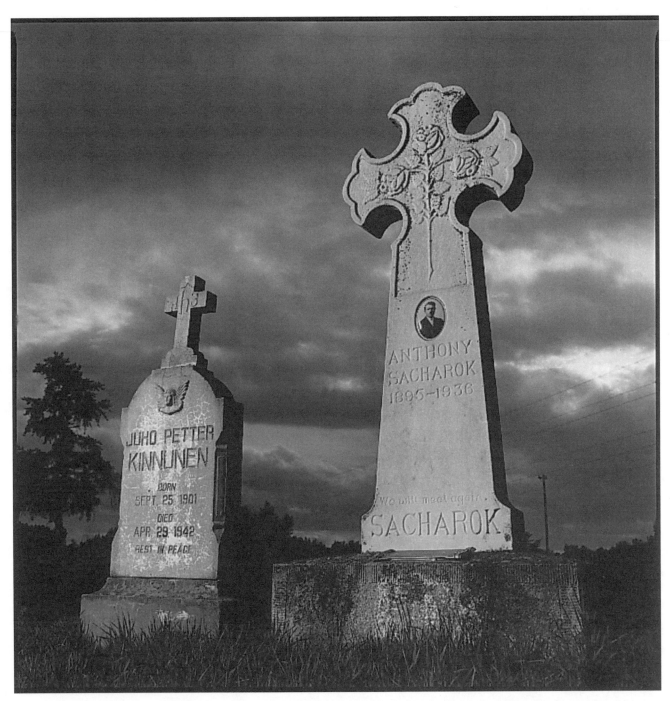

Graves of Juho Kinnunen, died 1942, and Anthony Sacharok, died 1936, both age 41 ■ Timmins Cemetery

Kajanon First
Choir.

754-6411?

Aug 10/66

St. Andrews
church

September

Do not worry about your destiny. Like the lapping waves, it will come to greet you at your feet.

2
Friday

S M T W T F S
1 2 3
4 5 6 7 8 9 10
11 12 13 14 15 16 17
18 19 20 21 22 23 24
25 26 27 28 29 30

31, Hawaii

Introduction

WE SPENT OUR SUMMERS WALKING in the fields of the dead. As soon as the warm weather came, my grandmother gathered my sister and me for the yearly walk to the graveyard. Its location was hardly auspicious—on a back road out of town, boxed in by trees, a trailer park, and the imposing waste-dump hills of the Hollinger Mine. Just a few acres of memory carved out of a Jack pine forest.

But even among the dead, the vitality of a northern summer imposed itself. Buds bloomed, birds ca-cawed, and the stillness of the landscape was broken by the background static of grasshoppers or the eerie creaking of trinkets hanging from homemade shrines. On hot days, the air was sweet with the smell of freshly cut grass.

And summer brought, if not life, then individuality, back to the graveyard. By mid-May the faces had all emerged from the blanket of snow to bask in the warmth of a northern summer. Those faces never changed. They peered out from gravestone ovals—young, proud immigrants from places like Finland, the Ukraine, Croatia, Bulgaria, Syria, and Italy.

Few people ever visited the fields of the dead. It was the domain of old women: aged, immigrant, mining widows picking among the graves like displaced crows. My grandmother was one of those crows. Her husband, Charlie Angus, died in the machine shop of the Hollinger Mine in April 1962. I was born seven months later.

But visiting Charlie's grave was only part of the reason we were there. My grandmother's world was passing away and she knew it. She spent her increasingly short days filling out the long, drawn-out summer of the young ones. Over tea and scones she conjured the ghosts of the Somme, Culloden, and Bannockburn, and through the trips to the graveyard she introduced us to the faces in the ovals. They became friends waiting on the other side.

I spent countless hours running among the rows. Over time I learned the layout of the "neighbourhoods"—Chinese here, Yugoslavian there, Protestant on this side, French over yonder. It was a parallel townsite of memory and mourning.

To be sure, there were numerous graves of people from my background—British Isles/Canadian. But I preferred the graves with the compelling oval portraits. There's Mattie Butkuvich, gassed in the

We don't write of the past except when we've been ejected from it. The only way back is through memory, haphazard and unreliable as we know it to be.

— Joyce Carol Oates

1

Coniaurum Mine. He's a neighbour to Big John Bunzeak, crushed by a locomotive falling into the Hollinger shaft. In the section behind them lies thirteen-year-old Giulia Cicci, peering out through the glass like a frightened prisoner of time.

Over near the garage bay, where the groundskeepers sit for their morning smoke and coffee, lies beautiful Annie Kostelac. Betrothed to a man who had immigrated to the area two years before she was born, Annie made the trip from Croatia when she was twenty-four years old. Barely had she arrived in her new home of Schumacher when she was brought down by typhoid fever. Her husband, Milan Bogdanich, died four years later at the ripe old age of forty-eight.

What was it that brought these people from such far lands to die here in this isolated place? The romantic version of Canadian history tells us they were drawn by the lure of gold. But a more realistic assessment reveals that, in the early years of the twentieth century, Canadian immigration policy treated its newcomers as industrial serfs for the mining and lumbering camps of the frontier.

Certainly one of the largest frontiers was Northern Ontario's Porcupine region, eight hundred kilometres north of Toronto. The region, marked by the Porcupine-Destor geologic fault, stretches forty kilometres from the Fredrickhouse River in the east to the shores of the Mattagami River in the west. Unlike the short boom and bitter bust of so many mining areas, the Porcupine has been sustained by the richest gold fields in Canada (producing over sixty million ounces over the years). The Porcupine has provided nearly a century of steady mineral and lumber production.

Canada, at the time of the Porcupine gold rush in 1909, was defined by an overwhelmingly Anglo-Protestant gestalt. Italian immigrants coming into the country dismissively referred to the heritage as "mungacake" (a spongy, tasteless cake). Today we might use the term "white bread" culture. But the Porcupine, set apart by distance and lack of communications from the dominant culture of the south, was certainly not a land of mungacakes. By the early 1930s, the area had over fifty-one nationalities living in a patchwork of ethnic neighbourhoods. Families were putting down roots, and their children were intermarrying with the children of other immigrants, creating a highly textured hybrid culture. The Porcupine was an early example of the multicultural society, which urban Canada would later claim to have invented.

And yet, Canadian media and history studies have largely over-

You wouldn't put this any of this in a book, would you? I mean it's not really history. It's not the kind of thing you write down.

—woman discussing the Moneta ethnic riots

looked the rich history of this region. The multi-ethnic identity of the hardrock mining camps has never seemed to fit into the comfortable clichés through which Canada "tells its story"—petticoats on Prince Edward Island; fiddle-playing lumberjacks; stoic prairie farm women in print dresses; Klondike music halls with roller pianos.

This lack of representation is compounded by the local culture's tendency to accept the terms of the dominant culture's historical references. All too often in Canada an amalgam of kitschy folklore defuses the powerful pedagogy of place. In the case of the Porcupine, history has been rendered as a few "colourful" hero tales—Harry Preston slipping on the golden staircase; Sandy McIntyre trading a massive gold mine for drinking money; sweet, old Mr. Schumacher, who gave the children Christmas presents every year. Over the span of one or two lifetimes, the darker clouds of an immigrant and class-divided frontier have been airbrushed from memory.

This then becomes the real issue of Canadian history—the need to look beneath the accepted tableaus and ask ourselves why some stories are told and others are forgotten or glossed over.

Guilia Cicci
1928—1941

■ ■ ■

I used to believe that if I stood in the right place long enough or watched with careful eyes I would find the mysterious passageway that separated me from the faces on the other side of the ovals. Perhaps there's a part of me that still believes it.

For much of my adult life I have been haunted by the feeling that my own journey is rooted somewhere on the other side of the glass. Occasionally, for example, I would be in conversation with someone from the Porcupine area when a word or phrase—Moneta, Paymaster, high-grader—would trigger a memory. The problem was, these memories weren't mine. I could tell that the words were pregnant with a deeper meaning. But the place they took me to had somehow been stripped of all identifiable landmarks.

Over time I came to realize that the words were hot links to long-forgotten conversations overheard at the Kresge's lunch counter while my two grandmothers and their cronies stepped effortlessly into their immense vault of memories. As a child I thought nothing of slipping into the vaults with them. Back then there was no need for explanation or context. The tales were simply part of an oral landscape seeding in my imagination.

As an adult I have struggled to recover the contours of this landscape. The old ones, being long dead and buried, are unable to guide me. The historic record is sparse or bare. The adult, caught up in a busy and increasingly fragmented world, has often wondered if this landscape was ever real or tangible. Was it, perhaps, just the fruits of a colourful childhood imagination?

But then there are the faces in the ovals. I find myself coming back again and again to stare into these mirrors of stone. But unlike the child, I come looking for a passageway, a key, an explanation.

In researching this book I realized that I was probably twenty years too late for the task at hand. There are few living witnesses who can verify the stories I heard as a child. The written records seem to be remarkably cleansed of the more contentious elements in this history. What is left are pieces of a broken jigsaw puzzle.

In many ways the cemetery has become the only repository of the gritty realities of immigrant life in the Porcupine. Admittedly it is only a partial record—the recording of sorrow and loss rather than milestones of joy, hope, and promise. But the faces and the dates tell their own compelling stories; row after row of foreign men cut down in their thirties and forties, young mothers dead in childbirth, a field of little children.

This book makes no attempt to tell the story of the mine-builders and the town fathers. Nor does it attempt to convey the development of a community through a linear pattern of dates. The main focus of my work is to follow the broken strands of memory, to wander into dead ends, searching for connecting links to the present. The stories I have chosen reflect my own personal journey into memory, identity, and place.

My search for answers brings me back to the fields of the dead. The faces in the ovals taught me my first lessons in history. They continue to teach me lessons in life. I see their faces like indelible watermarks on the canvas of my life. I want them to know that after all these years the little boy still comes back, and he never did forget.

PART I

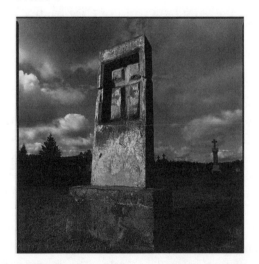

Strangers on the Land

PROLOGUE: The Road to Emmaus

BEFORE THE COMING OF THE TRAIN, the only way into the Porcupine was by way of portage and canoe routes north from Fort Matachewan and along the creeks feeding into the Whitefish River. White men had been coming into the region since the seventeenth century to trade with Ojibway and Cree trappers. They followed the water routes that led into Night Hawk Lake, the Fredrickhouse River, the winding Porcupine River, and then Lake Porcupine.

These white travellers learned quickly that the land that gave so bountifully with one hand could also strike back brutally with another. In the terrible winter of 1812, for instance, fresh game was non-existent and people did terrible things to survive. At the Hudson's Bay Post on the Fredrickhouse River, a dozen or so Natives and traders were murdered for their supplies, allegedly by a band of Cree from a settlement along the Abitibi River to the east. The following spring, a search team reached the post and found the victims--a Native man and his wife shot in the back, their baby suffocated beneath them; doors torn off the hinges; dogs, cats, and poultry missing; other bodies ripped apart by animals in the bush. No one was ever charged.

Nearly a hundred years after the massacre, not much had changed along the isolated and lonely waters of the Fredrickhouse. One morning Don Pecore and his Métis partner were paddling their way up the river carrying teamster supplies when they saw smoke from a campfire rising along the shore. Intrigued, they made their way in the direction of the smoke.

They came upon a Catholic missionary priest. He was on his knees saying mass by the shore. Fascinated by the scene, they knelt down and listened to the prayers being offered in Latin. The missionary was a francophone Oblate. He invited the men to join him for tea. Speaking mostly in Ojibway with Pecore's partner, he explained how he travelled these waters visiting the various Native communities scattered along the waterways.

The missionary had precious few supplies with him--just his Bible, chalice, and a piece of fishing tackle. He seemed unequipped to handle the dangers of the land. Finally Pecore blurted out, "Father, this land isn't safe to travel in. Don't you think you should be carrying a gun?"

The priest shook his head, smiling. "I am not afraid of the animals. This land belongs to them. When we travel through it we need to be asking their forgiveness."

We were always sure something good would come from the North. We had faith in it.

—Eva Derosa, immigrant midwife

We landed in Golden City on Christmas Eve, 1910. I put up my stocking but all I got was a piece of hardtack. Prospectors ate it because it would not spoil no matter how long it was kept. I asked my father why Santa hadn't brought me any presents and he replied that Santa hadn't heard of the Porcupine.

—John Campsall, pioneer

Little did any of them realize that within a short period of time this land would no longer belong to the animals, the Indians, or even themselves. As they were speaking the railway was pushing through to Mileage 222 (north of North Bay), which reduced the canoe and portage journey into the Porcupine to a mere thirty miles.

The train was initially built to impose an identity on the land--anglo-Protestant rather than francophone Catholic. In 1902 the government of Ontario had agreed to run a rail line 110 miles from North Bay to the fledgling anglo settlements along the upper part of Lake Temiskaming. The train was sold as a political necessity, a means of preventing the northern land from being settled by Québécois farmers.

In 1903 railway workers had found massive deposits of high-grade silver along Mileage 103 of the track. The Cobalt silver rush imposed a new story on Northern expansion. Land that had been considered good for nothing was now being viewed as ripe for the taking. To facilitate the plunder of mineral development and the onrush of prospectors and settlers, the train line was pushed steadily northward.

In 1909 the discovery of the deposits that would make up the Dome, McIntyre, and Hollinger gold mines created a flurry of international stock speculation. Investment dollars from U.S. and British mining speculators created towns, industry, and eventually multinational empires. In the flurry to make a dollar, nobody had time to heed the priest's advice. Thousands were soon trespassing on the land of the boreal forest, and forgiveness was the last thing on their minds.

You could shoot a moose and divide it among the neighbours. You'd get three hundred pounds of great pike in about three or four hours [of fishing]. If you set forty rabbit traps you'd have thirty-eight rabbits in the morning. But there were too many fishermen and too much log driving on the rivers. The bark got on the bottom and spoiled all the spawning grounds.

—Hamer Disher, pioneer

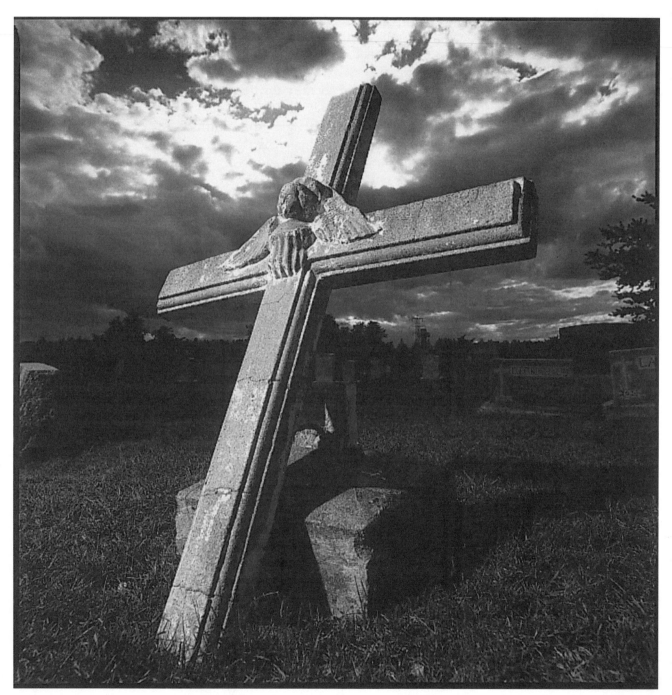

Broken cross, unknown grave ■ Timmins Cemetery

1 Relics of the Pioneers

THE COMBINED RELICS of three separate wings of the Angus family fit nicely into a little orange chocolate box on my closet shelf. Once in a blue moon I take the box down and sift through the fragments. But there's not much there; an old Mason's pin, some share certificates of the Workers' Co-operative of New Ontario, a broken gold watch, a yellowed wedding certificate stating the marriage of Charles Reid Angus, iron-turner, to Jane Boyd, daughter of a "yardwinder" and a soldier, in Clepington Church, Dundee, Scotland, February 24, 1924.

There's a pocket King James Bible with the inscription, "From Charlie to Jenny 2/4/21." The Bible holds some old Wintario lottery tickets, a few locks of children's hair, and a ripped photo of my paternal grandparents – Jenny and Charlie.

The box also contains a small sepia photograph taken some time in the 1930s. It's the only one I have of the immigrant Angus clan: a snapshot of Charlie and Jenny along with his two sisters, Sarah and Jean, and their men, Jim Gordon and Jim Brough. Three couples leaning on a wooden fence, laughing at the camera. Cocky immigrants against a backdrop of bush. They now make up three sets of names on tombstones in the Protestant section of the graveyard in Timmins. I think I'm the only one who's ever gone to visit them.

The three wings of the family produced two offspring – my father John and his first cousin William Gordon. There are no photos of Cousin "Wully." He's been dead for decades. I don't ever remember meeting him. I don't even know where he's buried. The only "memory" I have of him comes through a story my father sometimes tells.

It's the 1930s in the playground of Moneta Public School. Cousin Willy, fresh off the boat, has just shown up for his first day of school decked out in proper Scottish school-boy uniform--short pants and school-boy cap. My father watches his cousin's approach, knowing that he will soon be fighting on Willy's behalf with the tough Italian kids, who might not take kindly to the strange attire.

When I was younger I used to shake my head at this image of my father's first cousin, so woefully unprepared for life in the new world. As I grow older, however, I find that there's something poignant about cousin Willy. From what I can tell he was a good-natured, gregarious Scot. He left no kin of his own. Perhaps he simply lacked the tough shell needed to sprout seeds on the rocky soil of the Porcupine.

Mrs. Spadafore would put any model to shame with her glorious posture, carrying three pails full to the brim of berries. She had one in each of her hands and one on her head, never losing a drop. We gazed in awe as she walked like a queen on that dusty road.

—Minnie Gram (Levinson)

The Angus clan first arrived at a time when a tough shell was a necessity for survival. The year was 1924 and the Porcupine camp was barely in its teens. Few houses had running water or indoor toilets. Medical facilities were poor and the community was beset with high rates of tuberculosis, diphtheria, and a host of other diseases. Infant mortality rates (particularly in the francophone neighbourhoods) were high. The lost-time accident rates in the mines ran at a staggering 30 per cent of the workforce per year.

Any complaining newcomer would have faced a barrage of hair-raising tales from camp veterans. These were the folks who had first trekked north after that heady summer of 1909 when news leaked out of rich gold finds near Porcupine Lake. The settlers had first flocked in during the coldest winter in memory. Tents and hastily built wooden shacks offered little comfort in the forty-below weather. Coal was non-existent. Fuel came from what wood supplies people could cut. There were no wells. Water had to be hauled from holes in the lake. On really cold days, the women simply broke off icicles from the roof and melted them on the stove.

By the second summer a number of squatter settlements had grown up—Shunia, Pottsville, Golden City, South Porcupine. Some thirty or so gold operations were soon operating, the production bankrolls coming from intensive stock activity among U.S. speculators.

By the summer of 1911 the railway had been pushed through to Porcupine Lake, bringing with it more settlers, freebooters, and other adventurers to a camp that was already a festering mess. Poor sanitation and a lack of adequate housing materials placed a major burden on the increasing numbers of would-be settlers. Added to this, with the arrival of warm weather many of the men were leaving to go on prospecting crews, which left a camp of women and children to deal with the tough task of establishing liveable quarters.

Summer came early after a long, dry spring. By the end of June the bush was a tinderbox and the skyline was a haze of ominous but indistinct intentions. Sporadic fires were already burning in nearby Deloro, Bristol, Whitney, and Tisdale townships. But just how close, or how threatening, was anybody's guess.

By July 11 the fires had formed into a fourteen-mile front moving towards the Porcupine from three directions. The fire hit first at the Hollinger Mine, wiping out the bunkhouses and surface buildings. The fire crews didn't stand a chance in the face of blast-furnace heat and raging winds. The fire then quickly moved westward in the direction of

In Pottsville the Scandinavians had built a large public hall... In this community centre, known as the Finnish Social House, the whole population gathered on Sunday afternoons to hear a concert... For its opening number the band was in the habit of playing 'The Internationale' until the Mounted Police objected and requested them shift to 'God Save the King.' This they flatly refused."

—Pierre Van Paassen,
To Number Our Days

Porcupine Lake. At one o'clock in the afternoon the whistle of the Dome Mine pierced the air, warning people to run wherever they could to find shelter.

But where do you run to in a land surrounded by flaming bush? The flames were 150 feet high and speeding along the tree tops faster than people or horses could run. Mrs. John Campsall's husband was somewhere in the bush with a prospecting crew, so she gathered up the children and the belongings and put them on the family cart. One of the neighbouring men found a team of horses to pull the wagon but the horses panicked and bolted. As the Campsall children stood by helplessly, the wind ripped the top off their family trunk and hurled their belongings into the fire.

Mrs. Campsall froze in the path of the fire. A man who was running past saw her standing still with the children. He shouted at her to run to the lake. She didn't move. "I don't know how to get to the lake," she said in a terrified voice. The man grabbed her by the shoulders and physically turned her around. He then shouted, "Now keep going." This action brought her back to her senses and saved her family from the inferno.

It's little wonder that people panic in a bush fire. People in the path of a firestorm can become disoriented because the oxygen is being starved from the atmosphere. They lose the ability to think clearly.

A woman left her two-year-old daughter behind in a tent that was in the path of the firestorm. She took refuge with her other children in a water hole where the Russell family were hiding. When the Russells noticed that two-year-old Patsy was missing they asked the woman where her child was.

"I left her in the tent," the mother replied vacantly. They looked up in horror to see flames beginning to converge on the tent. Mr. Russell rushed out from the water up into the fire zone. Family members begged him to come back. "Oh you're too panicky," he shouted as he headed into the heat.

On the way back down the hill with the little girl, he was overcome by smoke and fell. People quickly rushed out of the water to haul the two of them to safety.

■ ■ ■

In the face of a firestorm there are, perhaps, no right and wrong moves. It is all a matter of chance and luck. Compare the experience of two separate parties faced with the decision of trying to outrun the fire or taking shelter down a mine shaft. Eleven men from a crew that was

Luccia Elpi
1902—1937

I remember the neighbourhood women with tears running down their cheeks, standing near their homes with their arms outstretched praying for rain —a rain that never came.

—John Campsall,
describing the days leading up to the Porcupine fire

sinking an incline shaft three miles out of South Porcupine tried to run for town and were burned to death along the way. Three other men—John McCambridge, Herb Wilson, and Sam Crawford—went down the shaft. They sat on submerged cases of dynamite in the cold shaft waters while the fire blew over them.

Miners in the West Dome Mine weren't so lucky. Big Bob Weiss from Butte, Montana, was the mine manager. At six-foot-seven, 440 pounds, he was one of the more noticeable figures in the Porcupine. People liked to tell how Big Bob would come into the overnight portage stations along the waterways and lie down on the floor of the dining room. "Yup," he would say, patting his immense stomach, "I think it will hold me."

With the wind from the fire breaking trees in half, Bob told his crew he didn't think they could make it to the safety of Porcupine Lake. His suggestion was to hide at the bottom of the newly sunk eighty-foot shaft. Seventeen miners joined Bob, his wife, and daughter in riding the hoist bucket to the bottom. The rest of the crew decided to chance it by running through the bush. They made it. The last words they heard from Bob Weiss was a comforting comment to his wife, "You're not afraid, are you?"

How afraid she must have been in the darkness of the shaft. Fire burnt the timbers along the wall to a depth of thirty feet. The Weiss crew suffered the same fate as many families hiding in the bomb shelters during from the 1943 firebombing of Hamburg; the firestorm sucked the oxygen out as it blew over them.

It was said that in the aftermath of the fire, salvage crews needed a block and tackle to get Bob's body out. Years after the fire, miners complained about the grease stains on the shaft walls and the smell of burnt fat that marked the spot where Big Bob Weiss and his family died.

■ ■ ■

My grandfather Charlie, like other immigrants, would have heard the tales of the great fire. It was part of the emerging pantheon of legends that the Porcupine claimed as its own. But along with the new stories, there was still much baggage imported from older lands.

All settlers in the Porcupine—whether they were born in Canada or overseas—were, in a sense, immigrants in a foreign land. What we understand today as a Canadian identity was defined then as a British Protestant "heritage." The Canadian-born families who trekked north from the Ottawa Valley, the Maritimes, or Quebec found themselves try-

Nora O'Shea was born in the lake during the 1911 fire. They had six men holding the blanket and the mother was on the blanket and six or eight men holding another blanket on top of her. They kept throwing water on the top blanket to keep it from the heat. The doctor and nurse were working to deliver her. When the men would get too hot, they'd go under the blanket and the other bunch would come up.

—Eva Derosa,
Porcupine midwife

ing to defend or impose their own cultural backgrounds in a sea of other immigrant cultures.

Jobs in the Porcupine camp were relegated according to the old religious bigotry of the British Isles. Surface work was strictly the domain of Orangemen and Masons. Catholics and immigrants were relegated to the more dangerous work underground. Jews and Syrians tended to work as merchants, while the Chinese, as in so many other frontier communities, ran restaurants and laundries.

Charlie, having served his apprenticeship in the Orange-dominated trades of Glasgow and Dundee, had a proven Protestant pedigree that made it possible for him to get a surface job in the machine shop at the Hollinger Mine. But he didn't come to the new world to be burdened by the bigoted history of the old. If he had any politics, it wasn't Orange or Green, but closer to Red.

My grandmother says that when the immigrant ship landed in the harbour of Quebec City, Charlie looked out the porthole at his new home and promptly tossed his bowler hat into the churning water. The bowler hat, the ultimate symbol of the defiant Orangeman, floated for a moment and then disappeared beneath the waves. As far as Charlie was concerned, the old world was dead.

This belief in the new world explains the other item in my chocolate box. It's a rawhide bound copy of Robert Service's Ballads of a Cheechako. Inside, written in neat, male handwriting, is the name of my great uncle Jim Gordon. The book, with its fanciful tales of the northern lights, prospectors, and Yukon gold, must have seemed the perfect book for an idealistic young immigrant. Never mind that the Klondike lore had little to do with the large-scale industrial gold mining of the Porcupine.

But Uncle Jim, like thousands of other immigrants, was ready to embrace the myths and emerging culture of the Porcupine. The Scottish values of the old country learned to intermingle with the tastes of the new land; family feasts centred around cabbage rolls, schnitzels, tortieres, spaghetti, or Finnish breads; my maternal grandmother peppered her rebuttals with French phrases; my father tried his hand at speaking German with his buddies at the Finn's steam bath. All of these elements were typical of the emerging multi-ethnic identity of Porcupine settlers.

My Grandmother Angus, perhaps like many of the women, always talked about her dream of going back to the old country. But it was just a dream and she knew it. I don't think my grandfather ever thought much of going back. The Porcupine was now home. He never looked back.

William Proc
1873—1939

Fong Horn, a local Chinese Chef, shot himself in the outer lobby of the New Empire Theatre at 2:15 Saturday morning. Recently he had been employed by the Anchorite Mine but had taken ill with influenza...The man was more or less delirious and had the typical Oriental aversion to sickness and suffering.

—The Porcupine Advance, Oct. 30, 1918

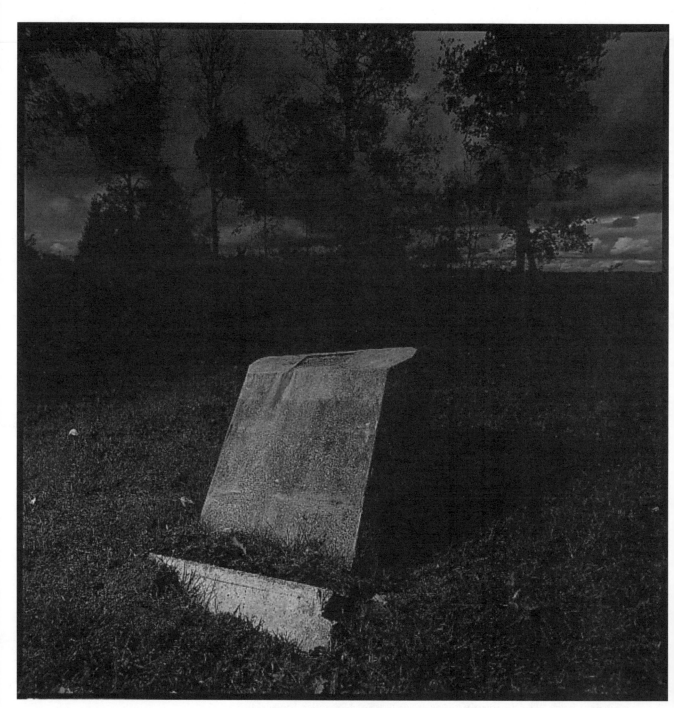

Unknown grave ■ Dead Man's Point

2 Outlaws in Murphy Township

THE BIG FIRE SPELLED THE END of the frontier. The freewheeling squatter settlements were wiped off the map. In their place rose ordered company townsites that spread through the region like a patchwork of clearly defined medieval fiefdoms.

Development ran east to west following the path of the gold-rich Porcupine-Destor geologic fault, and commercial activity was centred in the three main communities clustered around the three major sources of gold mining activity. In the east, in the shadow of the Dome Mine, was the town of South Porcupine. The Dome Mine, the site of the first major gold discovery in the Porcupine, would blossom into the home of the international mining giant Placer Dome, and today, after ninety years of steady production, it remains one of the largest gold operations in the country (300,000 ounces in 2000). Seven kilometres west of South Porcupine was the settlement of Schumacher, which was little more than a winding strip of hotels, immigrant boarding houses, and miners' shacks built in the shadow of operations like the Vipond, the Schumacher, and the ever-growing McIntyre Mine. Operating until 1988, the McIntyre would become the second-largest gold mine in Canada, behind the Hollinger. From its earliest days, Schumacher was a shit-kicking town. If you wanted a good time or a hard time, you could find both among the Yugoslavians of Schumacher.

Schumacher gave way to the train station at Timmins. That town was named after the Timmins brothers, the owners of the richest gold mine in the British Empire—Hollinger Consolidated Gold Mines. The Hollinger provided its investors with nearly sixty years of spectacular dividends (and nineteen million ounces of gold). The town growing up in its shadows quickly established itself as the dominant community of the Porcupine.

Between the three main giants were numerous smaller and mid-sized mining operations. Some were little more than a shaft and a hoist room. Others maintained bunkhouses, offices, and managers' homes. Over the years a number of long-standing company-owned townsites developed: the Delnite, Aunor, Paymaster, Pamour, Buffalo Ankerite, Preston, Dome, and Dome Ex communities.

From the earliest days of the camp, the social makeup was defined by boarding houses full of single young men drawn largely from Eastern

The miner's strike (in the Porcupine) seems to be assuming vicious tendencies for one so young.

—Cobalt Nugget, Nov. 16 1912

Europe and the Mediterranean. Some of the men were hired right off the boat. Others were hired by "gatekeepers" within the various ethnic communities—men who searched out prospective workers from villages back in the old country.

The managers preferred to hire immigrants rather than Canadians. They had found that Canadians just wouldn't put up with the brutal work of "mucking"—hand-shovelling broken muck (rock) in the underground working "stopes" where gold production was centred. Stopes were caverns built to provide access to the veins of mineral wealth. The gold ore was drilled and blasted out in a series of eight-foot lifts, starting from the bottom of the vein and working upwards like the staging of a building project. The work was hard, dangerous, and, over time, deadly, as the silica dust cut away at the throat and lungs. Some 75 per cent of the men being hired in the Porcupine mines quit in the first month. The mine captains knew that Canadian-born workers were unlikely to stay on the mucking gangs but that foreigners had few other options. A young man escaping political persecution in the Ukraine or hunger in rural Italy was not about to quit on the mines with the spectre of failure or even deportation hanging over him.

Many of the immigrants came over on short-term work contracts. These men had left their families in the old countries to come over and earn enough money to buy land back home. They were willing to put up with the harsh conditions because they had no long-term attachments to the region.

But the managers had other reasons for preferring foreign workers. Most members of the managerial class were veterans of mining camps in the American west or in the silver mines of Cobalt, where skilled "packsack" miners had been tainted with the heresies of industrial unionism. The managers believed that the presence of so many foreigners in the Porcupine would lessen the ability of the Western Federation of Miners or the Wobblies to organize in the bunkhouses.

Matte Butkuvich
Killed in Coniarum Mine,
Oct. 17, 1937

"May the black earth be easy on you"
(translation of Croatian script
on gravestone)

■ ■ ■

By 1912 the union (Local 145 of the Porcupine Miners Union—Western Federation of Miners) had been making steady gains among the workforce. Men were angry about the high cost of living, the poor conditions in the bunkhouses, and the hard conditions underground. Then came the news that the mine managers were posting a drop in wages. Management had decided that since the railway had reached Timmins, the miners were no longer entitled to a bonus for isolation pay—even though the coming of the train had not had any mitigating impact on the extremely high cost of living in the camp.

The men voted overwhelmingly to strike, and twelve hundred miners set up picket lines at all area mines. The Mine Managers Association followed the pattern of labour disputes set in the American West. They hired one hundred "detectives" from the Thiel Detective Agency in Montreal to break the strike by whatever means possible. The strike quickly degenerated into a nasty street war fought with guns and mob beatings. On December 2, 1912, a violent confrontation took place outside the Goldfields Hotel in downtown Timmins, where the Thiel detectives were holed up with a group of strikebreakers.

At one point during the street battle, Mayor W.H. Wilson tried to stop a gang of Thiel men from putting the boots to an old man. A Thiel detective pulled a gun, stuck it in Wilson's chest, and pulled the trigger. The gun had already been used to fire into the crowd and the chamber was empty. Wilson later told the police this case of attempted murder was just one of "dozens of occasions" he had witnessed where the Thiel men assaulted or shot at citizens who were "doing nothing at all."

The miners responded to these battles by ambushing lone detectives with baseball bats or launching raids on the trains that were transporting the strikebreakers. Despite the violence, the strike dragged on through the winter. The union strike fund was soon depleted, and miners found themselves cut off from income and credit in area stores. The union set up a hostel to help afflicted families, but most strikers survived the winter by trapping, hunting, and ice-fishing.

As conditions continued to degenerate, the English-speaking miners began to depart in droves, leaving workers of other nationalities to hold the picket lines. The English strikers may have supported the ideals of the strike, but when things turned bad they had places where they could go to escape. The others had nowhere else to go. They were at war

His face had been kicked out of all human semblance by the hob-nailed boots of the mine guards... All his fingers had been smashed with hammers... Following this mutilation by the henchman of law and order [Charles] Barton had taken to the woods and lived in a log cabin located on Moose Creek... Barton's only companion was McDougal, an enormous black cat... Some mine guards sneaked up to Barton's cabin and in his absence riddled McDougal with buckshot. They hanged the dead cat's body in front of the door.

—Pierre Van Paassen, describing Porcupine union activist Charles Barton

in a foreign country, cut off from supplies and support. That they held out for six months is a tribute to their determination or, perhaps, their desperation.

The remaining English residents—management, merchants, and settlers—began to look upon the strike as an "ethnic" uprising. They carried loaded guns on the streets to hold off the foreign menace. The strikers tried to calm their fears by maintaining strict discipline. They carried banners that read "the Capitalist Is the Only Foreigner," but it was to no avail. After the men had spent nearly half a year living without wages, the strike crumbled. Men who wanted to return to work ended up fighting it out with the remaining militants. But by that point many of the jobs had already been taken by other "foreign" elements, notably Italian and francophone workers.

Leo Mascioli, an Italian contractor, had made a deal with Hollinger management to help keep the mines running throughout the strike with labour brought over from his home village of Villa Santa Lucia. The mine managers never forgot Mascioli's loyalty. He became a wealthy man from the construction contracts offered by the mines.

Another pivotal figure in breaking the strike was Father Charles Theriault. Knowing full well that francophones were at the bottom of the pecking order in other mining camps, Theriault went to the mine managers and offered to bring in men from his congregation to help break the strike. Theriault's gambit paid off. In the years following the strike, the francophone community enjoyed steady work in the region's logging operations and mines. A sizable French middle-class developed and Theriault remained on good terms with the mine managers.

■ ■ ■

The failure of the strike was the beginning of the end for the Western Federation of Miners in the Porcupine. It also marked a pivotal change in the social relations between the companies and the community. The mines were sitting on geological marvels, and many of those mines could remain productive for decades, perhaps even for much of the century. A long-term vision was needed. The old-style "brass knuckles" approach to labour relations was hampering development and preventing the companies from carrying out expansion.

Management had to find ways of cutting down on the high turnover of labour. Rather than accede to the union demand for higher

The 1912-13 strike was a divisive point in the history of Timmins but over time it began to be restructured to suit local interests. It came to be seen by English Canadians as a rather minor development rarely mentioned in any of the local histories... As one member of the local historical society said about the English old timers she talked to, "They can remember every wave of a flood, every flame of the 1911 fire, but not a thing about the strike." Many of the records dealing with the strike were eventually destroyed in a pointed effort to diminish its historical importance.

—Peter Vasiliadas, "Dangerous Truth"

wages, the companies set about dealing with the high cost of living. The Hollinger Mine set up a company store offering low-cost goods to compete with the high prices charged by the various merchants. This initiative was just one of a number of company moves to try to reward "loyal" employees.

The Dome Mine carried out a major recruitment drive to entice Cornish miners—"Cousin Jacks"—men known for their hard work and their total lack of union politics. Other ethnic workers derided the Cousin Jacks for their habit of taking their caps off in the presence of management. The Dome housed these Cousin Jacks in a new company townsite (The Black Shacks). Hollinger followed the lead with an even more ambitious housing development, which offered low rents to long-term employees and their families. All of the mines supported recreational sports to keep the men occupied and entertained.

In 1919 the still exploded in Dagenais Hotel... The Reeve at the time said, "What the heck, let it burn. Only foreigners live there."

—Minnie Gram (Levinson)

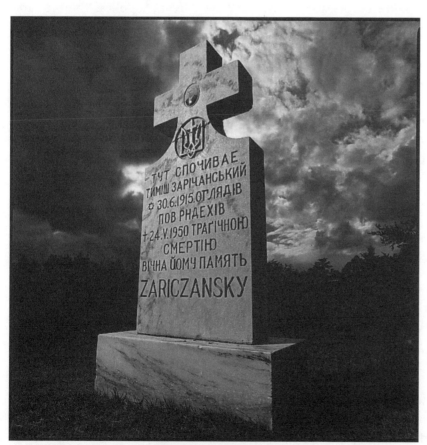

Grave of Tymko Zariczanksy, killed in Paymaster Mine, age 35, 1950
■ Timmins Cemetery

But along with the velvet glove came the hard fist against "trouble-makers" in the immigrant communities. In the aftermath of the strike there was a wave of firings and blacklisting (the blacklist being a technique shared with mining camps throughout the North). With the coming of the war, many leaders in the Ukrainian community were dragged off to prisoner of war camps. Other ethnic leaders were deported as agitators. It would be forty years before the miners were organized enough to risk another confrontation with the companies.

Some of the men escaped the conscription and internment drag-nets. They took to the bush, where settlers and police were unlikely to follow. They lived a bare subsistence by prospecting and trapping. A number of them moved up into the isolated bush country north of Murphy Township.

In winter they hauled ore samples on toboggans to go-betweens who sold the rock in exchange for basic living supplies. The ore samples, streaked with copper and base metals, attracted some interest because they were unlike any other ore found in the camp. But mining money in the Porcupine was driven by rumours of gold, and the town-ships directly north of Murphy—Kidd and Wark—were too far away from the geology of the gold-bearing Porcupine-Destor fault to attract serious backers. After all, what kind of fool would bankroll a drilling program in uncharted muskeg on the word of blacklisted agitators? These outlaws with their dream of class solidarity were soon forgotten as continual waves of settlers moved into the Porcupine with dreams of making a better life.

■ ■ ■

We would probably know nothing about these outlaws in Murphy Township were it not for a series of oral interviews conducted in the early 1970s with Porcupine "old-timers." Jack Pecore, a veteran of the 1912 strike, happened to mention them to a local historian during one of the interviews. Pecore made no mention of how many men were involved. He didn't give a list of any names.

The only reason the story seemed worthy of interest was that the land north of Murphy Township had recently been the scene of a spec-tacular mineral rush. The discovery of a massive base-metal deposit in Kidd Township created an unprecedented flurry of excitement on the stock market. Was this the same terrain staked by desperate political

outlaws? We will never know for sure.

But in light of the fantastic new riches of Kidd Creek, Pecore reflected on the hopelessness and poverty he had encountered among the men who tramped the ground north of Murphy Township. "They knew there were big ore bodies there...they knew it as a big thing but nobody would touch it... They would pass the time looking into the wood fire. They'd look into it and it would take their minds off things, watching this fire. A lot of fellows told me they would pass endless hours like that... They died very young for they had an awful hard life of it back in the bush."

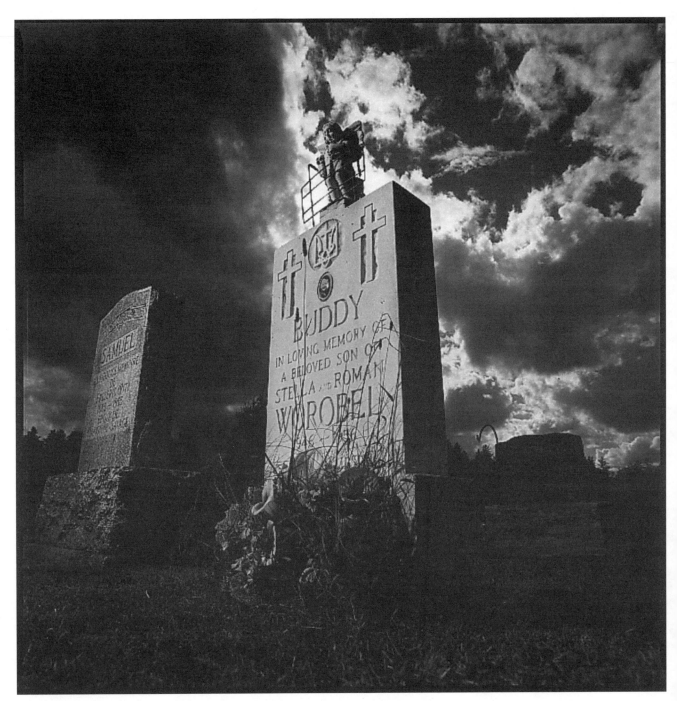

Grave of Buddy Worobel, died age 10, 1956 ■ Timmins Cemetery

3 The Short, Unhappy Life of Natasia Baldiuck

BY THE TIME THE COPS FOUND HIS BODY she was gone. The Rumanians weren't doing much talking. The most they would admit to was that there had been a big party the night before. Not much of a surprise there. All these boarding houses ran liquor to keep the men happy.

The deceased was a mucker named Mike Lasiuck. Death had been caused by a severe blow to the head from a coal-oil lamp. The body was covered with numerous slash marks from an axe. Laid out beside the body were a Rumanian prayer book, two candles—burnt right to the base—and a wedding certificate, dated 1922, stating the marriage of Lasiuck to Natasia Baldiuck.

Now, two years after the nuptial event, he was dead and she was on the run. Lasiuck had been a resident of the boarding house. His wife had apparently just come north to Timmins to be reunited with him. She had arrived at the boarding house a little before the party started. The way the cops figured it, the drinking got heavy. Lasiuck got nasty. Now he was dead.

Nobody saw anything. They never did. The best the cops could come up with was that sometime late last night Baldiuck emerged from Lasiuck's room in a very agitated state. She threw the other men out of the house and then holed up inside, prowling around for the next eighteen to twenty hours. After she fled the scene, the men returned and found the body.

Where could Natasia run to in the Porcupine? Nowhere. The cops knew this. The Porcupine had hundreds of Natasias—immigrant women without the tongue or the protection of the new land. At least the men could pick up English at work. The children took to it in the schoolyard, but the women were forced to rely on a patched-together network of kin ties. They shopped in grocery stores run by fellow Croatians or by Ukrainians or Italians.

But they also learned to rely on their neighbours—other miners' wives who knew the universal female language of mutual assistance; women who could be counted on to look out for the little ones playing on the road or be on hand with their own ethnic dishes and old country remedies in times of sickness and domestic need. These links were

White slavers kidnap girl to send north... On Thursday, Montreal judge Gustave Morin sentenced Alexander Brebant, aged 33, to prison for five years, for his part in the scheme to drag Alida Tremblay, 19, into a life of prostitution and send her to Timmins. Mrs. Germaine St. Maurice was given a two-year term. According to the evidence, the woman advertised for domestic help and then held two girls against their will to forward them north for immoral purposes.

—The Porcupine Advance, Sept. 16, 1935

vital for young mothers, because there was no other social support in the Porcupine.

In 1974 Lempi Mansfield told the story of three children who lost their parents during the influenza outbreak of 1918. The orphans were shunted back and forth among the neighbours until the oldest child, a fourteen-year-old girl, managed to find work at the telephone office. She and her younger siblings moved into the telephone office and slept on the office floor.

During the first years of the camp women and children were not even entitled to treatment at the local hospital. The hospital, run by the Nuns of Providence, was maintained by deductions from the miners' weekly paycheques. If you weren't a working miner, you didn't get coverage.

Once Eva Derosa, an Italian immigrant and midwife, personally appealed to mining magnate Noah Timmins for permission to have her young daughter treated in the hospital for a case of acute appendicitis. But even with the benevolent intercession of Noah Timmins the hospital could do little, because the primitive facilities offered no skilled surgeon. The only alternative was the expensive and long train ride to Toronto. Eva took her little girl and boarded the train with all the money she had managed to save. Before leaving she wired ahead to Dr. Lowrey in Englehart (150 kilometres south of the Porcupine) in the hopes that he might be able to help. He was waiting at the platform when the train stopped in Englehart.

Dr. Lowrey did a quick examination of the child. "Your daughter will never make it to Toronto. She'll be dead before the train gets in." The child needed surgery, and it was beyond the capability of a country doctor.

"The only chance you have," Dr. Lowrey told her, "is to get to Cobalt where Dr. Mitchell is doing operations. I'll wire ahead and tell him to wait until you arrive."

When the train stopped in Cobalt, Eva Derosa made her way to see the visiting surgeon. Dr. Mitchell was very matter-of-fact. "It'll cost $50 for me to stay over and save your little girl," he said. Fifty dollars was a lordly sum, but Eva agreed without hesitation.

After the operation was over, Dr. Mitchell came out to see Eva. The little girl would live, he told her. Flushed with gratitude, Eva asked for her bill.

"Mrs. Derosa," he said, "I know you are a poor woman and that

Anka Kostelac
Born Croatia 1912,
emigrated April 6, 1936,
died July 27, 1936

you can't afford to pay this bill. If you give your daughter to my wife and I, we will consider the debt cleared."

Eva reeled in shock. "Dr. Mitchell," she stammered, "I may not be able to pay you but I would never give up my little girl. I have fought too hard to save her."

Dr. Mitchell tried to reassure her. He explained how he and his wife were childless and how much they had come to like the child. "I'm a doctor," he said. "We could give her all the best—a good education and the things you could never afford."

Eva stood her ground. "I will give her the best I can. She couldn't ask for anything more. I am not going to give you my little girl." Eva paid the bill and many years later ran into Dr. Mitchell at a hospital in Toronto. She walked up to him and asked him if he remembered the time he tried to barter for her little girl. "Yes," Dr. Mitchell said sadly, "My wife and I think of her often."

Another successful party was held by the Ladies of the Orient at the home of Mrs. J. Johnson, who was assisted by Mrs. Geddes. Ten games of euchre were played. The first prize was carried off by Mrs. Ed Lee, now of Haileybury, who was visiting her sister, Mrs. Fairbrother.... The next event will be a masquerade and by all accounts is going to be a genuine humdinger.

—The Porcupine Advance, April 21, 1927

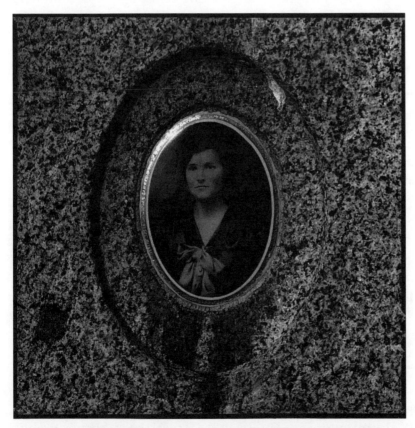

Grave of Maria Ziliotto, died age 26, 1928 ■ Timmins Cemetery

■■■

The triumphs and tribulations of such women were not the stuff of the local society column—that was strictly the domain of the people with names like McCrae, Davidson, and Little. Among the litanies of euchre parties, strawberry socials, and gatherings of the Rebekkah Lodge, you would never see a mention to the effect that "The Derosa family is happy to announce that young Mrs. Derosa successfully took back her daughter from an anglo surgeon." Among the visitation announcements you would never read something to the effect that "There was much rejoicing in the boarding houses of Moneta when Natasia Baldiuck, pretty young bride of mucker Mike Lasiuck, arrived in the Porcupine to join her husband."

No, such listings were strictly the domain of the "white" people. Edmund Bradwin, in *The Bunkhouse Man*, his study of Northern bush camps, refers to ethnic gradations as being defined by those who were considered white and those who were not. For example, Swedish immigrants were white and Bulgarians weren't. Rumanians were just above Bulgarians when it came to the bottom of the pecking order. And yet these women were the yeast in the leaven of all-male bootleg joints and boarding houses. Their arrival transformed the ethnic neighbourhoods of Schumacher, Moneta, and Mountjoy with the vibrancy of community and family.

But when fate chose otherwise, the options were bleak. Who looked out for a woman with five mouths to feed when her husband was choked in a run of muck underground? Who was there to stand up for a foreign woman who faced the rage of a man abused day after day in the stopes?

The English shift bosses worked these foreigners hard. They knew that for every Russian or Finn who cracked under the strain, two more men were waiting to take their place. Sometimes, however, the men fought back. Once, in 1916, two Russian muckers, Mike Volni and John Petric, almost kicked an English shift boss to death. At the Dome Mine John Primak went berserk underground and killed two Englishmen.

But all too often, those at the bottom took it out on the only people below them—the women. Consider the story of the "bright, young Russian girl" who married Mike Kulick, employed as a mucker at the Buffalo Ankerite Mine. He was in his forties, she was barely twenty.

We had a bunkhouse behind the store. It housed workers for the Dome Mine. Most were Slavic. Dad did all their writing to their families for them and read the letters sent to them... It was always an occasion of celebration when one of them brought their family over. Their first stop was at our place before going to their new home.

—Minnie Gram (Levinson)

Early into their marriage he began abusing her. The way the papers described it, "The man who promised to love and cherish has been a haunting terror to her life."

Determined to make it in this foreign land, Kulick's wife presented him with separation papers and then went looking for work as a serving girl in the homes of the English. Her new employees, the Cunninghams, thought very highly of her. They wanted to help her get a new start. It didn't work out that way. Not long after the separation, Big Mike Kulick stormed into the Red Ukrainian Hall and blew her away in front of the gathered crowd. When the cops finally caught up with him he blew his brains out.

■ ■ ■

And so where could Natasia Baldiuck run to in a town where the only way out was a ticket on the train? She made it as far as the Mattagami River bridge. The next day the cops fished her bloated body out of the muddy waters. It was pretty easy to fill in the missing pieces. After killing her husband, she had kept vigil with her prayer book and marriage certificate until the candle burnt down and she ran out of options. She then headed for the furthest point in town—the Mattagami River. Unable to go any further, knowing she couldn't go back, she tossed herself over the side of the bridge. Nobody to intercede. Nobody to mourn. Just another crazy foreigner for the police files.

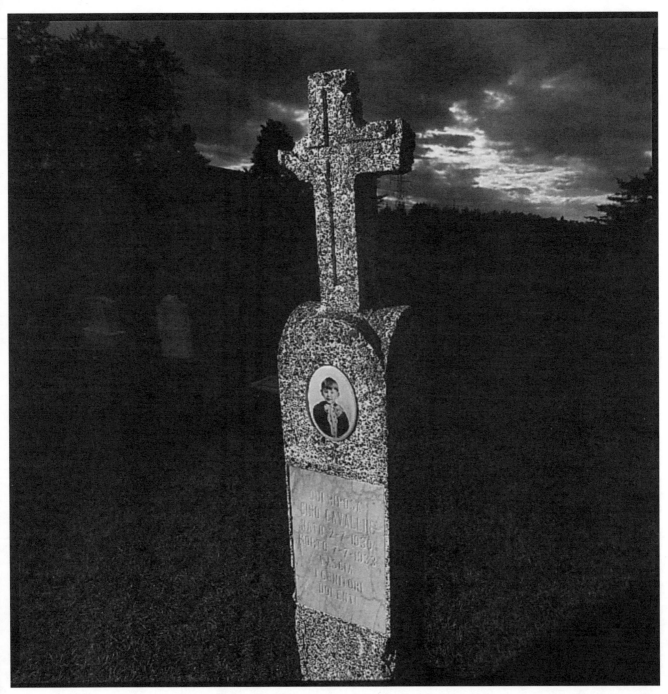

Grave of Gino Cavallin, died age 3, 1933 ■ Timmins Cemetery

4 Joe Basill Gets Whacked

ON A WARM THURSDAY EVENING IN 1924, Joe Basill found himself bleeding to death all over a downtown street in Buffalo, New York. It was a bad end to what should have been a sweet deal. Joe had gone to Buffalo looking to sell gold "high-graded" from the Porcupine. Instead Joe learned a tough lesson about messing on other people's turf.

The cops called high-grading Ontario's biggest crime. The judges said it was a cancer eating at the provincial economy. The mine managers warned that high-grading crippled the future of the mines and robbed the shareholders of what was rightfully theirs. But such sentiment couldn't buy you a half-filled glass of flat draft in any beer parlour in the Porcupine.

Tell a guy who risked his life every day in the narrow-vein stopes that he had an obligation to the shareholders. Try raising sympathy for the plight of the investors among people who had seen their fathers die from silicosis or seen widows and children put out on the street. The gold ran in silica-ladened veins, often invisible to the naked eye. On average it took a ton of rock to produce a quarter-ounce of gold. The lucky mines counted on those few precious veins where the gold content ran much higher, veins where the gold values ran thousands of dollars to the ton and VG (visible gold) glistened like a jewellery shop. Mines that boasted "jewellery shop" stopes took numerous precautions to protect their assets. The stopes were often cemented in with a sealed door. Only bonded miners were allowed to work in these stopes and were often watched by guards. A mine with a few good "high-grade" veins could offset the costs of maintaining a number of lower-grade stopes.

The men working at "the face" were also on the lookout for the glint of gold. Stolen high-grade flowed out of the Porcupine gold mines like water through a sieve. Miners packed gold fragments into unfinished sticks of bread in their lunch·kits. They pulled out tooth fillings and filled the cavities with gold chips. They stuck flakes under their fingernails, balanced chunks under their tongues.

The mines cracked down and made the men strip and walk past security guards on surface. But the high-graders simply shoved vials of gold up their asses and walked through smiling. The mines invoked random strip-searches, but the gold still slipped out—shipped to surface in broken stoper drills, swallowed in packages, hidden in boot bottoms: all

At least four prominent citizens of Timmins are known kingpins in the high-grading racket and are protected by the fear of death, Murdo Martin, New Democrat Member of Parliament said today. "Anyone informing against them would be risking his life," he said. "They all appear to be very nice fellows. They have big cars and nice homes but no visible means of support. People here know from experience that the higher-ups in the high-grade racket don't fool around with informers... Several people involved in the racket have disappeared."

—The Toronto Star,
Jan. 5, 1963

for five dollars an ounce—the going rate paid to miners willing to high-grade.

The high-grade was sold to "fences"—men who would smelt the gold ore and have it moved down to the main markets in mob towns like Buffalo, Hamilton, or Montreal. In those cities the gold, pegged at $35 an ounce (on the legitimate market), could be turned around for as much as six times that amount from black-market buyers in the Far East. In the years following World War II it was estimated that the Porcupine mines were losing between $1 million to $5 million a year (over $42 million U.S. in today's value) to high-grading.

■■■

Targisio Bassi
1885—1935

Joe Basill had run afoul of Rocco Perri's mob in Hamilton. Perri had a long-standing connection to the Porcupine. When Merritton, Ontario, police chief Joseph Truman was gunned down by a Perri acquaintance in 1922, provincial police traced the murder weapon right back to South Porcupine. When Perri was taken out of action by the wartime incarceration of Italians, his girlfriend Annie Newman took over the rackets, and her first order of business was making the trip into Timmins to fill the void left by the busting of a high-grade gang run by Charlie Lamothe and Simon Dollinger.

Annie Newman's racket relied on the high-grading links maintained by Willie Franciotti, Albert Macuzza, Frank Deluca, and the Labreque family (Albert, Paul, and Lionel). The conduit for the gold operation was Sydney Faibish, a Toronto optometrist and founder of Crown Optical on Yonge Street. Annie's racket was busted up in 1941 when Bronx resident Harry Julius and another fellow, Charles Abrahams, were busted trying to bring gold into Buffalo. Annie was charged with having stolen over $850,000 in gold. She was sentenced to three years in jail.

Once the gold was secured from the mines it had to undergo a rough smelting, usually in a pot belly "Quebec stove" in a farmhouse out in the sticks. The gold would then be poured into small, easy-to-hide "buttons" varying in value from $500 to $3,500.

It was in just such a farmhouse out in Stock Township that the cops found the body of David Palmer on the morning of May 14, 1943. He had been beaten so badly that robbery was immediately ruled out. No thief would have wasted the energy. Somebody wanted Palmer dead in a very serious way.

The night before he got whacked, Palmer certainly seemed in a hurry to wind up his affairs. He was planning on moving as far as he could from the Porcupine. After the killing, one of Palmer's buddies turned himself in, not as a suspect, but as somebody begging protection from the cops. Sure it was a high-grade killing, but nothing ever came of the investigation. After all, you would never connect a bum like Palmer to the high-graders.

In general, the high-graders knew that the less they leaned on people the smoother things would go. People liked high-graders. Their presence was seen as a way of evening the playing field. It gave the guy at the bottom a chance to take his own cut out of the riches reserved for distant millionaires.

High-grading depended on the Robin Hood factor. Good fences had to be able to move around in a rat's-ass town with everybody—from the paperboy up to the chief of police—knowing exactly who they were and what they were doing. They could only achieve this if the general population felt that somehow, some way, there was something in it for them too.

It didn't always work, of course. Frank DeLuca was a good fence. He'd been in the Porcupine since 1937, first acting as a dance-hall operator and then moving full-time into bootlegging and gold running. His home address was the abandoned Belvedere Restaurant just a stone's throw from the Mattagami River. His only visitors were cops and cars from out of town. Deluca used to spend his time in the bootleg joints betting fifty bucks on a turn of the card. In 1948 the cops found Frank with his belly slit open. The official police report suggested a shake-down—a couple of punks trying to fleece him for some of that easy high-grade money. But one of the stories going around the beer parlour was a little different. Frank, they say, double-crossed on a sale in Detroit—substituting brass buttons for gold. Detroit boys put the word out in Timmins and Frank was a goner.

Nicola Bodluavic
"In dreams resting... Mother Earth, be hospitable in peace"

Is the tape recorder off?
Okay, now I'll tell you about
high-grading.

—former Timmins miner, 1994

■ ■ ■

The real skill in a good high-grading operation was finding the runners. These people formed the links to the southern markets, and the cops were always on the lookout for runners. The more respectable the runner, the better the chance of getting through. The best runners were women—especially ones who looked like school teachers. The fact was, cops just weren't that comfortable doing a frisk down where it counts. One cop did and found a set of measuring weights hidden in the girdle. If a woman could hide a set of weights down there, who knows what else they could hide?

Despite crackdowns by mine management and a special provincial crime squad dedicated to busting the rings, the high-grade black market thrived. People laughed at the pronouncements of the Provincial Police's "high-grading squad." Sure the cops nabbed a lot of hapless miners trying to walk off mine property with gold in their lunch boxes, but they never so much as graced the steps of the resident high-grade kingpins. This even though everyone knew damned well who was running the rackets.

The Toronto Star was bold enough to give accurate descriptions (albeit without names) of the four major players known to run high-grading in the Porcupine, but it didn't matter. In the Porcupine these men were, and in some cases still are, untouchable.

Even when a low-level ring was busted, the juries showed surprising leniency. Here's a classic tale: the cops bust this house on suspicion of high-grading. While the miner keeps the cops busy on the main floor, his wife tosses the evidence out from an upstairs window—right into the waiting arms of a cop. And there she is in court, bold as brass, saying she wasn't the one who tossed it. Must have been somebody else who looked like her. And the jury let her off. Lack of evidence.

■ ■ ■

From my own visit to the Timmins area... and speaking to the man on the street I was left with three main impressions: 1) Gold smuggling is widespread. 2) It is a considered a challenging hobby that any miner might engage in. 3) It's considered good for local business.

—Frank Shields,
The Toronto Star, Dec. 6, 1963

All of which brings us back to Joe Basill. He couldn't fence and he couldn't run. When his wife first came up to the Porcupine from Hamilton they nabbed her on the train for liquor violations. The Basills were damaged goods from the beginning. No sooner were they back in Hamilton than the cops had her nailed again, this time for holding high-grade.

They missed Joe by a flash. He fled to Buffalo, hoping to contact the big boys and sell the rest of the stash. But that's not the way it worked out. Three of Rocco Perri's boys riding in a car drew up alongside Joe, who was walking along the street. Joe nervously glanced around—seeing potential witnesses all over. But the Perri boys didn't seem to care. They took their time chatting with Joe Basill and then when they were done they pulled out their pieces and blew him away.

Bad luck for Joe, but a good reminder to everybody else back home that when it comes to selling high-grade, you play by the rules or not at all.

Grave of Chevrier Family ■ Timmins Cemetery

5 The Hollinger Fire

ON DAYS WHEN IT WAS TOO COLD, too wet, or too dismal to play outside, my grandmother rooted around for things to keep us occupied. Every now and then she let us rummage through her collection of newspaper clippings and postcards. There was no apparent rhyme or reason why this was saved and that wasn't.

There were some hand-coloured postcards of Loch Lomond and the bridges on the River Clyde. There were no postmarks or writing on the cards. Whoever purchased them must have waited until they returned to Timmins to give them to my grandmother. These tourist trinkets were the closest she, or any of us, would ever get to the old country.

Besides the postcards, there was a tattered book on Scottish tartans and a few old newspaper clippings relating the deaths of various friends and relatives. None of the names meant anything to me. I quickly put them aside for more interesting finds, such as the April 1962 issue of Hollinger Miner magazine. It contained a photo and the obituary of my grandfather.

Since we had very few photos of Charlie, the photo in that issue is imprinted in my memory. I see my grandfather as a stout, old man in work overalls, dwarfed by the massive sheave (hoist) wheel from the Hollinger sand-bucket plant. The mine ran an aerial tram of sand buckets to a nearby pit so that the sand could be used as backfill in the underground stopes (local kids used to ride the buckets out to the blueberry patches). It was Charlie's job, working on a lathe, to sharpen the wheel to cut down friction on the tram cables. It was precision work with no margin of error. He is looking at the camera disinterestedly, as if he isn't going to waste his energy on a smile for the company photographer.

Charlie died working the lathe. The obit simply states that he suffered a seizure and had worked thirty-eight years for the Hollinger Mine.

There were a few other clippings in my grandmother's collection— yellowed newspaper accounts of Daughters of Scotland functions, the results of some local beauty pageant, and a striking photograph dating from February 1928 that shows a large crowd gathered around a series of coffins. The people are standing in front of the old Red Finn Hall on Algonquin Avenue. The ground is covered in snow. The people look cold but determined.

Mr. Brigham came from South Africa where he had been manager of the Jagersfontain Diamond Mine....He was a person of strong character who managed affairs in a paternalistic manner... He ruled his empire from his large house atop the hill in the centre of the mine property. His daughter Fay was considered the life of the town.

—C. Bruce Ross,
"The Hollinger Mine"

The coffins are arranged on sleighs. They contain the bodies of eight Finns and one Ukrainian, who were among the thirty-nine miners killed in an underground fire in the Hollinger Mine. The photo captures the crowd just before the Finnish Concert band began to strike up a death march and the people trudged out through the snow towards the cemetery.

Along the way, they covered the path in front of the sleighs with cedar boughs. Men from the Finnish community shovelled out a large path from the cemetery gates to a deep trench dug in the frozen soil. There the nine were buried in a mass grave. Supporters of the Red Ukrainian and Red Finn factions covered the cost of a large monument. The photograph of the crowd and coffins outside the Finn Hall was sold as a fundraising postcard among labour and left-wing groups all across Canada—proof of the perfidy of the capitalist system. Proof of the need to restore industrial-based unionism in the Porcupine.

■ ■ ■

By 1928 the Hollinger Mine was not only the largest gold mine in North America but also the largest gold mine in the British Empire. With over one hundred miles of underground tunnels (eventually it had well over five hundred miles of tunnels) and nearly two thousand employees, the Hollinger was a vast, multi-ethnic underground city. During its fifty-eight years of production, which ended in 1968, the Hollinger Mine employed over forty thousand men.

The mine was geared to well-organized and long-term production. When a lack of electric power hampered production levels, the mine hired 450 men to cut a seventy-six-mile rail line to the Long Sault Rapids on the Abitibi River, where the company installed its own hydro plant. Hollinger maintained massive timber yards, a machine shop, and two sawmills. By the late 1920s the mine was operating twenty-four hours a day, 363 days a year, and producing two million tonnes of ore each year. The only two holidays—Dominion Day and Christmas Day—were unpaid. Norwegian immigrant Magne Stortroen was struck by how New Year's Day, a big festival in his home country, was just considered another working day. Writes Stortroen, "This brings to mind the old Scandinavian proverb, 'When amongst the wolves, you must howl like the wolves.'"

When we came to the Hollinger townsite the outstanding feature was the flat roofs and small windows. At first we did not know what this was and we just stopped and looked. Somebody said, "That must be packing boxes for pianos, out here in America they must have bigger pianos, too." In Norway we had been told how wonderful living conditions here were and how high the wages. Further up there was a whole row of black tar paper shacks. None of us had ever seen housing like this.

—Norwegian immigrant Magne Stortroen, describing his first day in the Porcupine

Underground production was centred out of four main shafts. The Central and Schumacher shafts were used mainly for hoisting ore, while the No. 11 Shaft and Main Shaft were used for hoisting men and supplies. The afternoon shift, which started at three, was reserved for "drifting." The drift crews had the task of drilling and blasting the tunnels (drifts) that provided access to the gold veins and served as transportation arteries. Essentially they were opening up new sections of the mine to development. When the drift crews had finished, the graveyard shift started hauling down timber from the surface to various blasted-out drifts and stopes. With the timbering in place, the day crews took over the main work of production.

On the morning of Friday, February 10, 1928, the day shift began as normal with the usual staggered time descent for various crews—miners at seven o'clock, timber crews at eight, and the samplers and surveyors at nine. By ten o'clock in the morning, the surface crews realized that something drastically wrong was happening down in the depths of No. 11 Shaft. Miners who should have been on their way to their stopes were at the cage stations ringing for help. Other men were fleeing up the emergency raise ladders. They told of thick smoke billowing out from the 550 level. The toxic smoke was being carried downwind through the various working levels.

The ground at the 550-foot level was cold and wet all year round. It seemed impossible that an underground fire could happen there in the hard rock of the shield. The surface managers were having a difficult time getting an accurate sense of what was going on. They had no way of alerting men in other work areas of the danger. And as miners continued to escape from underground, management struggled to get a tally of who was accounted for and who was still missing. Adding to the pressure and confusion, news of the disaster was all over the camp within the hour. The mine gates were clogged with panic-stricken women and children. They wanted to know where their loved ones were.

Hollinger miner Frank Martin was one of those clamouring for answers. He had taken the day off because of illness, while his brother, partner, and best friend Ossie had gone to work. Frank and Ossie had fought through the First World War together. They were inseparable. Now Ossie was trapped somewhere down near the fire zone. Despite pleas from co-workers and family, Frank refused to leave the shafthouse. "I'm not going home," he said firmly, "until I bring Ossie home with me."

John Bunzeak
Born Roumania 1893,
killed Hollinger Mine 1930

"Left a wife and two children"

Among the victims of the disaster, none were more popular than Messrs. C. Richards and Harold Barrett. These two men were particular friends in life. The two families have been next-door neighbours on Cambrai Avenue. In death the two men were still neighbours, passing away in the same disaster and being buried at the same place and time, while the two widows tried to comfort each other.

—The Porcupine Advance

Hollinger, which had prided itself on its long-term industrial planning, was completely at a loss. There wasn't a single mine-rescue crew in Ontario. There was no respiratory gear at the site and nobody on staff was trained for underground emergencies. The mine wired down to Toronto for help, and a special train was outfitted with gear from the Toronto Fire Department. All traffic along the line was cleared as the train raced north. A second call was put in to the nearest mine-rescue crew, stationed in the coal fields of Pennsylvania. But even though the train from Pennsylvania was speeding through a blizzard, it wouldn't be able to make it for at least twenty-two hours. In the meantime management began to poll the ranks for volunteers. Men who had faced gas attacks in the Great War were asked to come forward and lead rescue operations after the gas masks arrived.

Until the rescue gear arrived, the best the mine could do was to run the cage up and down No. 11 Shaft in the hope that some survivors would make it to an underground cage station. By mid-day men stopped coming up from underground. At least fifty men were still missing. A full day went by and the silence from the shaft was increasingly ominous. And then on Saturday afternoon the men on the surface heard the cage bell ringing at the 675-foot level. Cage tender Pete Benki rushed down and found fifty-two-year-old George Zolob, a big Yugoslavian miner, at the point of collapse. Zolob breathlessly told Benki that he had left six other men further down the drift.

The men had survived thirty-two hours underground by using their shirts as face masks. They had fought back the smoke by breaking the air hoses. The broken air lines had almost deafened them with their roar in the confined space of underground. After their lamps gave out the men knew they would not survive the darkness so Zolob, a veteran of the war in the trenches, opted to try his luck at moving through the smoky drifts to get help. Rescuers found a total of thirteen men still alive on that level. Some of the men had been kept alive throughout the ordeal by artificial respiration performed by their trapped compatriots.

By the time the fire crews arrived from Pennsylvania there were no more hero stories to tell. Frank Martin, who had spent three days with little to eat and no sleep, finally left the mine property, taking with him the body of his brother, one of thirty-nine pulled up from underground.

■ ■ ■

The fire was a serious blow to the prestige of the Hollinger Mine. In its aftermath a number of meetings were held for local miners. The communists were there. So were organizers from the Mine, Mill and Smelter Workers Union, the Wobblies (IWW), and the One Big Union (OBU). Each group hoped the grief and anger would stir membership drives. Speakers addressed the large crowds in Finnish, Russian, Yugoslavian, French, and English.

Outspoken Finns denounced the anglo bosses for denying compensation to common-law spouses. (Some of the dead miners had wives back home and new families here. Others were socialists and refused the recognition of a wedding sanctioned by either church or state.) The union organizers demanded an inquiry. A government commission was appointed, and it gathered ten thousand pages of evidence. It was determined that the fire had started spontaneously in an abandoned stope that was being used as an underground garbage dump. The miners knew fully well that the stopes were regularly filled with old powder bags and waste because the company's rigid production schedule did not allow enough time to fully clean the underground workings.

Government investigators came back with a verdict of gross negligence against the company. In the end the Hollinger brass provided a short mea culpa by firing an underground superintendent. The company then set about taking the steam out of the union drive. All workers were paid for the two weeks the mine was shut down. The widows were quickly compensated (except for five Finns who lived common-law). In the coming months the company quietly dismissed a number of the more outspoken Red Finns.

The union drive stalled, and within months it was back to business as usual for the mighty Hollinger.

Grave of Jim Dubinsky ■ Tisdale Township

6 Joe and Lola

SHE WAS WORKING IN THE FRACTURES WARD the night they brought in the big man. He was unconscious, with numerous broken bones, lacerations, and a busted back, compliments of the heavy earth in the McIntyre Mine.

The men from the mine who brought him said his name was Joseph MacNeil, aged twenty-eight. His address was to be expected—a Cape Breton boarding house in Schumacher. She washed the grime off the big man's face and helped bandage the cuts on his arms and chest. If things went well, he might live, but he'd never work underground again.

He came to consciousness, trussed up in a back brace and unable to move. The French nuns had little time for him. They said he mumbled rather than spoke. She took it as shyness. Cape Bretoners were like that. They were painfully respectful of women.

When she wasn't being run off her feet, she'd tell the big man about herself. Her name was Lola Jane Lindsay. She was one of eleven children, from Mattawa in "the Valley." Her mother's family were famine Irish who had landed first in Quebec City and then slowly worked their way up the Ottawa Valley. Her father was an Orangeman from Glasgow. He worked for the railway.

She had come to Timmins to learn a trade as a nurse. Well, that wasn't quite true. She had come because her sister Mamie promised her a job at the telephone office, but there was no job waiting when she arrived. Too proud to go home, Lola took to cleaning houses until she managed to get herself accepted into the nursing program at St. Mary's Hospital.

And then she would push him to talk about himself. He was from the village of Iona, prettiest country God ever made. He left home at seventeen to get out from under the thumb of his domineering Gaelic father. Joe knew the Porcupine was a good bet for employment because his older sister and brother-in-law were already established in the North. Joe got his ticket out of Cape Breton by convincing his cousin at the telegraph office to fake a telegram promising him work in the mines. The telegram was the only way to get his father's approval to leave Cape Breton.

Single young Cape Bretoners were a dime a dozen in the Porcupine. They came looking for a way out of scratch farming or the brutalities of

I was seventeen years old and I got a job underground driving a horse at the McIntyre Mine. The mine used wild horses captured on the prairies. The horses would be put in the cage to go underground and they'd just kick the shit out of the cage. But once they were taken down three or four times, they got used to it. The horses were more intelligent than some of the men. They'd never go into unsafe ground.

—W.T. "Red" Phillips, retired Timmins miner

41

the coal mines. Like other immigrant groups they congregated in their own boarding houses and hotels. Joe found lodging in the Furlong Boarding House in Schumacher. He was soon joined by two brothers and numerous cousins.

Throughout the 1920s and 1930s the Porcupine mines steadily expanded. Impressive new mines like the Coniaurum, Delnite, Pamour, Hallnor, Preston, and Broulan Reef were coming onstream. The big three—Hollinger, McIntyre, and Dome—continued expanding underground. New men were being hired all the time. The McIntyre Mine personified this expansion with the sinking of its No. 11 Shaft. The 4,000-foot shaft was considered one of the engineering marvels of the mining world. The mine would eventually reach a depth of over 8,000 feet and produce over ten million ounces in gold.

Joe's brother Albert worked as a linesman on surface, while Joe went to work underground. His first job was running the "honey wagon"— shovelling horse and human shit out of the drifts. New miners faced various hazing rituals, and Joe was no exception. The older miners thought it would be funny to tell the seventeen-year-old kid to unbolt some timbers. As a matter of course they didn't supply him with any wrenches. No problem. Joe simply reached up and secured his hand around the damp, rusting bolt and, with all his might, loosened it. Nobody ever tested Joe again after that.

McIntyre had the best of men. Very good. At least they thought something of their employees. They used to hold a McIntyre Field Day. It was lots of fun. Everything was a nickel, even for outsiders. People from uptown came with kids. Ice cream was five cents.

—retired McIntyre miner

McIntyre used to tell us that it was cheaper to kill a man than to cripple him, especially if he was a young man and then they'd have to pay him compensation for twenty-five or thirty years. They didn't want that.

—Felix Brezinski, retired McIntyre miner

Grave of Jusef Talaska, died age 43, 1934 ■ Timmins Cemetery

Over eight years Joe worked his way up to the post of underground electrician. But Joe was homesick. He longed for the salt waters of Loch Bras D'or. He missed the cadence of his people. All he had to show for his years in the Porcupine was a room with a single bed and cases of empty beer bottles left over from "day drunks" with his pals. It couldn't compare to the warmth of a ceilidh in the kitchen. In 1930 Joe packed his bags and went home. With the depression on, he was lucky to land a job at No. 16 coal colliery in New Waterford. But he soon realized that he had simply traded one set of boarding houses for another.

The shift bosses at McIntyre had been tough, but they had nothing on the coal bosses at Dominion Coal in Cape Breton. The coal company had a nasty little policy of hiring many more men than it needed and letting them each work just two or three days a week. It kept the families at near-starvation conditions and the men desperate to hang onto whatever work was coming their way.

During this period the collieries were hit by a series of long strikes, but Joe wasn't one for fighting. He filled the long days of idleness walking along the beaches playing with a camera he had purchased. It was an aimless and unfocused life. One afternoon as he sat on a rocking chair on the porch of the boarding house he realized that he felt like an old man watching his life pass by in front of him. He quit his job and boarded a train back north.

It was a gamble. The gold mines of the Porcupine had become a magnet for unemployed men from across Canada. They rode the rails into the camp in desperate hopes of finding jobs. Large squatter colonies formed on the edges of towns. Every day hundreds of men lined up at mine gates hoping to be hired on the bull gangs. To maintain a job underground, workers sometimes had to pay kickbacks to a shift boss. It wasn't unheard of for a mine captain to demand the pleasures of a pretty wife in return for a miner keeping his job and his children fed.

But Joe had friends in Schumacher and a good reputation at the mine. He went back to work underground. And now, less than a year after coming back, he was lying in a hospital bed with a busted back and the bitter knowledge that hundreds of men would jump at the chance to take his place in the heading where he was almost killed.

Steve Sarkotich
Born Croatia 1887,
died Hollinger Mine, 1937

It was rough work. You were totally at the mercy of the company. They cared less for a man than they did a shovel because a shovel cost money and men could be replaced merely by going to the gate and picking out a strong one.

—Bob Miner,
former union activist

Lola spent much of her spare time helping Joe learn to walk. There was no such thing as compensation for injured miners, but the companies tried, whenever they could, to rehire men who had been hurt. The company told Joe that once he was back on his feet he would be hired to work in the lamp room on surface, maintaining the underground lamps. Lola, ever the pragmatic one, reminded him that at least it was a job. He shouldn't complain.

She had reasons for paying so much attention to the wounded Cape Bretoner. Lola knew early on that this was the man she was going to marry. And marry him she did. Over the next six years they had four children—John Lindsay, Margaret, Anne Marie, and Kathleen. In the years to come they ended up with eight grandchildren, and one of them was me.

The Cape Bretoners were such good miners. But they were young and frustrated. There wasn't much for them to do except fight and party. I used to hear them at night in the rooms above us playing the fiddle and stomping on the floor.

—Gertrude MacDonald

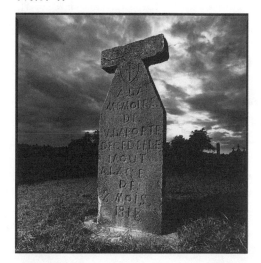

Strangers and Memory

PROLOGUE: Stumbling through History

THE WELCOME HOTEL ON A FRIDAY AFTERNOON: an old Croatian fellow is nursing a glass of draft in the corner, two French guys from the Dome Mine are shooting pool. Up in the back section, a couple of penny-stock players are gazing into the future of Black Pearl, Mustang, Pentland, and other Cinderella options. After spending the day doing research at the library, my plan is to have one beer, shoot the shit with owner Wayne Brown, and then head home. But it doesn't happen. Already the regulars are starting to pour in, and in no time at all I've had three different people buy me beers. If this keeps up, by midnight I won't be able to walk.

Such hospitality is typical of the numerous beer parlours that dot the Porcupine landscape: bars like the Gold Range, the Moneta, the Maple Leaf, the Rendezvous, the Windsor, the Victory, the GV, the Schumacher. If you want lower-class action, you can take a cab down to the strip joints along the river.

The beer parlours tend to share a common architecture and crowd demographics. They are often two-storey structures, with the upstairs sectioned off into small rental rooms (a throwback to the days when housing was at a premium and rental units favoured single men). The main floor is a dark cavern with splashes of neon advertising various beer brands.

What separates the Welcome from other beer-slinging rivals is the paraphernalia on the wall—a Red Wings banner competes with album covers by the Velvet Underground, the Ramones, and Black Flag. A portrait of the McIntyre No. 11 Shaft shares space with a poster of the first Clash album. And then there's the jukebox. Forget Garth Brooks and Shania Twain (and their antecedents Porter Wagoner and Connie Francis): the Welcome jukebox blares out an endless parade of techno, grunge, punk, and rockabilly.

But despite its decor and music, the Welcome is very much a part of the beer parlour tradition in the Porcupine. The beer parlour has always been an integral part of nightlife—the place where people socialize and blow off the steam from a hard day or week at work. It hearkens back to the days when, come quitting time, hundreds of tired miners washed the dust and silica out of their throats with a pitcher of draft before heading home to the family. To ensure they actually made it home, the liquor laws demanded that every bar stop serving drinks during the supper hour.

Comments from the big crowd showed that everyone is heartily sick of the wanton impudence of a bunch of ignorant foreigners.

—*The Porcupine Advance,* April 16, 1931

Correspondent objects to so many foreigners being employed at mines.

—headline, *The Porcupine Advance,* July 9, 1931

Today, along with the few miners, the late-afternoon beer parlour crowd is a mixture of young professionals and service-sector workers. But the influence of the old mining days is still obvious amongst this new generation of workers. Mining culture is marked by its "live for the moment and damn tomorrow" attitude. Nobody celebrates or parties as hard as people who live on the edge. That lust for celebration has carried over into the children and grandchildren of the old Delnite, Hollinger, and McIntyre boys. And so as the crowd continues to pour into the Welcome the bar becomes increasingly loud and boisterous. The air is blue with cigarette smoke, the jukebox blasting. This is a town that isn't afraid to let down its hair.

Nicki Boychuk arrives with a gang of girls from her ball team. "Spigs" Spigharelli is telling me about the new house he bought in the Moneta, right near where the bootleggers lived when he was a kid. The big, brawny Kangas boys are holding court at the bar.

Someone asks me what brings me to town. I mention the book. People seem to dig the idea. Stories get passed around. Wayne Bozzer is telling me about his old man, the famous softball king Lino Bozzer.

A woman is telling me about her grandmother, who came from Croatia. The grandmother was betrothed in marriage to a man who told her parents that he owned an estate with hundreds of acres in the new country. He did have hundreds of acres alright—a scrap bush homestead north of Timmins. The woman's grandmother spent her whole life in Canada refusing to speak English, a personal act of defiance against the land and her husband.

A guy starts asking me what I know about a street battle between the Italians and the local regiment at the beginning of the war. Not much, I reply, and ask him what he knows. He simply shrugs, says he heard his folks talking about it once.

And this is how our history is passed on—drunks yammering at a bar table, a casual reference dropped during a family dinner, a fragment of some old-timer's story alluding to ethnic troubles or mine accidents. And this is how our history is lost, too—casual references from old folk that aren't followed up; stories that go unnoticed or forgotten in the busy light of day.

We grew up multilingual. Jewish and English went hand in hand. From our playmates—the Desjardins, the Robilliards, the Montpetits, the Gagnons, the Racicots, we had a working knowledge of French. From our customers we had a pretty good knowledge of Russian, Ukrainian, and Polish. We picked up quite a few words of Finnish from our friends the Schneiders, Jakolas, Uukolas, Klingas, and Kerpis.

—Minnie (Gram) Levinson

Grave of Stanislaw Dyrczon, died age 4, 1936 ■ Timmins Cemetery

7 Burning Crosses and Red Co-operatives

WE SPENT LAZY SUNDAY AFTERNOONS in Uncle Lindsay's room trying to figure out if it was Colonel Mustard in the kitchen with the rope. Lindsay was my mother's only brother. His bedroom, on the second floor of my grandparents' house, hadn't changed since the day he left home in the late 1950s with his childhood buddy, Kenny Haapanen, to work in the booming mines of Elliot Lake.

My mother's old bedroom was across the tiny landing at the top of the stairs. It hadn't changed either: one big bed for the three sisters—Margaret, my mother Anne Marie, and her younger sister Kathy. As teenagers they were still sharing the same bed.

My maternal grandparents, Joe and Lola, slept on the main floor in a room just off the dining room. The house sported a narrow front room, plus a kitchen and a cellar. All in all it was typical of a cramped miner's home in the Moneta district of Timmins.

In Lindsay's room my sisters and I learnt to cheat and finagle at Crazy Eights, Clue, and the Credit Union Game. While other friends were chasing each other around Boardwalk and Park Place, we were learning the principles of co-operative money management as espoused in the Credit Union Game. Well, that was what the game was supposed to teach. My sisters and I were impervious to the notions of co-operation and fair play. We thought nothing of embezzling or embellishing to get to the finish line first. My older sister, when faced with a losing position, preferred to scatter the game pieces rather than admit defeat.

Old Joe MacNeil had given us the Credit Union Game for Christmas one year. He was a stalwart in the local Consumers' Credit Union. The credit union was part of the larger Consumers' Co-op, which ran a number of grocery stores in the Porcupine area. By the time he retired from the mine, Joe was the accounts manager of the Credit Union. Not bad for a mucker from Cape Breton with no formal education.

Joe had been brought into the co-operative movement by his neighbour Charlie Haapanen, an American Finn. Haapanen first came to the Porcupine in the 1920s as a co-operative organizer. The Finns were no strangers to co-ops. From the earliest days of the camp, they resisted the exploitive prices charged in many boarding houses by operating their own co-operative boarding houses.

The idea behind a co-operative store was simple. The co-op operated the grocery store for the benefit of its members. The members bought

From its first days Workers' Co-operative was a major pinion of support for the working class of the Porcupine Camp...When economic conditions weighed heavily on mining families, Workers provided small loans and did not press for repayment. When the state outlawed some political and ethnic organizations, Workers remained a refuge for the outcasts. Ironically, an organization that had such a vital role in the history of the mining town is today part of the forgotten chapter in the annals of the community. Moreover, many wish it to remain forgotten.

—Peter Vasiliadis, "The Truth Is Sometimes Very Dangerous"

shares, which entitled them to shop at the store, take part in decision-making, and share in the dividends. To help members through in times of crisis, the co-operative set up a credit union. All members of the working class were welcome to invest their savings and apply for loans.

The Workers' Co-operative of New Ontario opened in 1926, during a period of relative calm and co-operation in the community. Despite the ethnic turmoil of the previous decade, the Porcupine was steadily becoming a melting pot of influences. British children picked up Finnish and Ukrainian phrases from schoolyard friends. Young Jewish girls were featured in Italian cultural events. Irish kids from the Ottawa Valley went to family gatherings in the homes of Yugoslavian neighbours.

During the annual march of the "Glorious Twelfth," Ulster Protestants, Glasgow tradesmen, and British shift bosses sang the militant songs of the Boyne and Limerick. But at the picnic afterwards, a number of Italian and French children were listed among the winners of various three-legged races and egg-toss events.

In 1919 the "ethnics" had been denounced as a wellspring of Bolshevik tendencies. But now, seven years later, with the opening of the co-op, attitudes seemed to be changing. The local press was covering events in the various ethnic halls, treating the gatherings as proof positive that the community was vibrant and growing.

To be sure, there were those who looked on this as a dangerous watering down of British influence; and to serve warning, a local branch of the Ku Klux Klan burnt a cross on the flat, dead land of the Hollinger waste slimes. The first cross-burning was written off as a prank, as was the second one. But by the time the third cross was lit, word was going around that the Klan was using the Orange Hall for a local recruitment drive. A similar effort was taking place in Sudbury. The birth of the Ku Klux Klan in Timmins coincided with a major rebirth in Klan activity in the Southern United States. In the period following the excesses of the post-reconstruction era, the Klan had disappeared from the Southern landscape. In the 1920s a second wave of Klan activity arose in response to immigrant and Catholic migration to working-class areas in the Southern states. The Timmins chapter, with its emphasis on ethnicity rather than colour, was very much part of the resurgent Klan vision in the U.S. South.

On a cold night in February 1927, four Klansmen made a public showing in the heart of Timmins's Protestant community—the Sunday evening worship at the United Church. Bold, they were, too—marching

Communists seeking control of stores. Red element to make cooperative benefits a side concern for the benefit of the communists.

—headline, *The Porcupine Advance,* April 23, 1931

I don't know what a communist is. I went to school with them, I marched with them in the May Day parade, but how can you compare Canada to Russia? I went to a meeting in Toronto and [Communist Party leader] Tim Buck spoke there. He electrified that crowd and we donated aid to Russia. I gave my skis to Russia and they used them to attack Finland. Politics is a funny thing.

—Gertrude McDonald, retired member of Consumers' Co-op

50

right up to the front row and sitting themselves down as if they owned the place. Some parishioners giggled, others fidgeted nervously. Reverend Parks stared down at the hooded figures and commented dryly that they, like other organizations, should have consulted him first before deciding to use his church for a parade. His dismissive attitude was, perhaps, the perfect anecdote for the cowardly bluster of the Klan. After all, it was one thing for the Klan to parade about in the heart of the Protestant community, but just let them try pushing their weight around in the Croatian neighbourhoods of Schumacher. For all its perceived menace, the Klan in Timmins did little more than spawn a rash of bedsheet jokes.

The Workers' Co-operative, though, quickly proved that it was a force to be reckoned with. Charlie Haapanen, a hard-nosed businessman, knew that service and accessibility meant more to the average miner's wife than did idealism. He quickly pushed forward the expansion of local stores in each of the Porcupine communities. The Workers' Co-op pioneered chain stores long before the concept became a standard among the capitalist grocery operators. Haapanen walked a tightrope between ethnic and political factionalism. The base of co-operative support came from the Finnish and Ukrainian communities. Customers from those groups expected service in their native languages. Leadership roles in the co-operative carefully included representation from each of the main ethnic groups. With the local union movement in tatters, the Workers' Co-op emerged as the only organized voice of the working class in the Porcupine. It was bound to be a centre for political agitation, particularly from the Communist Party. Having been pushed to the margins in the big cities, the Party was seeking to expand its base in the still militant Porcupine.

Nowhere was the volatile mix of ethnicity and politics more evident than among the Finns. It had been less than ten years since a brutal civil war that caused an exodus of "Red" supporters of the failed Bolshevik-supported revolution. These exiled Reds made up the bulk of the burgeoning Finnish community in the Porcupine. As the 1920s wore on, however, new immigration from Finland began bringing in supporters of the "White" leader, General Carl Gustav Mannerheim.

Efforts to build a cohesive Finnish community in the Porcupine were constantly undermined by the memories of atrocities committed and scores to settle. The left-wing Finns were supporters of the Red community hall and the ascendant Finnish Organization of Canada (FOC). The

Elino Olavi Vloijoki
1927—1942

Whites found themselves in a minority and bitterly opposed to the FOC's pro-Communist policies. In response, they opened their own community centre—Harmony Hall—to challenge the work being carried out from the Red Hall. White Finn choirs, athletic clubs, and drama groups worked hard to outdo similar efforts by their more left-wing cousins. In a period of calm, there was room for such infighting. During the 1926 May Day Parade, for example, twelve hundred people from the various labour, ethnic, and political tribes carried their separate banners and then sat down to celebrate a picnic together.

The coming of the Great Depression transformed the mood of the Porcupine almost overnight. Canada quickly moved to shut its doors to immigrant labour. In a hungry land the pecking order suddenly became all-important. As more and more out-of-work Canadians poured into the area looking for work, attention focused on the large numbers of foreign-born workers still holding down jobs at the mines. The recent immigrants who had been welcomed into the lowly mucking jobs in the stopes were now being castigated as job-stealers.

This external pressure transformed internal fissures into dangerous chasms. The Finns had been attracting attention since the Hollinger fire, when many left-wing Finnish miners had been tagged as "trouble-makers." Now the newspapers were rife with stories about the anti-British, anti-democratic views of the Finns. When King George V fell ill, the left-wing Finnish newspaper Vaupus (based out of Sudbury) attacked the institution of the monarchy. "Of the King's condition, the whole world is informed through telegrams. But is anything wired of the conditions of the millions who right now live in misery in the very heart of the British Empire, England....Will the King die? If he does, we hope royalty will die with him and a republic take its place."

The article created a backlash across the country. Editor Aaro Vaaro was arrested on the grounds of seditious libel. Petitions circulated throughout the anglo and francophone communities in Timmins demanding the suppression of the Finnish paper. The image of the Finns also underwent a tarnishing when it was announced that two hundred Finns were leaving Canada to help build the Soviet Union. The Porcupine Advance pushed the issue by hinting at the need to deport the whole Red Finnish community of the Porcupine to Soviet Russia.

The politics of all ethnic workers came under the magnifying glass. Men who had sat around bootlegging joints arguing the intricacies of class struggle and anarcho-syndicalism were now being denounced as threats to the very order of the Empire. Why should such men hold jobs when loyal Canadians were going hungry? The White Finns were quick

to distance themselves from their Red enemies.

The campaign against the Finnish Canadians was led by Sudbury United Church Minister R.T. Jones, in charge of a mission to carry out "Anglo Saxon work." The good Reverend pointed out the pernicious influence that the Red Finn parents were having on their own children. He noted that Finnish school children refused to sing "God Save the King" and were "bitter against God, teachers and imperialism." Reverend Jones claimed to have had his own direct run-in with the Reds during a Finn's funeral. The reverend "agreed to the funeral," wrote The Porcupine Advance, "if they promised not to insert any of their disloyal and treasonous stuff in any part of the service. They then proceeded to break into singing the Red Flag and he forcibly closed their books saying he would rather fight than let them proceed."

Reverend Jones must have felt his prayers were answered when, in 1931, a Finnish minister, Reverend A. Lappala, appeared in the Porcupine to set up a Finnish United Church. The church drew immediate praise from the members of the English community. It was a proof that even among the Finns, "loyal" people could be found. Mayor George Drew attended the dedication of the church and offered greetings on behalf of the "British people of Timmins." The press was lavish with praise for the English who came out to the opening. It displayed the "goodwill and friendliness of the British people." Little comment was made about the many Finns in attendance.

Laura Helin, at the time a young girl, recalled later how her Finnish neighbours threw rocks at her family when they were setting out for the Finnish United Church on Sunday morning. The local papers told how Atbi Siren, a reportedly drunk Finn, pulled a gun on another Finn in a Balsam Street pool hall after he learned the other man was planning on joining the church. The left-wing Finns looked upon the church as a hammer to be used against politically active expatriates, and it didn't take long before a letter of recommendation from the Finnish reverend was a big plus in retaining work in the mines. With the threat of a blacklist or even deportation hanging over politically suspect Finns, the refusal to go to church took on serious consequences.

A similar struggle was taking place in the Ukrainian community, where the new Provista Hall was challenging the "Red" Labour Temple as the predominant voice of the people. White Ukrainians, like the White Finns, were being championed as supporters of the Union Jack and hence worthy of holding onto jobs in the mines. The Croatian and Polish communities were also witness to struggles between left- and right-wing factions.

Maria Kushnir
Died age 33, 1938

All foreign Reds should be deported.

—The Porcupine Advance,
June 18, 1931

■ ■ ■

The current inter-ethnic tension was bound to have an effect on the Workers' Co-op. In 1930, when Charlie Hapaanen decided to return to the United States, a power vacuum developed in the workers' organization. Soon after his departure, supporters of the Communist Party under the leadership of Nick Trachuk made their move to secure control of the Co-op. At a monthly board meeting they stacked the sparse hall with party members, many of them from the south. The old board members were voted out, and a new slate of more militant members took their place.

The move came during a time of increasing Communist agitation in the Porcupine. Throughout 1931 the area saw a series of tense demonstrations by unemployed men and other angry workers. The new militant leadership of the Workers' Co-op was directly involved in organizing efforts throughout mining camps from Porcupine to Noranda. Many of these actions ended up as street battles with the police. To hold off the baton charges, the marchers would ring their columns with a forward guard of women and children.

The French Canadian community was strongly opposed to the Communist-backed marches. During one demonstration children from the local French school were given the day off classes if they came out to jeer the foreign "Communists." Mary Kernsymien, one of the participants in a fall demonstration, slapped a boy who had been mouthing off from the sidewalk. When a policeman tried to arrest her, she bit his hand. During an August 1st street battle, Lillie Martinuk of South Porcupine was fined $50 for throwing stones at the police. But there were other ways of targeting the troublemakers. A series of police raids—at the Ukrainian and Finn halls, as well as at the homes of a number of local citizens—led to numerous charges of sedition. Confiscation of property and the threat of deportation became the means of keeping the trouble-causers in line.

The Red struggle was also going on outside of the ethnic neighbourhoods. Even Timmins mayor J.P. Bartleman and his council came under attack from the press for being Communists. "I think there is no necessity in stating that I am not a communist," Bartleman responded. "That is the propaganda being spread by the Timmins press. The paper seems to hope that we will all become communists." Bartleman's feuds with the local press were legendary. While a councillor, he started his own paper, *The Citizen*, as a way of carrying on his feud with *The Porcupine Advance*. After managing to alienate most of his readers, he was forced to sell the paper to Roy Thomson, who renamed the publication *The Daily Press*. Within a few short years the *Press* was battling actively against

Yesterday morning, transients in Cochrane [neighbouring community to the Porcupine] staged another parade and it is expected that it will be the last one held there. The men, practically all of foreign extraction, numbered about three hundred and paraded in a body to the town hall to present their demands...They found hundreds of citizens waiting armed with clubs and other weapons... They were beaten until there was no fight left in them. They were then taken to the railway tracks and started out of town, some being helped along the way forcibly.

—The Porcupine Advance, Sept. 24, 1931

Bartleman. When Bartleman tried to convince town council of the need to take over the Thomson radio station, the *Press* started denouncing the mayor's "Soviet" leadership.

The issue of Communist control was a common theme whenever the papers covered unionizing attempts or progressive local political candidates, but nowhere was the issue more heated than in the battle over the Workers' Co-op. Within six months of the Communists taking control of the Workers' Co-op, dissident members had pressured Haapanen to return to the Porcupine. In 1931 Hapaanen launched the breakaway Consumers' Co-Operative. This store was soon followed by a bakery to compete with the worker-owned bakery. Wherever a Workers' Co-op store operated, the rival Consumers' Co-op set up a competitive operation nearby.

For the next fifty years the two co-ops fought with one another for predominance. Both movements, claiming members across Northeastern Ontario, operated competing stores in the Porcupine, Kirkland Lake, and Larder Lake. Hapaanen made it his life's mission to bury the Workers' Co-op. Yet, for decades both co-operatives remained vital and financially sound operations.

The Workers' Co-op, while never as financially successful as the Consumers' Co-op, nevertheless attracted many dynamic and idealistic leaders. Decorated Second World War veteran Garth Teeple ran the education wing of the Workers' Co-op, while fellow veteran Ray Stevenson looked after the youth wing (Stevenson later became a prominent union activist in the camp).

Throughout the 1930s and 1940s, the struggle between the Consumers' and the Workers' co-ops formed a chasm cutting through ethnic communities, political factions, and even within families. The Angus family members, for example, were strong supporters of the Workers' Co-op. Charlie Angus believed that the only real co-op was the Workers' Co-op. He sent my father to the Workers' Youth camps, purchased his goods in the Workers' stores, and invested money in Workers' share stock. The MacNeils, on my mother's side, were stalwart supporters of the Consumers' Co-op. But old Joe never told us about the divisions and struggles that had led to its creation. By the time we came on the scene, the credit union movement, like much of Porcupine politics, had shed any vestiges of political radicalism or ethnic factionalism.

The once-bitter struggles could easily be overshadowed by the roll of a dice and the divvying up of playing cards by children. In 1980 the last outlet of the Workers' Co-op closed. Within a decade the Consumers' Co-op was also history. Both were done in by chain stores, easy credit, and a generation with no memory.

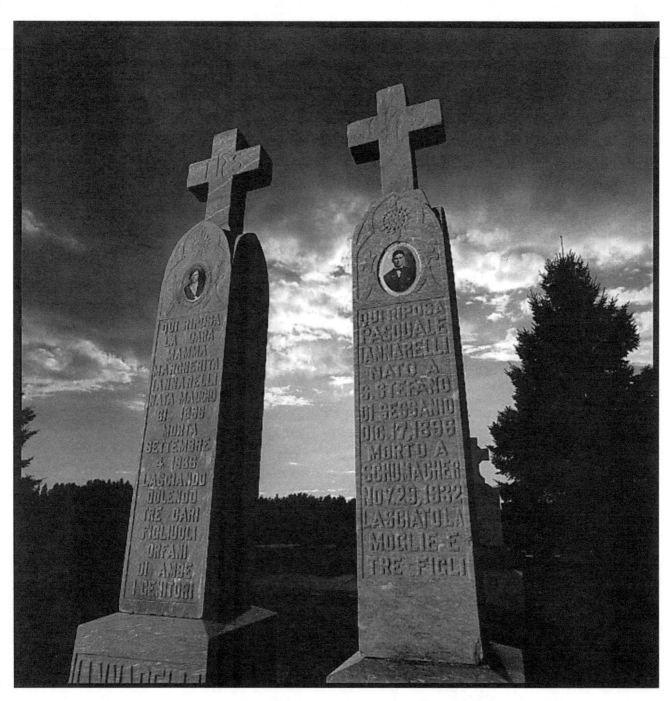

Graves of Pasquale Iannarelli, died age 36, 1932, and Margherita Ianarelli, died age 40, 1936
("Left three children as orphans") ■ Timmins Cemetery

8 The Afternoon Matinee

MATI AHO COULD HAVE FOUND SO MUCH to keep himself entertained. There were plays, socials, and sporting events taking place in church basements and ethnic halls across the Porcupine. Pete Samatlick, for example, was holding regular concerts of his Croatian Tamburitza Orchestra. The Ukrainian Labour Temple was a hot spot for touring acts such as the noted Ukrainian singer Lili Popovich.

If culture wasn't his bag, Aho could have immersed himself in the local hockey and baseball rivalries. First and foremost remained the pride of Schumacher—the McIntyre MacMen. Crowds in their thousands came out to the beautiful McIntyre ball field to watch these top-notch ball players from Southern Ontario and the United States. Their main rivals were the Hollinger Gold Miners led by tough-assed Vince Barton, Hollinger shift boss. Barton, originally from Edmonton, had played in 102 games over two seasons with the Chicago Cubs. Hollinger maintained its own picturesque park and ball field to compete with McIntyre's.

If Aho wanted something rougher he could have wagered money on one of Tex Jardine's boxing cards. Jardine ran a mixture of local favourites like Dutchie Johnson and Shorty Chenier against a continual string of out-of-town pugilists.

But poor Mati Aho had run afoul of a lesser known pugilist, and now he was joining the regular cast of high-graders, bootleggers, dope heads, and hookers who paraded before Magistrate Atkinson's court in the ever-popular "weekly matinee." Atkinson, an old-timer in the North, knew how to play his crowd. The folks in the cheap seats liked fast-moving trials, liberally spiced with smut and witty repartee, all of which was artfully captured in the local press.

A perennial favourite was listening to poor foreigners attempt to conduct their own defence in the King's English. Take the crazy Pole found wandering the streets in a woman's dress. Court wags commented favourably on the outfit, but said the moustache spoiled the effect. Then there was the Ukrainian George Odinak, charged with obtaining credit under false pretences. He had run up a bill of $18 for clothes, claiming he had a job at the Hollinger Mine, when, in fact, he was still unemployed. Odinak's case wasn't hard to figure out. One of the hundreds of unemployed men who joined the long lineups for work outside the mine gates, Odinak gambled on the premise that if he showed up at

Timmins was a boom town and certainly had its share of characters...The chief of police, when appointed, made headlines by booking his sister on prostitution charges; he also closed down his mother's bootlegging operation... [There was] Issie, a fast-talking operator from Montreal, he took orders for suits and coats...Issie operated a taxi and a brothel in town. When you ordered a new suit you were entitled to one free night on the house.

—A.E. Alpine,
"Timmins Yesterday and Today,"
Northern Miner, March 23, 1994

the mine decked out in oilers and proper boots he might get hired. He wasn't hired and now, unable to pay for the clothes, he was up for fraud.

Every time Odinak attempted to explain his case to the judge, the courtroom broke into laughter. They loved the way he referred to Magistrate Atkinson as "Mr. Lloyd George." Atkinson wasn't amused. He finally shouted at Odinak, pointing out that the great British leader was nowhere near the courtroom. He banged the gavel and tossed Odinak in the can for thirty days. Afterwards it was pointed out that Odinak might have been trying to say "Lord Judge." No matter. Case closed.

Odinak had nothing on the plight of Mati Aho, who, for starters, appeared in court with "his face puffed and discoloured, his eyes blackened and bloodshot, and his head held together by clamps." On top of that, he was a witness in two different cases. And five would get you ten that by the time Aho finished his sad tale, there would be convictions all around.

These were the kind of cases that drew the crowds. After the long litany of domestic disputes and fraudulent cheques written for the benefit of hungry children, there was nothing like a bawdy-house trial to get the blood moving. It was enough to make a two-dollar-a-day scribe dance for joy.

Aho's troubles had begun when he was caught doing the dirty deed in the home of the notorious Latour sisters. Rose and Blanche Latour were veterans of police bawdy-house raids. Rose, a mother of four children, ran the operation out of her house. She had a total of four women on the roster. Aho testified that he had paid the Latour sisters two bucks each for a bit of frolic. When Magistrate Atkinson asked Rose if she was guilty, she shrugged. "Guilty a little bit."

"Well there's no doubt about that place," Magistrate Atkinson said, shaking his head at the state of the Latour homestead. He fined Rose $100 plus costs and her sister got stiffed with a $50 fine.

Another woman picked up in the sweep was an obvious novice to the racket. She admitted that she had just left her husband and two children the day before the raid. "Go home to your children," Atkinson said, dismissing the charges against her.

Atkinson also dismissed charges against the lucky fellow who happened to have his clothes on when the cops busted down the door. He was sticking to his story that he had come over just to light the fires in the stove. Atkinson, no doubt feeling well disposed that day, decided to buy the thin tale.

Unlike most movie critics who sneer, jeer and cheer performances after they are completed, Simone Belfontaine chose to make her very audible commentary while it was taking place. Result--$10 and costs on a charge of disorderly conduct. Police Constable Guolla said that three calls were received from the Cartier Theatre during a midnight performance. When they arrived Miss Belfontaine was drawing quite a crowd from a little show she was staging from her balcony seat. In no uncertain terms was she giving her opinion of the performers on the stage... Asked by the Magistrate if she had been displeased with the performance, Simone said no. On the contrary, she said she enjoyed it.

—The Porcupine Advance, April 11, 1940

After the smut was dealt with, it was time to find out the cause of Aho's affliction. The newspaper reporter described his face as being in the same condition as a rare steak. The sad tale unfolded. After leaving the chaos at the Latour place, Aho decided to cab it down to the riverside. The beer parlours and hotels along the riverbank were the home turf for tough working-class francophone lumbermen and miners. If you wanted your ass kicked you could find many obliging folks among men with names like Thibault, Dagnegais, or Gervais.

But Aho didn't even get as far as the bars. His trouble came from cabbie Jean Baptiste Lacourse over the price of the fare. Aho paid fifty cents; the cabbie wanted more. When Aho decided that discretion was the better part of valour and made a beeline for the road, Lacourse went after him with a baseball bat.

"Why did you run after him?" Judge Atkinson asked.

"I got mad," replied Lacourse.

Atkinson wasn't impressed. Lacourse was given two months in the slammer. Aho was left to lick his wounds before an amused community.

Revelry by night in a Mountjoy Township blind pig featuring gun play and fisticuffs made quite an interesting court story on Tuesday afternoon. The matinee, which regularly attends the weekly session, was given thrills and chuckles aplenty as the tale unfolded.

—The Porcupine Advance,
April 11, 1940

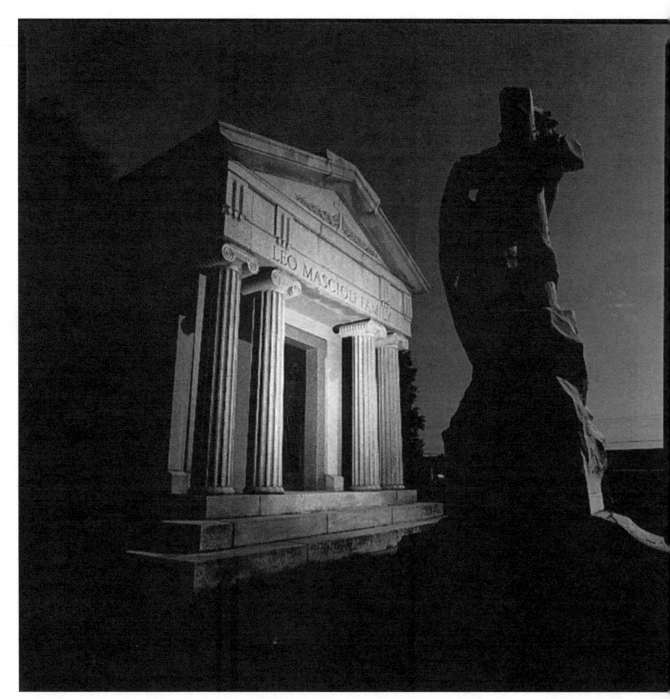

Mausoleum of Leo Mascioli family ■ Timmins Cemetery

9 The Night in Moneta

SUNDAY AFTERNOONS IN THE MONETA—the booming Scottish tenor of Kenneth McKeller, the sweet Cape Breton strathspeys of Winston Scotty Fitzgerald, gaelic songs from Mabou—a bittersweet soundtrack of the exiles. My grandfather Joe was the consummate host. He ran the bar and the record player with careful precision, paying close attention to the size, timbre, and feistiness of the gathering. He even handled the cooking of the Sunday feast. When the gathering promised to be particularly large, he always cooked up a big pot of spaghetti.

Even as a boy I found it funny that our family's idea of a feast consisted of eating spaghetti to the sound of bagpipe records. One time I asked my grandfather how he learned to make such great spaghetti and he told me the recipe came from an Italian miner at the McIntyre Mine. The miner's wife had died, leaving her husband unprepared for dealing with a growing family. Lola and Joe watched out for the children, and in gratitude the miner taught my grandfather the secrets of a great pot of spaghetti.

That was how things were done in the Moneta. People looked out for one another. They shared their traditions and their meals. Like most neighbourhoods in the Porcupine, the Moneta was a mongrel's quilt of ethnic backgrounds. But the Moneta—Italian slang for coin—had become synonymous with the Italians. The vast majority of the Porcupine's three thousand Italians lived in the neighbourhood in the south end of Timmins bounded by First Avenue in the north and Moneta Avenue in the south and east-west from Spruce Street over to Mountjoy Avenue.

Sacred Heart Church stood at the heart of the Moneta. It was just a stone's throw from Moneta Public School. The Italian social hall, the Dante Club, was set up over on Cedar Street. Numerous bakeries, meat markets, and taverns stretched along Pine Street to the edge of town.

For a boy growing up in the late 1960s and early 1970s, you couldn't find a better neighbourhood in which to spend Sunday afternoons. Now, looking back with the eyes of an adult, I can see why the old ones kept their peace about that terrible night in the Moneta back at the beginning of World War Two. How to explain the fear and fever of war to a generation reared in comfort? How to explain the old divisions?

Nearly every town in Canada has some aliens who lack the grace and decency to keep their mouths shut. It is not true tolerance to let these aliens have their contemptible way... [The newspapers] urge on aliens to use a little sense and decency so that harsher methods may not be necessary.

—editorial, *The Porcupine Advance*, April 24, 1939

■■■

There were those who got a great kick out of seeing the mighty Leo Mascioli being dragged off to an internment camp like a common criminal. "Serves him right, the Dago bastard." Such was the sentiment of folks who thrilled at the power of the crowd—two thousand of them, shaking their fists as the stuffed effigy of Adolf was hung from a lamp post on Third Avenue, cheering at the waving of flags and the beating of drums. Tossing Mascioli in the internment camp was payback for Poland. It was payback for him having allegedly sent money to the Fascists in Italy.

There were those who cheered in the beer parlour when some four-bottle hero decided to teach an unsuspecting paesano a lesson in British civility, and lots of lessons were taught during the fall of 1939 and the spring of 1940. The fights in the beer parlours soon spilled into the streets. Hector "Tops" Tellino, who was supposed to be fighting the South African Jimmy Webster at the McIntyre Arena, found himself tossed in the can for having a dust-up with two loudmouths on Third Avenue. Big mistake to call Tellino a wop bastard to his face.

Lots of lessons were being learned underground and at the shaft collar at the surface. Men who had worked peaceably for years now found themselves looked upon as enemies. Tempers flared. Punches flew. Somebody in the dark confines of underground was going to wind up dead.

I had just come out of the theatre and did not know what was going on. Dr. Hutchinson came up and said, "Come on, I'll drive you home." I told him there was nothing to worry about, but he told me there was going to be trouble. Well, I went along the street and was in front of the Empire Cigar store. I was standing in the doorway and somebody went by, a very good friend of mine as a matter of fact, and he yelled out "THERE'S ANOTHER BLACK WOP THERE." They were looking for black wops and I turned around to see who the black wop was... It was me."

—Italian Canadian describing the Moneta War riot to James DiGiacomo, *They Live in the Moneta*

Grave of Elia Riva, born in Schumacher, "flew to heaven, July 1929," age 7 months
■ Timmins Cemetery

R.J. Ennis, the McIntyre Mine manager, wasn't having any of it. He called the miners in for another kind of lesson. "The Italians built this mine," he told them. "If any of you don't want to work with them, get your time card and get off the property." There was a lot of muttering among the English afterwards, but none of them took Ennis up on his offer and no Italian was disciplined or fired for fighting at the mine.

That didn't end the matter. The government put the squeeze on to make sure that the Italians only remained in the lowest and hardest jobs underground. Anything better should go to a loyal citizen. The town also sanctimoniously announced that all Italians would be cut from the relief rolls. But only one woman, a recent immigrant, was found to be living off the largesse of the state. Given the size of the Italian community in the Porcupine, having just one lone person on assistance spoke volumes about the kind of people these were—proud, hardworking, and willing to support each other.

There were, to be sure, those who thought that what was happening was a terrible thing. Father Charles Theriault spoke out in the French community against the Mascioli internment. A shameful thing was being done. What threat was Mascioli to the British Empire? After all, Mascioli wasn't the only upstanding citizen to have cheered the advance of Mussolini. As late as 1937 *The Porcupine Advance*, taking its lead from Toronto's *Globe and Mail*, was reminding its readers that the Fascists weren't the real threat—it was the Reds. The papers noted the efforts made by the Fascists in bettering their people and their industry. Nobody was kicking down the doors of the Globe editors the way they had with Mascioli.

He had his enemies, of course. Some old union men had never forgiven Mascioli's role in the strike of 1912. Breaking that strike, they said, was Mascioli's ticket to the good life. Some folk in the ethnic neighbourhoods had looked upon Mascioli's trip to the internment camp as a quid pro quo for the Ukrainians and Finns who had been blacklisted by the companies and sent to prisoner of war camps in the last war.

But even his critics had to admit that Mascioli was the closest thing Timmins had to a founding patriarch. He ran the big construction projects. He had built theatres and hotels across the North. The name Mascioli was impressed on every cement foundation and every piece of new sidewalk in the town. He didn't make his money and run. He was loyal to the town. The Italians were like that. Like the French, they had deep roots in the Porcupine. It was home. A good percentage of Italians

When I was a kid we used to go to my grandfather's almost every Sunday. And when we went it was always a big deal with a big family dinner. My dad played music, his brothers played, almost everyone in the family played something. It seemed like we were always celebrating--celebrating or eating. People don't have fun like that anymore, just by getting together and celebrating and having a nice meal and all that music that came with it. People are too busy. The parents are working and there's no time to do anything else.

—Alana Pierini,
remembering childhood visits to
the Moneta, 1998

Secondino Petricola
Died age 10, 1937

Close to five hundred Italian citizens of Timmins were present at a mass meeting at the Goldfields Theatre last night to attest their loyalty to Canada and the British Empire.

*—The Porcupine Advance,
June 10, 1940*

in the Moneta were from Mascioli's home region of Abruzzi. He helped bring them over. He set them up with work. Not bad for a man who arrived in the Porcupine when the only way in was a thirty-mile trip through the bush.

What a shock for the patriarch to become an overnight pariah. What a shock for second-generation kids from the Moneta to be called foreigner by immigrants with British or Scottish accents. The other groups, however, knew the score. As soon as the war broke out, the Croatians, Finns, Rumanians, and Ukrainians were quick to make vocal and public expressions of good will and loyalty. Not that such expressions would help the left-wing Finns or Ukrainians. Their social halls were seized as a matter of course and sold off to help the war effort.

The backlash against the Italians started with insults and slurs and quickly degenerated into fisticuffs. Father Fontana, the pastor of the Italian church, urged his flock to stay calm. Better not to hold any dances or visible Italian feasts. Stay indoors, keep down, and wait for the hatred to blow over.

But all through the fall of 1939 and spring of 1940 the town was awash in patriotic marches and demonstrations. At the heart of the demonstrations was the local Algonquin Regiment. It would take five years of training and war to turn this motley collection of clerks and loggers into a unit capable of pushing the SS out of Northern France. In those early months of the war, the best they could muster was a series of parades through the downtown. With the Italian neighbourhood only a few blocks away, it wasn't surprising that some of these would-be heroes decided to test their mettle on the resident "enemies."

One evening members of the Algonquins led a march of local yahoos right into the heart of the Italian neighbourhood. Some Italian miners were having an after-work glass of draft at the beer parlour when the word reached them that the Algonquins were on the march. They rushed home to defend their families. Some were caught out on the street by the mob, others were beaten up in front of their houses. There are reports of the mob breaking into houses, stealing food, overturning furniture. They threatened women and scared children.

What an event. What a spectacle. Terrorizing defenceless neighbours hardly added to the prestige of Timmins's would-be war heroes. Not surprisingly, the local papers kept their peace. They figured that nothing good would come from raising questions about the value of such patriotic demonstrations.

As the war went on, the Italian boys of Timmins signed up in droves. Their parents posted patriotic Union Jacks in their windows. And in the years following the war few people were willing to talk about that night in Moneta. The war had done terrible things to people. Families were disrupted, lives were cut short. And in the postwar years, waves of new immigrants—the displaced persons from the killing fields of Eastern Europe—flocked into the community. Who could blame folk for not wanting to stir up the dark feelings of 1939? What happened in the Moneta was not "real" history. It was something to be forgotten.

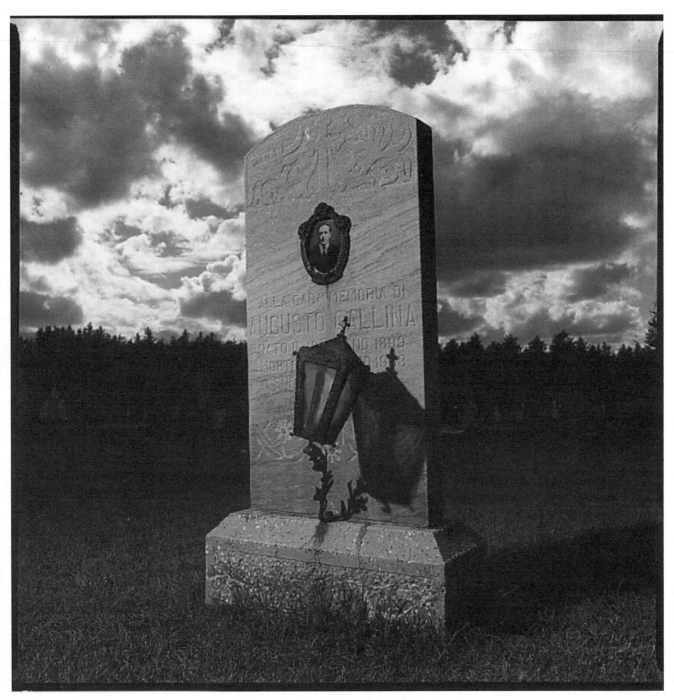

Grave of Augusto Gallina, died age 39, 1938 ■ Timmins Cemetery

10 Henry and the High-Graders

ARTIE SHAW NEVER SOUNDED SO GOOD: "Begin the Beguine" bouncing along the darkened walls of the drift, tickling the belly of Mother Earth, skipping across puddles of muddy water. Granted, a tin whistle was a poor substitute for the clean tone Henry Kelneck could muster on his horn, but then one couldn't be too choosy two thousand feet underground. Not that he was complaining. At age twenty-three, Kelneck was a crackerjack trumpet player and the undisputed king of the Riverside Pavilion—"the Pav." To top it off, he had a steady day job collecting sample bags of ore in the various underground stopes of the McIntyre Mine.

While the rest of the country was slowly coming out of the dark sleep of the Depression, Timmins was a magnet for out-of-work musicians. The town boasted a large population of young single miners looking for action. There were dances to be had in all the ethnic halls. Dance bands were king, and the king of kings held court at the Pav, on the banks of the muddy Mattagami River.

Adding to the Pav's allure was the fact that the dance hall had been built by W.T. Wilson, one of the town's pre-eminent high-grading kings. It was a converted horse and buggy barn. The large wooden floor was built on forty-foot crossbeams, a span that created a natural spring response to the hundreds of feet shuffling in time to the beat.

Local media tycoon Roy Thomson had added to the Pav's reputation when he started running live broadcasts of the various dance bands. Thomson, who bragged that he would work in hell if it paid a dollar, opted for the Porcupine in the early 1930s. He came north to sell radios, but without a local station the new gadgets weren't much good. So Thomson set up CKGB radio. Soon after that, he took control of a fledgling rival of the weekly *Porcupine Advance* and turned it into a successful daily paper—the *Daily Press*. Thomson's main advertising man was Jack Kent Cooke, who went on to become the multi-millionaire owner of the Washington Redskins. Thomson's acquisitions in Timmins became the basis for the massive Thomson Publishing Empire. Interestingly enough, seventy years after Thomson's first foray into the newspaper business, the Thomson publishing empire would be locked into a major turf war with another newspaper giant that also had its foundation in Timmins mining money—Conrad Black's Hollinger Corporation.

The Mattagami River would rise during the spring run-off. The Pav would be flooded but that wouldn't stop people from dancing... Those wanting something to eat or a pack of cigarettes had to take off their shoes and stockings and wade to reach the snack bar.

—Barbara Reynolds, "Dancing at the Pav," HighGrader Magazine, May 1995

Cavril Bojor
Born in Roumania, died age 35, 1928

People worked really hard then. Men worked six days a week but when they let loose they really wanted to have fun. I believe they had more moments of authentic happiness and authentic sadness than we do now.

—Ike Kelneck

Back then, every week folks from across the region tuned in to CKGB to listen to the big band sounds of Andy Conjino, Jimmy McFadden, or Al Pierini. A number of great local musicians—Moon Mullins, Freddie DelGuidice, Joe Slobodian, Norman Amadio—learned their chops on the Pav stage. For much of the 1930s Al Pierini and his Vagabond Kings—Bill Kendall, Gene Crocco, Laurie Salo, Hart Denille, Ken Tomkinson, and Warren Delorbe—were the dominant dance band in town. Al had been the leader of a successful dance band in the Detroit area and lured north by the promise of steady gigs.

The gigs were great, but with a growing family Al needed to maintain a day job. He tried his hand operating a nightclub cabaret complete with exotic birds in large cages. But times were too tough for such extravagance. Al then decided on a more realistic course. He accepted the offer of a job at a butcher shop in the nearby lumber town of Iroquois Falls. Al's departure left a big hole in the Pav scene, which was filled by young Henry Kelneck.

Barely in his twenties, Kelneck was already a seasoned performer. He had been playing live shows since the age of eight. As a youngster he honed his chops playing Polish weddings in the Thorold area of Southern Ontario. Young Kelneck used to play with the band until he fell asleep on the stage. He would often be nudged awake and sent back up to the microphone by dancers eager for another polka and waltz.

Kelneck lived for live performance, and in Timmins he found a crowd that seemed to live to dance. His one-month gig ended up lasting a lifetime.

The Pav was open three nights a week—Wednesday, Friday, and Saturday. Its main competitor—the mines—expected its men to work six shifts a week. If production levels had to be improved, the managers thought nothing of expecting men to work seven days a week—no exceptions, no complaints. Magne Stortroen, in his memoirs *An Immigrant's Journal*, recalls one young man who asked his shift boss at the Hallnor Mine if he could have one Saturday off to get married. The shift boss pointed to the ranks of unemployed men standing at the gates. "You don't see them asking to get married on a Saturday."

And yet despite the gruelling work schedule, the work population in the Porcupine remained restless, energetic, and always ready for action. Illegal bootleg joints and bordellos were a common pressure valve in the mining camps, but the mine managers also realized the need to support other interests. The mines always found room on the company

payroll for a good hockey player, ball player, or musician. The men would be put in a job where they wouldn't get their fingers crushed or their lungs damaged. Most of the guys ended up in the payroll or assay offices.

The sports leagues drew large crowds. As well, every neighbourhood boasted open rinks where young kids dreamed of becoming the next Teeder Kennedy or Barbara Ann Scott. In the late 1930s, J.P. Bickell, owner of McIntyre Porcupine Mines, built the North's premiere hockey arena and community centre—the McIntyre Arena. Bickell was already a pro at the arena business. Early in the Depression he had been approached by Conn Smythe, who was looking to build a massive hockey arena for the Toronto Maple Leafs. Bickell was a major contributor to the building of Maple Leaf Gardens and became the Gardens' first president (the Leafs' Bickell Trophy is named after him).

Right around the time Henry rolled into town, three young hockey players came off the train with the promise of work at the McIntyre Mine. Bob Crosby, a McIntyre manager, heard about this hotshot forward line playing in the Quebec leagues and decided to woo them over to play for McIntyre. What Crosby neglected to tell mine management was that the three players—Manny McIntyre and the two Carnegie brothers, Ossie and Herb—were Black. As soon as management found out, they immediately terminated the deal.

On Saturday nights they'd be playing ball on the Dome field or at the McIntyre or Hollinger. The fellas from the Hollinger used to watch us play ball from the roof of their mill. We'd be playing there around six o'clock and it would be lunch hour for that shift or something and they'd be all lined up there on the roof watching the game.

— Carlo Cattarello,
Porcupine hockey coach

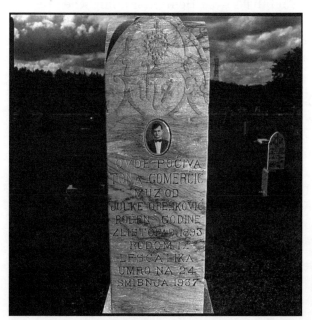

Grave of Tona Gomercic,
born in Croatia,
died age 44, 1937
■ Timmins Cemetery

Herb Carnegie was considered one of the best young prospects in the country, and with the war on the NHL was desperate for talent. And yet the Leafs refused to hire Blacks in the NHL. It was said that Conn Smythe said he would pay a fortune to the man who could invent a way of turning Carnegie's skin white. The Toronto Maple Leafs and the McIntyre Mine shared the same president and, it appears, the same racial policies.

No matter. The Buffalo Ankerite Mine, a small gold operation on the Porcupine back road, jumped at the chance to sign the two players. The "Coloured Line" became an instant hit in the Porcupine. Folks who weren't out dancing to the sweet sounds at the Pav were marvelling at the stickhandling abilities of the Coloured Line.

■■■

At the end of his one-month gig at the Pav, Henry Kelneck received an offer he couldn't refuse. In exchange for staying in Timmins he was given an easy day job on the McIntyre sample gang. It meant travelling to working areas all over the mine. After blasting was carried out in a stope, it was Henry's job to go in, bag a few samples, mark the bags, and ship them to surface so the boys in geology could check the grade.

It was easy work. And with his tin whistle for company, it was like getting paid to practise. And that's what Henry was doing when he saw the two men step out from the shadows blocking his path in the narrow confines of the drift. Henry knew who they were. He knew what they wanted. He kept playing, walking steadily towards them, trying to maintain the appearance of a man without a care in the world.

"Good tune, Henry," one of them said. "You going to be playing that one this weekend?"

Henry smiled the million-dollar smile that always seemed to win everybody over. "Gotta play Artie," he replied. "If that doesn't get the girls dancing with you, nothing will."

They all laughed. Uncomfortably.

The boys hadn't come to talk music or girls. Henry knew that. They were there to put the squeeze on. The sample gang was about the closest one could get to keeping tabs on where high-grade ore was being mined. The high-graders had come to make sure they got their cut.

"Look Henry," the older one said. "It's like this. All ya gotta do is put one knot on the bags with normal ore samples and two knots on any

There was a couple from Schumacher that came every week to the dances. They were beautiful. She wore an almost floor-length dress and he was handsome, dressed in a dark suit, something just short of a tuxedo. ... When they picked their song, most, if not all the kids would stop and stand back in a large circle, giving them the whole dance-floor and behold a thing of beauty—two people oblivious of their surroundings, performing something of love.... As members of the band it put us at an even higher place and we wanted to play to the best of our ability. They were beautiful and Al [Pierini] loved it.

*— Ken Onotsky,
letter to* Daily Press *(Timmins)*

bag with high-grade. Then when the bags are going to surface we'll know which ones to grab. Nobody will be able to trace it to you. You get a cut of everything we take. What could be easier?"

Sure, but it was still stealing. Henry wasn't about to get himself locked in with high-graders. On the other hand, if you tried to get high and mighty with these boys, you were liable to be found floating in the sump at the bottom of the shaft—just one more unexplained underground accident.

Henry laughed casually, trying to make it sound relaxed and friendly. "Now you boys know I can't do that," he began. "I'm just a horn man. Why don't you ask me for something easier to do, like playing at your daughter's wedding?"

One man, the muscle, moved forward menacingly, but the older one held him back. How could you play the heavy with Henry Kelneck? He was the kind of guy who liked visiting the old folks' homes, playing tunes from back home for the old Slavs and Finns. He was the man you were going to run into at every family wedding and dance. The two high-graders kept their eyes on Henry for a moment and then pushed past him. "Be seeing you around," the older one said.

"Sure," said Henry, unable to believe his luck. He gave the boys a few minutes to pass into the darkness and then put his lips to the tin whistle. His hands were shaking. "Begin the Beguine" sounded a little forced. But as he walked along the drift, the sound smoothed out. Yes indeed, it wasn't a bad life after all.

Mark Serdar
1905—1940

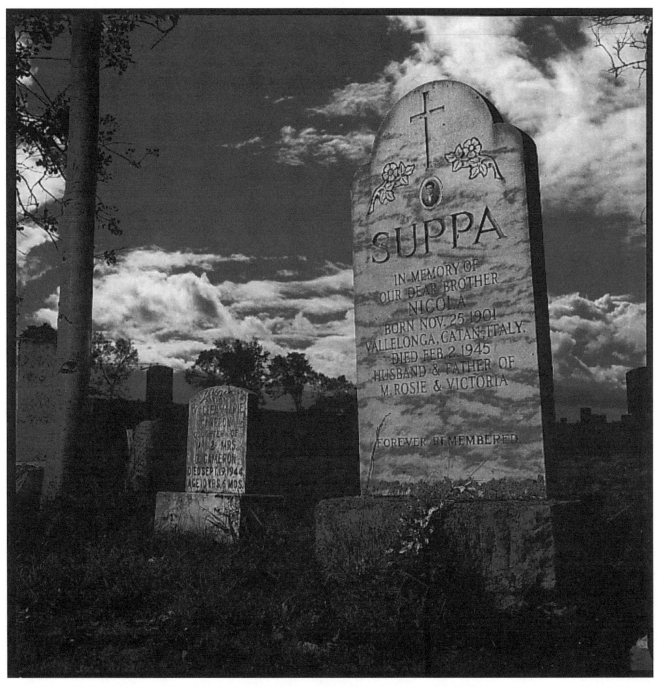

Grave of Nicola Suppa, killed in Paymaster Mine Disaster, 1945 ■ Tisdale Cemetery

11 The Paymaster Disaster

Y OU DIDN'T MISS CAGE CALL. Miss the cage and you might as well stay home. Miss the cage a couple of times and you'd better find another line of work. In the Paymaster No. 5 Shaft, the graveyard shift stopped hauling muck at around 5:30 a.m. Cage call for the morning shift started at 7:30 and ran until just after 8:00. When the cage bell sounded, every miner was expected to have his gear on, his lamp ready, and his day's instructions from the shift boss's wicket.

The cage was a double-decker operation. If you squeezed hard you could pack in eight big men on the upper deck and eight on the lower. The 140 or so men on the underground force at the Paymaster were ferried down in groups to the various working drifts, which were spread out like the storeys of an underground building. Most of the Paymaster's underground crew worked the ground between the 1,050-foot and 2,075-foot levels.

Every miner knew when to meet the cage at the start of the shift and when to be waiting at the end of shift. Eddie Taillifer and Larry Bilodeau were regulars on the third cage. It usually left the collar just before eight in the morning. On Friday, February 2, 1945, Larry and Ed unexpectedly decided to jump in with the boys on cage no. 2. There was a lot of good-natured shoving and calls of "Hey, get on the next one."

Just to rub it in, Larry called out to Paul Stringer, another regular on the third cage, "C'mon Paul, lots of room here." Paul jumped aboard, and the miners groaned and made room for one more. The No. 5 Shaft cage carried two cage operators—Nicky Suppa and Stanley Kolozjiepki. Seeing that the men were safely aboard, they closed the rusted cage door and rang the buzzer to give the all-clear. The cage then plunged into the wet darkness.

Meanwhile, on the main deck, Mike Parnetta and Melvin Markoskic were anxiously looking around to see if their buddy Stan Pylyk had shown up yet. The three were Ukrainian boys from Saskatchewan. They had been hired at the Paymaster just three weeks before along with Mike Parnetta's cousin Joe, who had been caught sleeping on the job the day before and handed a two-day suspension. If Stan didn't get there soon, he would also be facing a suspension.

Coming up beside them was somebody who should have missed this shift. Marvin Appleyard was coughing hard from a bad chest cold. He had

My mother used to say to me, "You'll be under the ground long enough after you're dead, why go there now?" But I never cared about that. I was more interested in the four bucks a day.

—Felix Brezinski

planned to take the day off to recuperate but changed his mind at the last minute. It meant he had to scramble to get to work on time. His pale complexion and wheezing lungs betrayed his mistake in judgement.

As the clock ticked towards eight, the cage reappeared at surface. The cage door swung up and the protective gate on surface was pushed out. Nicky Suppa stepped onto the deck and shouted for the boys to start hauling their asses. Mike Mohoruk jumped on board along with Ubald Legault, Alphone Auguer, and Albert Plourde.

Russell "Mickey" Dillon was next. All in all, things had turned out pretty well for Mickey. He had been an air gunner in the night war over Germany. Not many gunners made it through the mandatory fifty missions. But Mickey's burst eardrum had earned him a ticket home. Now he was back—a war hero, an Allan Cup hockey star, and holding down a safe job on the sample gang. After risking his butt among the flak over the Ruhr Valley, why sweat it out in a production stope at the Paymaster?

Nineteen-year-old Eino Niemi was the second sampler on the morning shift. It was his first week underground, and going down in the cage was still an adventure. It must have been a different sort of adventure for his mother. She had lost her husband John in the Paymaster Mine twelve days before young Eino was born. Eino's dad had been riding the cage in this very shaft when the cable broke and he fell to his death. But what were the chances of lightning striking in the same spot twice? Young Niemi jostled for space in the dark rusted cage along with two other Finns, T. Voutillainen and Eero Kohtala. Eero was just back at work after a six-month leave of absence.

Hector Poitras was already in the cage when someone pointed out to him that he wasn't wearing his light. The boys all laughed as Hector rushed back to the lamp room. He would have to catch a later cage. A. Beland, a father of eleven children, took his place along with Ligouri Lauzon, who was starting his first shift without his partner and brother-in-law Hector Beauchamp. Hector had decided the day before to switch shifts with another crew.

The father-and-son team of George and Larry Dubeau stepped on board. "Hey, there's no more room," somebody shouted from the back, and father George stepped back onto the deck. "You take this cage," he said to his nineteen-year-old son. I'll grab the next one." With that, the door shut and the cage began its third descent of the morning.

Nicky Suppa was an old hand on the No. 5 Shaft cage. He kept the

When I decided to quit the mine the manager came up to me and said, "What's the matter Clarence? Didn't we use you right?" I said, "Oh, the very best." "But what's the reason you're quitting?" I said, "I'll make it real plain—before my family has grown up I'll be spitting blood on the streets of Timmins." He didn't say anything after that.

—Clarence Brazier, former McIntyre miner

74

surface hoistman informed of the cage's progress by a series of rings of the cage bell. The crew had just passed the nine-hundred-foot level, however, when the hoist cable snapped and the cage began free-falling into the darkness. Immediately the emergency "dogs" sprang up from the sides of the cage and tried to lock into the timber lining of the shaft. For a few seconds the descent slowed, but the dogs quickly gummed up with shredded, wet wood. As the cage picked up speed, the dogs clawed and shredded their way down the timber lining, as useless as fingernails on an ice wall.

On surface George Dubeau heard the snap as the normally taut hoist cable suddenly started slapping impotently against the shaft wall. He ran to the metal gate, shouting for his son. Other miners tried to calm him down, but George was inconsolable. "I should never have let him go. I should have taken that cage."

Eddie Taillifer, Larry Bilodeau, and Paul Stringer were standing at the cage station on the 1,575 level when they saw the cage go hurtling past. There were sparks flying from the sides, and the eerie lights of the trapped men flashed out as the cage whizzed by. Normally the lamps would have been hidden by the cage gate but the force of the descent had pushed all of the men to the upper part of the cage. Eddie ran to the side-shaft compartment and began the precarious descent down the emergency ladders.

At 2,666 feet below surface the cage hit the ninety-pound iron rails that formed the top of the ore spillage pocket, a trap near the bottom of the shaft. The impact ballooned the bottom of the cage outwards and contracted its height to a mere two feet. There it lay, with the sixteen men trapped inside, suspended above the icy cold waters of the sump nineteen feet below.

It took Eddie fifteen minutes to climb down the slippery ladders. As he neared the sump, the only thing he could make out was a single miner's lamp that had been thrown at impact onto one of the lower landings. From somewhere in the cage, he could hear the sound of moaning, like men speaking in slow motion.

As Eddie got close, he could make out two voices. The rest were as silent as the surrounding rock. He called out to them, and his buddy Ubald Legault called back.

"Taillifer. Get us out as quickly as you can. We're dying in here."

But without acetylene torches to cut through the metal the only thing Taillifer could do was try and comfort his trapped friend. "Please

Throughout yesterday afternoon when word of the accident spread throughout the district, long lines of cars, bearing relatives streamed to the mine property. Police on duty at the shafthead, kept crowds back while the last victims were brought to surface... [One] relative, a woman, screamed when the body of one of the last men brought to surface was taken from the skip and the canvas covering the body was turned back to permit identification.

—Daily Press (Timmins), Feb. 3, 1945

don't tell my wife what happened," Legault called out to him. She was at home with their two children, five-year-old Annette and four-year-old Jacqueline. Ubald knew full well as he lay in the wet darkness that he would never see his girls again.

Meanwhile Bilodeau and Stringer had phoned to surface and then collected some men to go down to the 2,575 level by riding down the hoist on the internal shafts of no. 3 and no. 5 winches. But without torches there was little these men could do. They decided to head to surface and wait for the mine rescue squad to be assembled.

Bilodeau and Taillifer had barely reached surface when George Dubeau rushed over to them. He grabbed Larry Bilodeau. "What about my son? Tell me my boy is okay."

Having to face George Dubeau was the last straw for Larry Bilodeau. He tried to speak but just shook his head. Laurent Dubeau was riding on the lower cage, and Larry couldn't find the words to describe what had become of the lower part of the 4,000-pound iron cage. In the days to come both Bilodeau and Taillifer found themselves unable to sleep or eat. They broke out into constant sweats, haunted by the guilt, fear, and horror of the survivor. Both men vowed never to step foot underground again.

Paymaster mine manager Charlie Cook was also having a hard time dealing with the disaster. Other mine managers sent over their best men to help, but Charlie oversaw the rescue operations. It fell to him to deal with the families and the media.

The rescue mission was a dismal process. Ubald Legault was the only one still alive by the time the others got to the cage and opened it, and he died soon after they got him to surface. Mine rescue spent eight hours pulling the bodies from the upper cage. They then hunkered down for the gruesome task of opening the lower cage.

In the following months numerous inquiries, studies, and tests were done to determine how the accident happened and how to ensure it would never happen again. The cable was found to be corroded in a number of sections. The emergency dogs were set improperly. If they had been placed further apart they would have caught the wood and stopped the descent.

The sixteen cage deaths were added to other Paymaster fatalities in a twelve-month period: two Finns, Joseph Kukac and Pekka Mutanen, gassed in an underground stope; Andrew Kelford, crushed by the door of the ore bin; and trackmen Jean Bernard and Peter Canduso, who ran

Wasyl Babiak,
Killed in Paymaster Mine, 1952

a runaway ore train through the shaft station and down onto the cage being operated by John Lavrick. Bernard, Canduso, and Lavrick plunged to a very messy death at the bottom of the shaft that had already claimed the lives of those other nineteen men.

None of the investigators blamed Charlie Cook or the Paymaster management for the corrosion on the cable. Death in the mines, it seemed, was part of the price of doing business. Still, there were those who would always look at Charlie Cook as the man who "killed all those men in the Paymaster Mine." Poor Charlie knew it too. Some years later, after his wife died, he took a gun and shot his beloved dog. Then he shot himself.

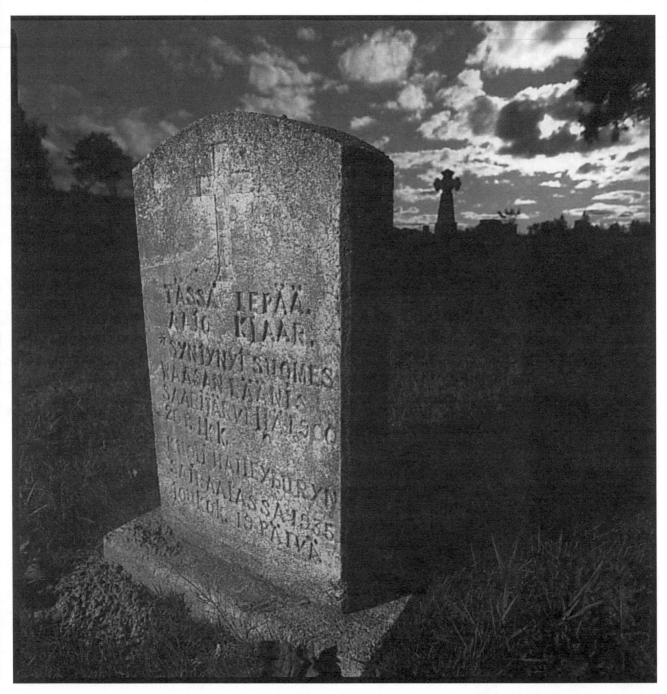

Grave of A. Klaar, born in Finland, died Haileybury Hospital/Sanatorium, age 35, 1935 ■ Tisdale Cemetery

12 Breathing the Powder

OLD JOE SPENT HIS LAST DAYS SITTING in the room that smelled of urine, cleanser, and madness. The television blared but nobody watched it. The old women walked in endless circles but never went anywhere. The men sat isolated in corners. Their faces, like the room, had been wiped clean of time, identity, and the past.

Joe's problem was that he had been only partly erased. The present, with its obligation of remembering the way to the bathroom, or which door led to the bedroom and which to the closet, had been irretrievably stolen. But the past remained surprisingly vivid. Joe never succumbed to the balm of living sleep that descends on most victims of Alzheimer's disease.

I used to visit him once or twice a week. We would pass the afternoon, both of us trying to blot out the stark reality of an Alzheimer's ward in Scarborough, Ontario.

After a while I started bringing in old photographs, hoping the pictures would fire the damaged synapses. They were snapshots he had taken in the late 1920s and early 1930s—relatives back home, fishing boats on the Bras D'Or lakes, pictures of boarding house buddies. Most interesting were photos he had taken at the mines. He had a detailed photographic record of surface and underground operations at the No. 16 colliery in New Waterford, Nova Scotia, and the McIntyre Mine in Schumacher.

Poor Joe was no longer able to recognize members of his own family, but he had no problem separating these sepia pieces of memory into their various piles. That one there, the big fella, that's Timber Boss Anderson; the little fellow here is Shorty Ellis, no relation to Charlie Ellis, second from the end; this shot is taken inside the No. 5 dry (the miners' change room); that's the internal hoist in No. 15 Shaft.

Joe was never quite sure who I was. He seemed to vary between thinking I was his only son John Lindsay MacNeil, or he would treat me like a buddy from work. One time an imposing nurse intervened in the midst of our conversation. "Mr. MacNeil, Mr. MacNeil," she said, speaking into his face as if it were a cavern. "Do you know this man? Can you say his name?"

Joe's face coloured.

"Of course, lady," he replied. "I know who this is."

When we first started getting the dust treatments they used to tell us we were supposed to breathe in heavy and that goddamned stuff would get stuck in our hair and in our nose. They told us not to blow our noses.

— retired Timmins miner

"Tell me his name, Mr. MacNeil," she said, pushing.

Joe hesitated and looked at me. I knew he didn't really know who I was, but I also knew he was embarrassed about being found out.

"John Lindsay," he finally said softly. "This is John Lindsay."

She turned to me for confirmation. "Are you John Lindsay?"

"Well, who else would I be?" I replied.

Joe looked at me slyly. I don't think he fell for my line either, but he seemed to appreciate my support. With the overbearing nurse gone, we soon fell back into conversation.

"You working day shift or afternoons—hoist or on the drills?"

Over time I became pretty good at faking the answers, and we spent the afternoons having a rare old time—the two of us make-believing that it was Schumacher 1934, both of us bloody aware that it wasn't.

They figured that silicosis is like rust. If you paint the lung with aluminum it won't get rusty.

—Homer Seguin,
union health and safety advocate

His memory for details of the mine was magnificent. The only thing he forgot to tell me about was the powder. He never mentioned the daily doses of finely ground aluminum that were blown into the dry at the start of every shift. Breathe in through your nose, the management said, let the dust coat your lungs. It will protect you from silicosis.

The idea for the powder had come from the boys in McIntyre's metallurgy lab. They noticed that when aluminum was introduced to the milling process, it seemed to impede silica fibres. Mine management began to experiment with the idea of using aluminum to coat the lungs of miners as a way of cutting down on the appallingly high rates of silicosis afflicting its workers.

The Porcupine mines had the highest level of silica dust of all Ontario mines. By the late 1920s, nearly 20 per cent of the underground workforce was suffering from some form of recognized lung ailment. By the end of the Depression the full impact of thirty years of mining was becoming evident. The average life expectancy of a Slavic miner in the Porcupine camp in the 1930s was a mere 41.6 years.

The mine owners always denied the full extent of the problem because they knew their compensation claims could skyrocket. They also knew that the only way to fight the heavy dust of underground was to undertake a massive overhaul of the ventilation systems—a measure much too expensive for the shareholders to sanction.

In 1940 the McIntyre Mine formed the McIntyre Research Foundation to study and promote the use of aluminum powder as a preventative for silicosis. Soon after the Foundation announced positive results of a trial study conducted on seven rabbits. According to the

tests, silica dust had a harder time sticking to lungs that had been exposed to aluminum powder. Experiments on rabbits soon gave way to experiments on dying miners. Under the watchful eye of the prestigious Banting Institute, a number of highly silicotic miners were used in an experiment that tested the effects of large doses of aluminum dust applied directly to the lungs. Seven dying miners at St. Mary's Hospital in Timmins were each subjected to a series of seventy treatments of "taking aluminum by hose."

Another group of miners, who were dying at the Queen Alexandria Sanatorium in London, Ontario, were subjected to a combination of aluminum dust treatments and exposure to an experimental vole vaccine. In the early 1940s the vole vaccine was undergoing trial experiments in England amongst guinea pigs as a possible cure for tuberculosis. Attempts in Canada to carry on a similar line of experimentation ran into problems when researchers had difficulty maintaining healthy guinea pig populations.

The Banting Institute, working in conjunction with the Ontario Mining Association, circumvented these problems by jumping right into human experiments. The Institute treated some two hundred tuberculosis patients in Ontario with the experimental vaccine between 1942 and 1943. It is not known if the experiment was confined to miners or to a general cross-section of tuberculosis patients. What is known, however, is that the Queen Alexandria experiments using vole vaccine and aluminum were a failure. Vole vaccine created bad reactions at the point of contact, and the Banting Institute gave up on the hope of using aluminum dust as a treatment for tuberculosis (what became of the human guinea pigs who were subjected to the tests is not known).

The Banting and McIntyre people were much more bullish on the results of the experiments taking place at St. Mary's Hospital. Noting that the seven silicotic miners seemed to respond to the aluminum treatments, the gold mines of Ontario instituted the widespread use of daily aluminum treatments for working miners. The McIntyre Foundation offered the use of its miracle cure as "available to mankind on a non-profit basis."

Numerous mining jurisdictions around the world attempted to reproduce the "success" of the Banting experiments, but the results invariably came up less than rosy. Scientific papers published in Germany, England, the United States, and South Africa found no evidence to support the contention that aluminum lung treatments could

Craziness. In a calm and orderly fashion a hundred men were sitting around coating their lungs with finely ground metal particles. I felt a flutter of panic; trying to see through the murk I thought I saw the lambent grin of lunacy. Bob clamped his hand on my arm.

"Take it easy," he said. "Some of these guys have been working here for five years and they're still walking around."

"Come on," I said. "Ten minutes of this and we'll be as crazy as they are."

—Ken Lafoli, *Claims: Adventures in the Gold Trade*

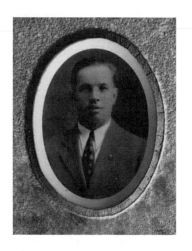

Aaro Hanga
Walked into a blast at the Pamour
Mine, 1937

retard the progress of silicosis. Rather, some researchers pointed out that daily doses of aluminum dust could result in a number of lung-related problems and might even be a factor in the spread of tuberculosis in miners. Nevertheless, the Ontario Mining Association embraced the McIntyre powder as a shield against silicosis in Ontario's gold (and later uranium) mines. Without any government trials or outside medical supervision, the McIntyre Foundation set itself up as the dispenser of a daily medical treatment that was applied to tens of thousands of workers. (Ironically, each canister of McIntyre powder came stamped with the instructions, "For Use Only Under Doctors' Directions.")

The treatments worked this way: as the men came in for the morning shift, the company saw to it that black aluminum powder was blown into the mine dry. The fine dust covered their clothes. It coated their skin and stuck in their hair. As the room became a black cloud of dust, the men were told to take deep breaths. The more aluminum they breathed, the healthier they would be. Some miners refused to submit to the treatments, but the price of refusing treatments was the loss of your job. At the McIntyre Mine one man, who was assigned the task of blowing the dust into the dry, used to dump the powder down the drain when the shift boss wasn't looking.

Despite the occasional attempts to fight back, Ontario's gold and uranium miners were forced to take unproven medical treatments for nearly forty years. The treatments were finally stopped in 1978 by the threat of wildcat strikes at the Rio Algom Mine in Elliot Lake. The men simply refused to go back underground unless the mine owners agreed to suspend the daily dosing of black powder. Two years later workers at the Dome Mine in South Porcupine threatened their own wildcat strike, thus leading the way to the suspension of the aluminum treatments in the gold fields.

By the time the treatments were finally stopped, conjecture had been raised about the connection between aluminum exposure and neurological impairment. The first hint came from a 1962 study of British aluminum workers, which found elevated cases of neurological impairment. By the 1980s Alzheimer's researchers had begun noting high levels of aluminum in the brains of dead Alzheimer's victims.

My mother, seeing the effect of Alzheimer's on my grandfather, went on a search and destroy mission of all aluminum pans in the house. It wasn't until a few years after Joe's death that we became aware of the aluminum dust issue. Our interest was raised by a 1990 study of

Porcupine miners by researcher Sandra Rifat, who looked at neurological impairment in miners exposed to aluminum treatments. The Rifat study found a higher level of neurological impairment in miners who had been exposed as compared with hardrock miners (from nickel mines) who had not. But no major follow-up was done to verify Rifat's findings.

I have no way of knowing whether my grandfather's Alzheimer's was in any way connected with his years at the McIntyre. Like so many other aspects of industrially related illnesses in the Porcupine, the links seem to be erased with time.

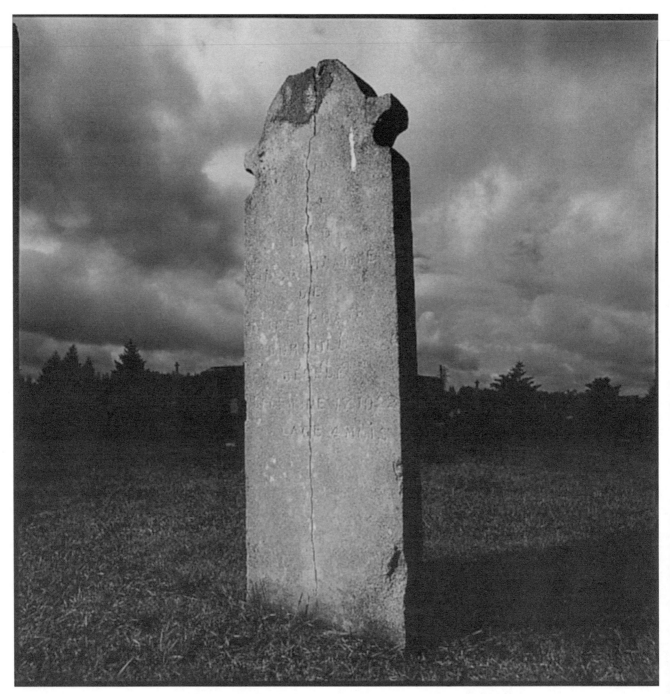

Grave of Leo Dumoulin, died age 4 months, 1922 ■ Timmins Cemetery

13 Death by a Thousand Cuts

AUGUSTE SALMINEN MUST HAVE REALLY WANTED TO DIE. The forty-one-year-old father of two decided that the best way to finish the job was to hang himself in the basement. The only problem was the cellar lacked the height to do the job properly. With a bare five feet of room, he had to really work at dying. Salminen fastened a noose and then curled his legs up at the knees and held them until he slowly strangled. He could have easily saved himself. But he never did.

Salminen, a Finn, was dying anyway. He was a former miner, now too sick to work. In his own eyes he had gone from being Salminen the provider of a family to Salminen the burden on a family.

Pete Procopio had gone from being a burden to a threat. Procopio hadn't been able to work for years because of his silicotic lungs. He lived with his wife and five children in the company housing of the Dome Ex Mine. As time went on and his condition worsened, Procopio became increasingly abusive and unstable. On May 9, 1945, he went after his wife with a sixteen-gauge shotgun. To get away, she jumped out an upstairs window and broke her twenty-five-foot fall by grabbing onto the clothesline. Procopio, taking aim from the window, shot her in the back as she hung on the line. The shouts and gunshot alerted the Warren family next door. Frank Warren and his wife Mary rushed out to try to save Mary Procopio, but crazy Pete decided to take them out as well. Frank was seriously wounded and Mary had part of her ear shot off. Then, with the Procopio children screaming away inside the house, Pete Procopio blew himself away.

Salminen and Procopio went out of this world in very visible ways. But over the years thousands of other Porcupine miners were quietly erased by a multitude of mine-induced lung ailments and cancers. At the most, their tragically short lives would be summed up in the neat little obituary phase—"passed away after a long illness." Many of them didn't even get that much.

It started out with a nagging cough or a shortness of breath. Big men, used to a full day of mucking ore with a shovel, found themselves getting tired quickly. They would break into hot flashes or cold sweats. They would stand there shivering underground in the dirty, cold water, telling their partner it was just a bug they couldn't seem to shake. They wouldn't tell the wife, either. But she'd soon catch on—blood in the sink, the pallid skin.

My mother made five dollars a day cleaning houses. At that time my father's pain killers cost a dollar a day. That was a lot of money back then. I remember my father sitting at the kitchen table crying because he was in such pain. My mother had to make the decision whether to spend the money on pain killers for him or for food for us.

—Jenny Gyokery, describing the slow death of her father, Kirkland Lake gold miner Walter Warecha, from mine-induced lung cancer

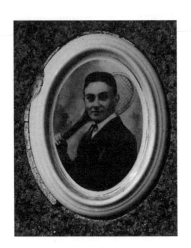

Philip Joseph
Died age 27, 1935

The wives would be so angry at the diseases that took their husbands from them. I dealt with one woman who had four children and she lost her husband when he was thirty-nine. She went home after the funeral and trashed her whole house. The anger was so intense and she didn't know what else to do.

— Carrie Chenier,
miner's compensation
representative, Elliot Lake

The big fear was being caught out in the annual X-ray carried out by the company doctor. The spot on your lung, the doctor would say, could be TB, better not aggravate it by going underground. The companies, after all, didn't want to be burdened with a sick case. And a miner who suspected he had silicosis knew that even if his case was accepted by the Workers' Compensation Board, the finding would subject his family to economic destitution. In the early 1950s, a miner making $60 a week could barely keep up with the costs of raising a large family. The rare few who were given silicosis pensions would see this wage drop to less than $10 a week. As a result, most miners continued working in the dust as long as they could—trying to feed the family but hastening a quick death.

The Porcupine had the highest tuberculosis rates in the province. The brilliant medical minds of Upper Canada had little to say about this medical anomaly. Even into the 1950s, as rates dropped off elsewhere, the Porcupine had rates four times higher than the provincial average. The men who lay slowly drowning in their own blood knew that their lungs had been shredded by years of exposure to silica dust. In the quartzite veins underground, the silica came off the rock like jagged pieces of microscopic glass. It burned in your throat as it went down. You could taste its acrid flavour in the crushing house and in the stopes after a blast. It settled amongst the fine hairs of the lungs creating cuts, abrasions, and infections. Over time the body became more susceptible to the onset of tuberculosis.

Clear-cut TB cases were sent to the sanatoriums in Gravenhurst, London, or Haileybury. The whole third floor of the sanatorium in Haileybury was reserved for miners who were not coming back. It meant the men died separated from family and friends, but at least they received some medical attention. But for most others, death was as familiar as their poverty. Their children grew up with vague memories of a father who never played with them in the yard, the shadowy man, propped up with pillows on the couch, who faded before them like a snow figure in the spring thaw. The men died on their living room couches, attended only by their wives and the neighbourhood women. As one woman told me, "We couldn't afford a doctor. My father died, choking in his own blood in my mother's arms."

Tuberculosis was not recognized as a mining-related illness, nor was lung cancer, throat cancer, stomach cancer, emphysema, right-heart failure, or chronic obstructive lung disease. And the compensation

people were diligent about enforcing the letter of the law. Silicosis was compensable, but a widow received compensation only if she could prove that silicosis was the primary cause of death. Even then the Compensation Board had a million ways of denying the claim.

Yes ma'am, your husband had silicosis, but it spread into lung cancer and it was the lung cancer that killed him. Non-compensable. Yes ma'am, your husband may have had silicosis, but he died of heart failure. Never mind that congestive heart failure was the result of stressed lungs. Non-compensable.

The men went to the town doctors knowing that the only thing that would save their families from a life of destitution was a doctor's statement that the miner was dying from silicosis. But many of the town doctors played golf with the mine managers, and they could be wary of blaming work for what was surely an act of fate. It was the cigarettes. It was the Eastern European diet. It was the air inside the house that may have exacerbated the condition.

Mr. M—— worked at Aunor Mine in 1162, 1160 and 1140 stope which was a large, very dusty quartz stope—40 feet wide by 400 feet long. At any one time there would be 20 timbermen, 4 scrapers and 5 drillers in this stope. It was about this time that he started having problems with his lungs. He would see Dr. H—— and Dr. G—— for his condition and they would tell him it was anything but silicosis... In 1978... he decided to go see Dr. —— and Dr. —— told him he had smoker's lungs. Mr. M—— explained he had never smoked in his life except maybe once or twice when he was a young boy. The doctor told him it was those two cigarettes that did it to him.

—case notes, outstanding compensation case, 1988

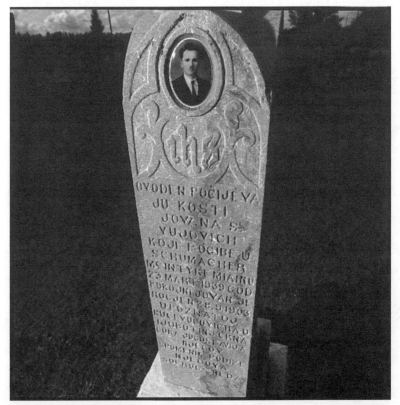

Grave of Jovana Vujovich, Montenegran Serb, killed in McIntyre Mine, age 36, 1939 ■ Timmins Cemetery

The women paraded their children in front of the compensation people to prove that they weren't out to cheat the system. But the compensation people scolded them about abusing the benevolence of their new homeland. The women learned English at night by trying to read the medical forms, and they relied on their ten-year-old daughters to write letters to the government people to explain in clear, neat penmanship that they were honest people and they needed help.

But help never came. And so the women took to cleaning houses and mending clothes to keep their families together. They rented out rooms in their homes to single miners to help pay the rent. Some women would sleep with those miners out of the hope that the men would divert part of their paycheques to help cover the needs of the children. The Compensation Board, which seemed so unwilling to intervene actively in the case of illness, was always vigilant when it came to the "morals" of the widows. Historian Nancy Forrestell points out that widows had to prove themselves chaste or lose their benefits. The Compensation Board paid close attention to the word of a jealous neighbour when it came to allegations of whether a widow was carrying on a relationship with one of her boarders.

After his death, Dr. H———, the family doctor, told the widow that her husband had silicosis but would not put that down on paper. As well, Dr. S———, the attending physician at the time of death, said the same thing to the widow, but would not put it on paper due to political reasons.

—case notes, compensation claim for miner who died in October 1975

Grave oval of Frank and Mary Hrovat ■ Timmins Cemetery

The widows faded into the unspoken background of life in the Porcupine. To publicly acknowledge the extent of their losses would put into question the whole basis of the gold economy. Little wonder that over the years, the companies and the compensation people quietly but thoroughly erased the links that would allow any kind of serious scrutiny of the level of industrial disease facing gold miners.

It is virtually impossible to put a number on the lives cut short by industrial disease in the mining sector. The McIntyre Research Foundation claimed in 1972 that it had all but eradicated silicosis from the mines of Ontario: "For the past 27 years, with perhaps one questionable case, no miner who has mined only in Ontario and who has received aluminum powder has developed radiological evidence of silicosis to the end of 1969." This picture is contradicted by an Ontario government assessment listing 279 cases of newly diagnosed silicosis in the period between 1973 and 1990. A Lung Cancer Study carried out by the United Steelworkers in the 1980s came up with a much larger number. The Steelworkers tracked nearly two thousand cases of outstanding compensation issues relating to silicosis, lung cancer, and other industrially related illnesses.

But even that number might be just a partial snapshot of a much larger picture. It does not include, for example, men crippled, blinded, or physically incapacitated years before their time. It doesn't even begin to take into account how the mines of the Porcupine were based on a largely fluid workforce of men who worked for a time and then moved on to other forms of work. How many of them left the region unknowingly carrying a ticking time bomb inside? An even larger outstanding number must include the big pool of single young foreign men living in boarding houses with no traceable dependants or families. Many of them could have fallen off the planet and no one would have noticed. Even when foreign workers had traceable dependants, it was difficult for the widows to get their just compensation. Nancy Forrestell relates the story of Vincent Greko, who was killed in the Buffalo Ankerite Mine in 1933. He had been working in the Porcupine and sending the money back home to his wife Maria and two children in Yugoslavia. The Compensation Board turned down her request for a pension, stating that it was unclear to what extent Greko had been using his wage to support the family—even though the widow supplied four money-order stubs as proof.

While he was there [in a sanatorium], he sent a letter to his wife saying he did not want to stay there any longer, that he felt uneasy about seeing other men in his condition. He told his wife about the hospital wheeling out dead bodies in the middle of the night. He was discharged from the hospital in his own care and returned home. A week before his death he was admitted to hospital... The two oldest children had to go out to work after their father's death and support the family.

— case notes, outstanding compensation case for Timmins miner who died in 1943

The only testament we have to the lives of these men is the gathering of stones in the Porcupine and Tisdale cemeteries. What a powerful witness it was, then, in the 1980s when a busload of mining widows from the Porcupine drove to the Ontario Legislature and planted tombstone-shaped markers commemorating their dead husbands on the front lawn of the legislature. They were pressing the government to begin paying compensation for mining-related lung cancers. The graveyard, which has always been the public repository of the real Timmins history, was put on display in a bold and defiant manner in the heart of Upper Canada's power structure. Soon after that, in 1988, the provincial Workers' Compensation Board accepted its first case of industrially caused lung cancer from a gold miner.

PART III

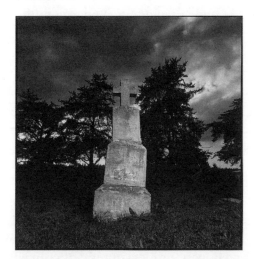

A Changed World

PROLOGUE: In Search of the Synagogue

THE MAIN HIGHWAY THROUGH THE PORCUPINE comes through Timmins via Algonquin Boulevard. A few years ago the town renamed the road Shania Twain Way. The renaming was apt. Timmins, once known as the richest gold belt on the continent, is now known as the home of Nashville's richest star.

Shania Twain Way itself reveals Timmins's struggle to throw off the old and embrace the new. A hip restaurant patio looks out over an abandoned open pit of the Hollinger mine. A modern-style hotel franchise backs out onto broken mill foundations. The roadway, once dominated by the headframe towers of the McIntyre and Hollinger mines, has been taken over by golden arches, strip malls, and gaudy signs advertising every conceivable brand of franchised donut slingers, muffler changers, and fried chicken hawkers.

Every midsized town in North America has its own Shania Twain Way—the strip, the great consumer artery that entices customers away from the old downtown and keeps them on the fringes where the shopping malls and asphalt parking dominate. On Shania Twain Way all our histories merge.

When I drive along this commercial pantheon, I find myself struggling with the gnawing architecture of memory. Buildings that were torn down long ago compete for attention alongside buildings that have gone up relatively recently. Characters from my childhood still cross the road only to disappear under the bright glare of sunlight. All of this, I know, is merely a transparent overlay of memory. The rational part of me says that if I visit a place often enough the glow of romanticism will be worn down by the mundane quality of the familiar. But despite countless trips, the ghosts of Timmins have proven to be particularly stubborn.

The lot beside the Bon Air Motel used to be home to Doran's Brewery. In my mind's eye, I can still see steam pumping from the brewery's stack, and the main loading bay waiting to unload kegs of draft. Driving under the railway bridge I see the imposing outline of Central Public School. Never mind that the school was pulled down in the early 1970s to make way for the 101 Shopping Mall. In my mind's eye it's still there.

Further down Algonquin Avenue, the old Consumers' Co-op grocery store has been converted into a Subway sandwich franchise. The nearby Finnish steam baths have become a body-piercing joint. At the

We are a culture that lives in little cubes. You go into an office building today and there's not much to differentiate this group of people in one office from that group of people over in that office. But I think back to the people who worked in the mines with my Dad. They had these wonderful nicknames that really summed up their personalities. They were characters. But we don't seem to have this same sense of living that they had.

— Ike Kelneck

bottom of the hill a profusion of strip malls and parking lots has erased the remnants of the Hollinger Townsite. When I was a boy this land was dominated by over four hundred red and green tarpaper houses, along with a community hall and tennis courts. The heart of the old townsite has been taken over by a Wendy's franchise. The store owners, in a nod to the past, have mounted a painting of the miners' homes on an inside wall. As you gather up your ketchup packets and plastic forks, you can muse over the change in neighbourhood.

The place that strikes me the most, though, is the large municipal parking lot that now dominates the corner of Algonquin and Cedar Street. Cedar used to be home to a wonderful mix—Ansara's (the Lebanese grocery store), Poirer's Barber Shop (before that, Herman's Dry Cleaners), the Victory Theatre, the old Esquire Grille, and, right in the middle of the block, the synagogue. A drab municipal bus transfer station has replaced the synagogue. The barber shop has been replaced by a convenience store. The Esquire Grille, with its rounded booths and a small jukebox on every table, has become a health food store.

Only the Victory Theatre remains. Every Saturday we used to go to the matinee at the Victory to see movies like *Five Fingers of Death* or *Planet of the Apes*. Today the theatre building serves as a dance club, though a large mural on its side still advertises triple-X porn movies. The mural overlooks the ground where families used to gather for high holy days.

In the early 1970s my Grade five teacher, Mr. O'Brien, took our class on a tour of the synagogue. As we stood on the steps waiting for the rabbi to open the doors, Mr. O'Brien muttered to us boys, "If any of you wiseacres makes a crack about them not believing in the Virgin Mary, I'll knock your head off."

We didn't make any cracks because we were so impressed by the seats—soft theatre seats, just like next door at the Victory Theatre—seats that made you feel you should be watching Disney's *The Love Bug*, seats where you could recite Kaddish.

In those days, McIntyre Park was an inspiring sight. There were masses of flowers particularly along the north side against the fence of the mine. Ponds and a little brook contained large goldfish... Many elaborate bird-houses had been constructed among the various trees and bushes. There were little bridges, trellises and fountains. I've never been to a more beautiful place.

—Max Carroll,
"Growing up in Schumacher,"
HighGrader Magazine

■■■

The Jewish community in the north dated from the earliest days of the mining and logging camps. It included Sam Buckovesky, a Ukrainian Jew who built up a chain of department stores across the North. The Buckovesky family has long since left the North and so has the chain, but the main store in Timmins remains. The Feldman family were also among the earliest settlers in the Porcupine. They set themselves up in the lumber business, and their mill quickly became a major employer in the community. Some ninety years later they are still big players in the local building-supply business.

Many of these frontier Jews came from the ghettos of Russia and Poland. They were determined not to be second-class citizens in the new world, as they had been in the old. They set up a local B'nai Israel Society. They advocated for a Jewish homeland in Palestine. The women organized under the Hebrew Ladies Society, the Timmins Chapter of the Hadassah. Families like the Pierces, Shankmans, Linders, and Slotnicks were well known and respected in the larger community. They all maintained close links with other Jewish communities across the North—in Cochrane, Kirkland Lake, Noranda, Englehart.

I would like to share with my children the sounds of the Dome—the constant hum and clang of the cage bringing men and equipment down into the mine and back to surface, and the whistle which signalled all breaks and shift changes. The whistle was a symbol of security for three generations of my family. It blew at the stroke of midnight every New Year's Eve. It signalled that all was well.

—Kathryn Pirie

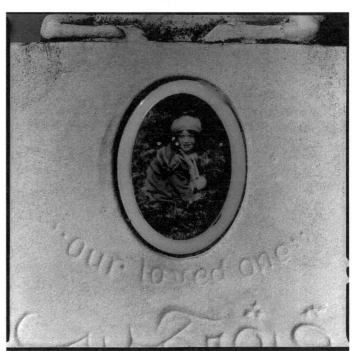

Grave of
Vivian Habib,
died age 4, 1931
■ Timmins
Cemetery

In the 1930s and 1940s the Annual Purim Ball was a major event for the whole community. The crowning of Queen Esther drew Jews and Gentiles alike. After the war, however, the community began to disperse and the great ball became part of a quickly fading memory. Families who had made their money as merchants didn't want their children to spend their lives standing behind a counter. By the 1960s, many of the younger Jews had moved south to take up new lives. One by one, the synagogues across the North began to close. Eventually the synagogue in Timmins closed too, and it was torn down a few years later.

In some ways the disappearance of the synagogue is simply part of the larger ethnic changeover in the community as a whole. The ethnic churches remain—the Italian Sacred Heart, and the St. Alphonsus church, in the old Croatian neighbourhood, with their largely English-speaking congregations, are doing a better trade than the ethnically based Rumanian Orthodox and Ukrainian Catholic churches. But the real change is noticeable in the disappearance of the ethnic halls. The Croatian Hall in Schumacher is about the only survivor of the many ethnic halls that once dotted the landscape. By and large, the young generation does not look to the old ethnic clubs for any sense of identity.

At the time, the tearing down of the synagogue did not make much of an impression on me. There was no reason why it should have. It was merely one part of the backdrop of a cluttered goyish childhood. Now I find myself drawn to the spot where the building used to be. I see its tanned walls, stone steps, and dignified, round front windows.

There are places, I'm convinced, where the lines of time are not straight and unbending, places impregnated with the need to remember. This is one such place. Even years after its disappearance the old synagogue still resonates over a landscape subdued by asphalt and oversized advertisements for cheesy porn movies.

The seventh annual Purim Ball, held last night at the Riverside Pavilion under the auspices of the B'Nai Israel of Timmins was the outstanding success of the spring season. Crowning Queen Esther was again the most popular event in the evening and this year the honour went to Miss Helen Johnston. Miss Dorothy Turcotte and Miss Ruth Babcock also won prizes... Refreshments served at one o'clock were of the usual high standard Timmins people have come to expect from the Purim Ball.

—The Porcupine Advance,
May 11, 1937

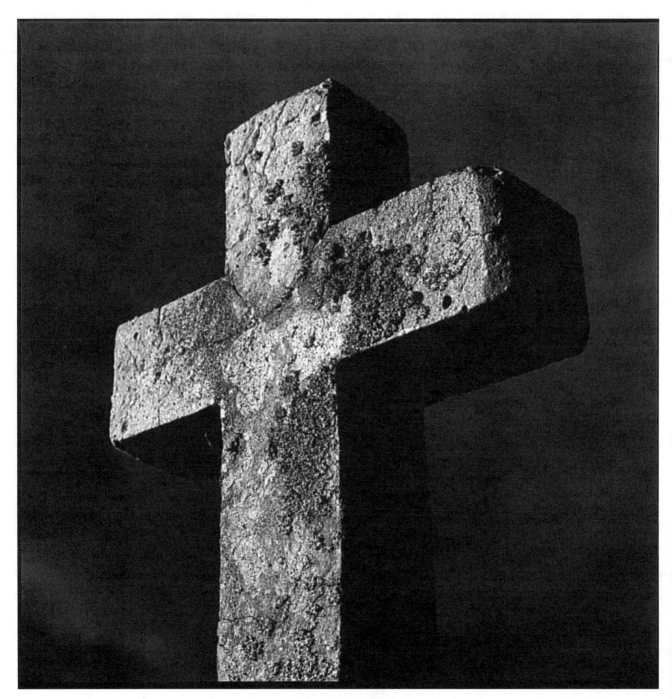

Cross detail ■ Timmins Cemetery

14 The Mystery of Bill Barilko

FOUR O'CLOCK IN THE MORNING—and the last of the graveyard shift has come up from underground. The boys, having showered and changed, are now stepping out into the cold darkness of a January night. The night is slipping away, but few of them head for bed. After a shift on the timber gang the body has to take time to readjust. After eight hours of taking in stale underground air, the lungs bask in the luxury of fresh oxygen. After being pounded by the roar of vent fans and the clang of motors, the ears struggle to readjust to the sound of snow crunching underfoot. Like deep-sea divers, the miners need a period of depressurization following their labours. A miner needs to acclimatize himself to the world at ground level.

Some boys head to the bootleggers for a quick drink before making their way home to the cold comfort of a boarding-house mattress or the warm comfort of a waiting wife. But other boys head to the lake, their skates over their shoulders. Some nights they challenge each other to a game of shinny—four on four, with duffle bags serving as makeshift goal posts. On other nights they just skate in the silence under the watchful eyes of Orion—the Finns lighting the darkness of the lake with hand-held torches.

Every neighbourhood had a rink. Every alleyway sported impromptu leagues of pickup road hockey. Every kid who played shared the same dream—skating out of this town and into the magical radio world described every Saturday night by Foster Hewitt's broadcasts from Maple Leaf Gardens. For a working-class kid from Schumacher the only ticket out of the mines seemed to be the prospect of learning to skate faster and hit harder.

The really good ones settled for the honours of the local mining leagues. Others converted their winter skills and took starring roles in the summer baseball and softball tournaments. A good ballplayer wielded a great deal of respect in town. They were guaranteed work in the local mines or mills, and their careers were closely followed by the large crowds that gathered in the wooden bleachers of Hollinger Park. Lino Bozzer, local softball king, drew crowds every time he played.

Every now and then a local kid made the huge step into the Cinderella world of professional hockey. Fans cheered the radio exploits of local heroes like Allan Stanley, Pete Babando, and the Mahovlich brothers,

Early in the morning
on the way down to the mill
we'd turn off onto Cedar Street
to the old Esquire Grille.
And the boys all sittin'
in the rounded booths
with their pie and coffee dark
arguing about the game last night
down by the Hollinger Park.

—Steve Fruitman,
"Ode to Lino Bozzer"

97

Frank and Pete. Each story followed the fable-like ascendancy of pauper to prince. It's a tale that has become ingrained in our national folklore—the myth that a kid from nowhere can become king of the world just because he can skate and shoot a puck.

But there's another hockey legend that is still told around the beer parlours of the Porcupine. It's a story of magic, mystery, and heartbreak: the story of Bill Barilko.

■ ■ ■

When I think of Bill Barilko I think of three distinctive photographic images. The first is a Grade seven class portrait taken at Central Public School in Timmins in the fall of 1940. Barilko, a son of Slavic immigrants, is sitting third desk from the back in the first aisle. With his thick stock of blond hair he has already begun to reveal leading man good looks.

At the back of the second aisle is Bill's good friend, my father John Angus. The buzz going around the classroom is that the Toronto Maple Leafs are coming to the McIntyre Arena, and Barilko has vowed to be the first in line for autographs.

At this point Bill's future options seem to be little different than most kids in the room. He's considered to be a good goalie, but other kids have even more noticeable standing: namely, Richard Moscorello, champion pole vaulter and baseball hotshot; and young Leo Curik, a kid also dreaming of a future in hockey. Barilko's father is already succumbing to lung damage from years of work underground, and by the time high school ends Bill will be looking at the daily cage ride to the bottom of the Delnite Mine.

But Bill's days in the mines prove to be short. Noticed by the Leaf talent scouts, Bill is scooped out of the mines and sent to Hollywood as a defenceman on a farm team, the Hollywood Wolves. Something of the Hollywood aura rubs off on young Bill. His perpetual tan and matinee-idol good looks add to his sense of dash and daring on the ice.

Called up to the Maple Leafs halfway through the 1947 season, nineteen-year-old Bill Barilko makes an immediate impact with his hard-checking approach. Some twenty-six games later he is sporting his first Stanley Cup ring. Bill quickly establishes himself with his power-house body checks and wicked puck hand. The press dubs him "Bashing" Bill, and he becomes a stalwart on a hockey dynasty. The

Mikosia Yephak
died age 32, 1954

After our skating lessons [at the McIntyre Arena] our whole tired gang would be bussed back to the Dalton bus station where I'd walk to Pine Street south carrying school and skate paraphernalia and literally fall into the family living room tired and famished. My mother would announce that "Barbara Ann Scott" had arrived and I was then treated to a well deserved Italian meal.

—Mary Anne Gervais-Amadio, letter to *HighGrader Magazine*

Leafs win three cups in a row—1947, 1948, and 1949.

The second image I have of Bill Barilko is a shot of Bill—almost airborne, flying forward on the ice. It's sudden-death overtime in the fifth game of the 1951 Stanley Cup against the Montreal Canadiens—the only series in history in which every single game was decided in overtime.

Going into overtime in this crucial game, Leafs coach Joe Primeau had given Barilko strict orders—hold the blue line at all costs and don't try anything fancy. Bill's job is to protect the Leaf goalie. But Barilko has also established a reputation as a free spirit. Primeau well knows Barilko's habit of taking chances. He orders the young Barilko to leave the scoring opportunities to the forward lines.

It's three minutes into sudden death and Barilko has decided to defy his coach and take the biggest gamble of his career. A shot from Howie Meeker bounces off Montreal goalie Jerry McNeil and flies back into open ice. McNeil is down and for a split second both teams are frozen, unsure of where the puck has gone. Barilko sees the puck and with his powerful stride dashes off the defence line. He swoops up the puck and pounds it past McNeil before the goalie has a chance to get back on his feet.

The photo captures Barilko sailing forward with a look of expectation on his face. The faces of the other two men in the photograph tell it all—Maurice "the Rocket" Richard looks stunned as Barilko sails past, while McNeil is staring over his shoulder into the open net. The goal gives the Leafs their fourth Stanley Cup in five years. It firmly establishes Barilko as a national hero. Even fifty years later the moment is acknowledged as the greatest goal ever scored in Maple Leaf Gardens.

Bill returned to Timmins that summer to bask in the glow of local adulation. As the summer neared its end, he joined two friends—brothers Dr. Henry Hudson and Dr. Lou Hudson—for a fly-in fishing trip up to James Bay. The three men loaded up the Fairchild 24 three-seater with supplies and began to move the float plane along Porcupine Lake in preparation for takeoff. It quickly became clear to all of the passengers, however, that the plane was too heavy and wouldn't clear the trees bordering the lake. Lou motioned to his brother to stop the plane. "There's not enough room for the three of us," he said. "You guys go on, I'll stay behind."

Lou climbed out, and the Fairchild 24 flew off, never to be seen again.

There wasn't much money in those days and I didn't have skates but lots of boys didn't have either. One of my first road games ended abruptly when one high-powered errant pass cleared the snowbank and the puck shot through a pane of glass and into a house. I was totally astonished to find myself all alone on the road. Boys had disappeared everywhere; over snowbanks, through yards and doorways... One boy had the nerve to come back out yelling at me to run. They explained later that you never hung around when calamities of that nature took place in case you got blamed for it.

—Max Carroll, Schumacher
—My First 14 Years

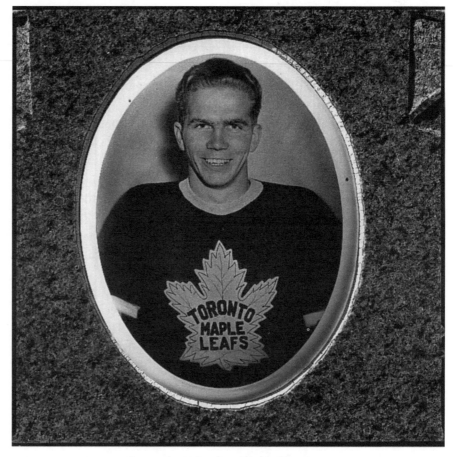

Grave oval of Bill Barilko ■ Timmins Cemetery

Each school had its own rink. Roman Catholics played in the Separate School League while Protestants played in the Public School system. Both leagues came together for a playoff tournament at the McIntyre Arena. When the playoffs occurred there was always lots of fighting in the stands, sparked equally by religious beliefs and the need to attract the eyes of young girls.

—Gregory Reynolds, "The Rinkmen," *HighGrader Magazine*, March 2001

■ ■ ■

This leads me to the third image of Bill Barilko. It's one that has been etched in my mind since I was a little boy—a gravestone oval of a cocky young hero wearing the fabled blue and white of the Maple Leafs. I have never made a trip to the graveyard without stopping at the grave of Bill Barilko and marvelling at the seven sets of dates chiselled on the marble: W.M. "Bill" Barilko 1927-1951; Stanley Cup winner 1947, 1948, 1949, 1951. And then the most telling dates: Died Accidentally Aug. 29, 1951—Buried June 15, 1962. Those eleven years between his death and his burial have clouded the memories of the fantastic goal in a swirl of mystery, fate, and speculation.

Barilko's overtime goal thrilled a nation in the way that Paul Henderson's overtime goal against the Soviets electrified a later generation. Imagine the impact if, within weeks of that 1972 series, Henderson had disappeared without a trace.

The plane, scheduled back on August 29, 1951, never made it. There were no radio calls for distress, no signs that it had gone down. A few days passed and then the media began to pick up on the concern that was clearly emanating from the Porcupine region. Canada's hockey idol was missing, and nobody seemed to have answers as to where he could be found. Leaf owner Conn Smythe kicked into action. Barilko had to be found at all costs. What followed was the biggest search and air rescue mission in Canadian history. Two RCAF DC-3s loaded with rescue teams were sent to Kapuskasing to begin searching the land south of Rupert House.

Days went by without any clues being found. Two giant Lancaster bombers were added to the search along with a flying boat and another DC-3. The nation's press was intently following the search. Everybody was clamouring for answers. Two B-25 bombers joined the search, along with a privately owned Grumman Goose. And yet despite the power of the technological age, seventeen RCAF aircraft, and numerous private planes, the boreal forest remained mute.

It didn't seem possible. How could a plane simply disappear? After nine solid weeks of searching the planes were called back to the hangars. There was no sign of Bill Barilko.

Barilko's goal was soon overshadowed by rumours and intrigue. Some claimed to have seen the hockey player in Florida. There was a theory that had Barilko flying north to defect home to Russia and help start a Soviet hockey program. And what would a mysterious disappearance in the Porcupine be without a high-grading connection? The story going around was that Barilko and Hudson weren't really going fishing but were using the plane to high-grade gold bars. The weight of the gold had caused the plane to crash.

Another thing people began to notice was that Barilko's disappearance seemed to have jinxed the Leaf dynasty. In all, ten years passed without word of Barilko and without the Leafs winning another cup.

Then, in the 1962 playoffs, the Leafs threw off the jinx, winning the series from Chicago. Soon after, Barilko's jinx was also lifted. In June 1962 a bush pilot on his way to Moosonee spotted what looked like a plane hidden in the trees near Fraserdale. Flying over the spot, he tossed

rolls of toilet paper out the window so that he would be able to identify the spot later on. And it was there that searchers found the bodies of Hudson and Barilko. Their plane had apparently run out of fuel and crashed into the trees. The thick foliage formed a canopy over the plane, obscuring it from the eyes of would-be rescue teams. Nothing mysterious. No great conspiracy. And yet, as the years have gone on, the mystery surrounding the name of Barilko has still not diminished.

■ ■ ■

The going is bad for searchers. They are working in muskeg and there is mud and water to their knees. After searching all day yesterday and last night, their eyes red from lack of sleep, they took to the air today to further the hunt.

— The Porcupine Advance,
Sept. 20, 1937

I have one more piece to add to the Barilko puzzle. It doesn't seem to have any apparent place as the puzzle is laid out, but it nonetheless nags as an odd outstanding fragment. A headline in *The Porcupine Advance* reads, "Searchers Believe Barilko Alive." The article tells the story of the vain search in the thick muskeg and bush for Bill Barilko. "If he is not alive," said Provincial Police constable Strickland after returning from an all-night search, "we would have found his body for we have combed every inch of that territory. We have scoured it."

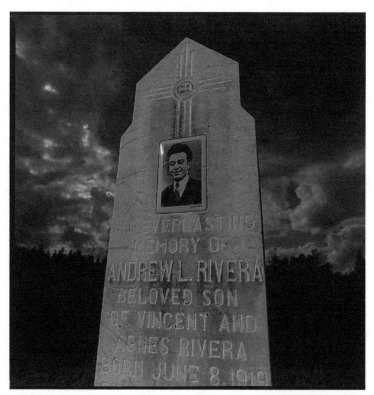

Grave of
Andrew Rivera
■ Timmins Cemetery

This newspaper article is not dated 1951—but rather September 20, 1937. And this twenty-two-old Bill Barilko, who apparently got lost, couldn't be the same Bill who at that point was a kid playing shinny on the playground of Central Public School.

Stumbling across this story in the microfiche, I find myself riveted as the tale unfolds over several days' worth of accounts. Bill Barilko, aged twenty-two, has gone missing in the dense bush outside of Timmins while on a hunting trip with two friends. Years later, Bill Barilko, aged twenty-four, has gone missing on a fishing trip that was supposed to include two friends. Both men were subject to an intense air search. (Much later I find out that the two Bills were first cousins.)

I know that it's nothing more than coincidence—a fluke of fate, time, and names. But the story that unfolded in 1937 carries a similar sense of urgency and concern to that experienced in the 1951 search. In the first search the residents of the Porcupine clung to the fading hope that the boreal forest would free young Bill Barilko and return him to his family. In the end their prayers were answered and the forest relented. Fourteen years later, however, with another Bill Barilko's life at stake, the forest apparently changed its mind.

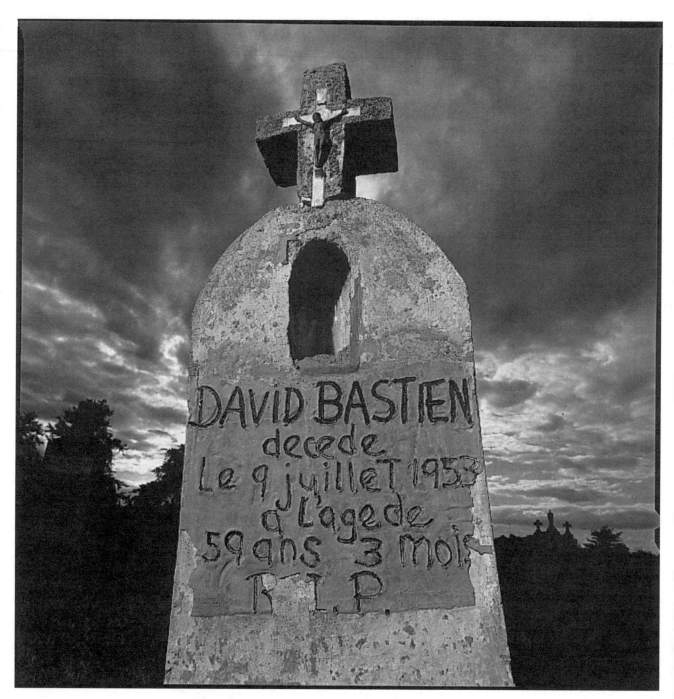

Grave of David Bastien, died age 59, 1953 ■ Timmins Cemetery

15 Battle at the Broulan Reef

STRIKES ARE FUNNY THINGS. They can turn communities into war zones and alter history. Once they are over, however, the majority of folk simply get on with their lives. A worker, looking back on the course of his life, will talk about many things but he is unlikely to pass on to a grandchild the details of long-dead labour disputes. It's like the grandchild asking a war veteran, "Grandpa, what did you do during the war?" And the grandfather will compress six years of suffering and life into a throwaway line. "I peeled potatoes." Or "I got blisters." At the most he will tell the odd anecdote. Often those anecdotes simply lull the younger generation into a pleasant sleep of forgetfulness.

Following are three anecdotes from the Porcupine strikes of the 1950s.

■ ■ ■

During the 1951 Hollinger strike my Grandfather Angus signed up for duty on the strike soup line. Charlie was a great believer in class solidarity, and my Grandmother Angus always got a kick out of telling how one of his less idealistic brothers swiped his favourite coat while Charlie was busy serving food.

Joe MacNeil told me only one story about the 1953 strike at McIntyre. The miners had been on strike for four months (other area miners were out a total of six months) and had depleted their savings. People were losing their houses and cars. The union called a meeting, where the leaders admitted that after months of hardship the company hadn't budged.

"All those in favour of ending the strike stand up," the union rep said. Nobody moved. As desperate as they were to go back, none of the men wanted to be seen as the one who broke ranks.

The union rep, knowing full well what was going on in the men's minds, tried again. "Well then, everyone in favour of ending the strike stay seated."

Nobody moved, and so the men went back to work.

Recently the mother of a friend of mine related another anecdote. The family lived down south, and until the mother struck up a conversation about my research on the Porcupine, I wasn't aware her family had any connection to the region at all. As I am wont to do, I pushed

I was in the tank corps and they sent us to Algeria. From there we invaded Sicily and fought our way up through Italy. That was a tough son of a bitch place to fight. After that we went to France. And then some of our division went as leaders into Holland. Ten thousand Canadians were killed in Holland. This is why [after coming home] I didn't give a damn about the job. I was a veteran and I wasn't afraid of anybody. I wanted my rights.

—logging camp organizer Johnny Leblanc

105

her for more details about her family's history in the area.

"I don't really know a great deal about the place," she explained. "We left there after my father was killed."

"Oh, did he die underground?"

"No," she said firmly. "He was killed."

Her father, she explained, was a "company" man. During the strikes of the early 1950s he refused to have anything to do with the union and willingly crossed the picket lines. After the strike ended her father set out on a hunting trip with his regular gang of hunting buddies. At the last minute each of the men phoned with various reasons as to why they were unable to make the trip. Her father, being Scandinavian and an experienced woodsman, decided to go hunting by himself. He was found a number of days later, his stomach blown open by a shotgun blast. With no witnesses to state otherwise, the death was ruled an accident.

"The neighbours pitched in and bought two sets of luggage," the woman explained, "one for my mother and one for me. They put the luggage on our front lawn and we got the message. We left the Porcupine and never went back again."

Intrigued, I asked her what her maiden name was so I could further research the case.

"Please," the woman said, "I've never told anybody this story and I really don't want to open any of those doors again."

Nicky Ursulak,
"beloved son"
1935—1944

■ ■ ■

Three Shots Fired in Strike War!
Picketers, Strike-breakers Clash
in Broulan Battle

—headline, *Daily Press*
(Timmins), July 24, 1953

The war ended. The good guys won. The young men and women returned (well, a lot of them did). The mines boomed with new hiring and the logging mills were once again going full out. The war swept the hunger from the backroad farm settlements and did away with the squatter camps. It was a new world. The bold, gaudy neon signs on busy Third Avenue in Timmins told the world that the Porcupine had come through the years of darkness better than ever.

To be sure, there were still the vestiges of the old ways. In the spring hundreds of loggers poured into the bars along the Mattagami River, eager to blow their winter's wages. The men went into the bush in the fall and came out with a fistful of dollars just before the muskeg thaw in the spring. Up at the St. Charles Hotel on Cedar Street, the prostitutes helped the boys unload their hard-earned money. It wasn't uncommon

to hear of a logger ploughing through his $1,200 earnings in two days. Then, sick and hung over, they would hang around the streets waiting for the next crew to go out.

But now, with the war over, the mills of the north—Feldman Timber, McChesney's, Mountjoy Timber, A.E. Wicks, Abitibi, Kimberly Clark, and Spruce Falls—were finding it hard to fill the ranks of winter logging crews. Men were no longer willing to put up with the isolation or the autocratic rule of contract bosses. Men who had fought through the hedgerows of Holland weren't content to live half the year in the bush sleeping on old hay and mouldy blankets.

One by one the bush-camp workers were signing up with the union, and a series of labour confrontations began to put pressure on the companies. The most dramatic of these labour confrontations ended in a bloody shootout at the Reesor Railway siding during the Spruce Falls strike of 1963. Three men were killed and eight more wounded in a gun battle between striking mill workers and settlers who were contracting with the company to sell pulp wood. But union pressure was only part of the changing dynamics. Bunkhouse life was disappearing, made redundant by diesel-powered bulldozers and chainsaws.

■ ■ ■

Big changes were coming in the mines as well, but for many they weren't coming fast enough. The war had exacted a terrible price from the gold mines. The mines had survived the war years by cutting back on development work, maintenance, and capital investments. As well, they had been forced to focus mining operations on the richest deposits, and the ones that were easiest to mine. By the end of the war the gold operators were faced with depleted reserves, stagnant gold prices, and ever-increasing costs. Prices for materials had risen throughout the war, but the price of gold was still pegged at the 1934 rate of $35 an ounce. Only the intervention of the federal government's gold subsidy kept the gold economy of Ontario from limping towards oblivion.

The situation was particularly telling at the Hollinger. For years the mine had reaped huge dividends from its spider's web of high-grade veins that weaved their way through the ground above the eight-hundred-foot level. Those veins were all but depleted, and despite extensive deep exploration work Hollinger was having difficulty adding to its ever-decreasing reserves. In an effort to inspire its workers, Hollinger

I remember when I was in grade 13, we lived in a small home and my bedroom was very small. I did not have a desk and a lamp in there so I would do my homework at the kitchen table...

The television would be turned off when I started and my parents would sit in the living room, not talking, maybe they would whisper to one another so as to not disturb me. These are the kind of sacrifices these people were willing to make to see that their children would succeed.

—Italian resident quoted in James DiGiacomo, "They Lived in the Moneta"

was putting its faith in a newly formed Industrial Relations Department. Buzzwords like "scientific management," "technical innovation," and the "Taylor principles" were bandied about by a young crop of desk-bound managers. Night courses and weekend seminars were offered. Mine staff were told to form study groups and to read books like *The Division of Work* by Luther Gulick and Lyndell Urwick or *The New Society* by Peter Drucker.

The other mine operators in the area deeply resented Hollinger's approach. The companies had always operated under the simple dictates of the "old school"—hardball managers with barracks-like discipline. Now they were facing a resurgence of union activity in the camp: eleven of the twelve main mines in the region had signed up with the Mine, Mill and Smelter Workers Union. By the end of the Second World War, Mine Mill had organized locals in Kirkland Lake, Sudbury, Timmins, Noranda, and Val-d'Or, Quebec. In the Porcupine, only Dome Mine remained unorganized (it didn't become unionized until 1968). As a result, many in the Porcupine Mine Managers Association believed that it was now crucial to close ranks and hold the line.

A great deal of dissension also existed within the Hollinger staff itself. Shift bosses and mine captains, men who had come up through the ranks by kicking butt on the mucking gangs, were now having to report to time-management consultants. New equipment—jackleg drills, slushers, and mucking machines—was replacing the old bull-work crews. Flexible three-man crews were taking over a multitude of mine functions (mucking, drilling, track-laying). The shift bosses were having to learn the give and take of working with these self-motivated and increasingly independent crews.

But the changes were not coming without conflict. Veteran drillers resented having to handle their own mucking work because it was seen as a step down in the hierarchy of job functions. Other miners mistrusted the ever-changing bonus incentives being set out to meet the increasing output of machine-based work. With the new machines, two shifts of three-man crews (two miners and a helper) were able to drill, blast, and muck anywhere from 325 to 425 feet of drift space a month. The old system was only able to average 180 feet per month. The older miners balked at having their work scrutinized by time-management consultants. As the new management program struggled to make gains, constant friction occurred in the mills and at the working face.

Hollinger's goals were laudable, and for the long-term feasibility of

the mine they were necessary. What Hollinger failed to take into account was that the workforce was demanding changes of its own. The men were tired of the benign autocracy of Hollinger management. They weren't mollified by the promises of the glossy new company publication, *The Hollinger Miner*. The men wanted collective bargaining and an increase in wages. They were not willing to wait until Hollinger's bright young boys with their bow ties figured out the pluses and minuses of new management.

For one thing, the living wage for a miner was not enough compensation for the risks taken on the job and the poor social conditions faced at home. In 1954 the Steelworkers in Timmins delivered a damning report to the Ontario Legislature on the health situation faced by miners' families in the city. "We submit that the housing situation in Timmins is a threat to the entire community and is a disgrace to the mining industry.... If they existed in a large city in southern Ontario they would be condemned as slums." The brief pointed out that the homes of many miners had to be seen to be believed. "It is incredible that people can live in them through the harsh northern winters... Many are no larger than a one or two-car garage, lack paint, are usually tar-papered, built without basements and often without water facilities." The average per capita income in Timmins was 30 per cent below what was considered a living wage at the time.

Still, even the dry political tone of the Steelworkers' brief to the Ontario government captured some of the strange ambiguities of life in the Porcupine. "If housing in Timmins is bad, the supply of beer outlets is excellent... We would like to point out two facts: 38 beer outlets in Timmins for a population of 38,000 people, gives it twice as many outlets in proportion to population as the Metropolitan area of Toronto." The brief suggested that one of the reasons that a region as poor as the Porcupine was home to such a well-developed nightlife was that "wherever housing conditions are poor, as they are in Timmins, the beer parlour is substituted for a decent living room in the home."

While this may have been true, the Porcupine, like other typical mining camps, was also still driven by the restless energy of young (and often single) working males. Never mind that they worked six days a week—there was always a desire for action. Most miners blew off this energy over a pitcher of draft at quitting time, but men looking for harder action were always able to oblige their tastes. Some simply headed across the Mattagami River to the new cocktail lounge set up there to make the

We went on strike so the miners went over to the [Broulan] Reef and blew the shaft up because there was a bunch of scabs there. Oh, there was a lot of fun going on here then.

— former Timmins miner

most of the fact that the township on the other side of the river was not under daylight saving time.

Others, looking for good gambling odds, simply headed over to the Porcupine Miners Club. Originally formed in the 1920s with the noble purpose of improving social life for the miners, the club was taken over in the 1950s by Hamilton mobster Johnny "Pops" Papalia. Johnny Pops had been brought into the Porcupine by mobsters Dante Gasbarinni and Tony Sylvestro. Sylvestro's connection to Timmins had come through his interest in high-grade gold.

The Papalia organization swore up and down that the Porcupine Miners Club was strictly a social organization that ran an honest gaming club. But other Papalia operations were notorious for the use of marked cards, or loaded dice in crap games. The Papalia mob felt at home in Timmins, with many of the region's best citizens coming out for a game of blackjack or five card stud. For two straight years the club operated without any heat from the cops. Eventually, though, the Papalia boys must have fleeced the wrong customer, because the club was closed down after a sudden police raid and the card sharks were run out of town. But by then Johnny Pops was onto bigger deals elsewhere. Later on he became a central figure in the "French Connection" heroin racket. Eventually, on May 31, 1997, he was gunned down on Hamilton's Railway Street.

■ ■ ■

The desire for a powerful industrial union was getting a sympathetic ear among the mine crews. But Hollinger management took the union drive by organizers of the Mine, Mill and Smelter Workers Union as a slap in the face. That Mine Mill was considered a radical, Communist-based union only made matters worse. The union had risen out of the ashes of the old Western Federation of Miners. Mine Mill made inroads across the North in the last years of the Second World War when the mines were desperately short of skilled workers and unwilling to provoke a reaction by applying the blacklist.

When the war ended, the gloves came off. In 1946 Noranda Mines forced the union into a strike that bled the Local dry. Noranda had always set the pace for labour relations (or labour conflict) in the Northern mining camps. The other mine owners seemed ready to follow the Noranda model for bankrupting Mine Mill before it could

become too entrenched. Mine Mill's leadership needed time to build a solid base of support, but time was not on their side.

All across North America the union was under attack from its bitter rival, the United Steelworkers of America. The Mine Mill-Steel war was carried out in every hardrock mining jurisdiction in North America. The struggle personified the Cold War pressure on organized labour to rid itself of its left-wing leadership. In the Porcupine, as elsewhere, the struggle played out as a nasty internecine battle fuelled by claims of Communist infiltration and counterclaims of CIA manipulation.

But the major issue dogging the fledgling Mine Mill locals in the various gold mines was whether or not they could deliver the goods. Any union taking on the gold companies needed to be able to wade through a long and expensive strike. Mine Mill had its respected labour organizers, but they were isolated from the larger union movement. Steel had the backing of the powerful Congress of Industrial Unions (C.I.O.) and boasted a war chest flush from the dues of millions of members across the United States.

As always in the Porcupine, the split in the ranks tended to fall along ethnic lines. The non-anglo ethnics, with a long-standing left-wing tradition, were strong supporters of Mine Mill. The francophone miners tended to throw their weight behind the Steelworkers. During the war years the underground demographics had become increasingly marked by the presence of francophone miners. The ethnic miners tended to resent this rising tide. They looked on the French as priest-ridden and politically naive. The French Canadian workers, for their part, had little time for what they looked upon as the squabbles of old-time Reds. A generation of tough, young francophone miners was looking for results, and they saw the Steelworkers as the only realistic hope for taking on the gold barons.

In 1948 local union leaders Ralph Carlin, Buck Beahie, and Ivan Vachon broke the Porcupine local away from the Mine Mill fold and passed it into the arms of Steel. The defection offered the Steelworkers its first and badly needed break in the North. But the Steelworkers had little time to gloat. Like Mine Mill before them, they now had the tiger by the tail. The union needed a victory in the Porcupine to show miners in the other camps, particularly Sudbury, that the C.I.O. could deliver victories that Mine Mill couldn't.

Going into this struggle Steel faced two major obstacles. One was the obstinacy of the gold companies, which were looking to discredit

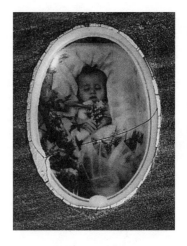

Kathryn Leblanc
Died age 7 months,
August 26, 1929

the union. As well, Steel was lacking badly needed support from many veteran union supporters within the mines. Mine Mill maintained its own shadow locals in each of the mines. Long-time union men still collected dues for the beaten rival and worked actively to unseat Steel.

In 1951 the Steelworkers went to battle against the mighty Hollinger. With just over 50 per cent of the workforce at the mine committed to Steel, taking on Hollinger was a big gamble. The strike was called over the issue of wages, but the union was primarily concerned with getting rid of the voluntary dues checkoff. As long as the union was forced to scrounge dues on payday from workers individually, it would never be an effective bargaining agent. Hollinger, with the backing of every mine in the North, was determined to prevent a clause on mandatory checkoff from being passed. After two months on the picket line, both sides called a truce. Hollinger conceded on the issue of wages and Steel accepted that it was not yet strong enough to take on the issue of checkoff.

In 1953 labour strife hit the Broulan Reef Mine, where old-school mine manager W.F. Brown was spoiling for a fight with his upstart union stewards. Whether or not Steel was ready for round two didn't

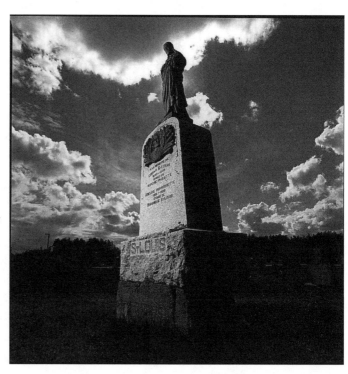

Grave of
Edgar St. Louis
(1893-1940) and
Adeline Morrisette
(1862-1938)
■ Timmins
Cemetery

matter. Angry union men, tired of being goaded by management, walked out of the Broulan Reef and set up a picket line outside the mine on an isolated road heading north from South Porcupine. The picket line effectively barred entrance to the nearby Hallnor Mine, bringing out those miners as well.

Once again, it was the supposedly "tame" Steelworkers leading the battle and forcing the supposedly militant Mine Mill members to recognize its rival's picket lines. In the forefront of the Broulan action were a number of young francophone miners. Peter Vasiliadis, in his study on ethnic conflict in the Porcupine, points out that the more experienced English Canadian miners were against the strike because they thought that given depressed gold prices and depleted gold reserves the action was bound to fail. Steel, however, believed that it had a strong chance against the Broulan Reef because the mine was small and completely dependent on underground water pumps to keep the shafts from flooding. If the union could shut down the Broulan, the company would be forced to negotiate.

The men went out at the Broulan and Hallnor on July 11 and over the next few months the strike spread to all of the area's unionized mines. By early fall over five thousand men were picketing at the gates of eleven local mines (Dome, the only non-union mine, continued production).

The main action centred on the Broulan Reef. In mid-July the company brought in twenty-five strikebreakers, vowing to house them on the property until the strike ended. Within days the mine was overrun by an invasion of fifty union men who attacked the strikebreakers in the company dry. Many heads were busted. The company responded by arming its guards with guns. Mine manager Brown gave his security guards the order to "wing" any picketers who came near the gates. Shots were fired. The union men started bringing their own guns to the picket lines. The house of a shift boss was blown up and an attempt was made to destroy the Broulan shaft.

Seeing that an all-out shooting war was afoot, the Ontario Provincial Police sent in reinforcements. They disarmed the mine guards and made a number of arrests on the picket lines. At the end of November the miners were back at work, having won minor increases.

The Broulan strike was a milestone in many ways. It showed that radicalism, which had always centred on ethnic and communist/progressive politics, was no longer at the helm in the Porcupine. The fran-

cophones were in the ascendancy. To be sure, immigrant waves of "DPs" (displaced persons) from Eastern Europe continued to flock to the Porcupine throughout the 1950s, but this resulted in a very different kind of ethnic presence. The older ethnic workers were, by and large, left-wing in their outlook. They had settled in the mining camps because few other opportunities were offered in Canada. The new DPs came from Soviet-occupied Eastern Europe. Many of them were bitterly anti-communist in belief. They came to the mines looking to make enough money to move on to easier work in the factories of the South.

The DPs were often at odds with the established ethnic communities. They arrived in the region after a nearly fifteen-year freeze of immigration. In Schumacher, the arrival of many new Croatians—veterans of either side of the very brutal Yugoslavian phase of the Second World War—created tension in the normally tight-knit neighbourhoods. The accusation of being a "Titoist" (communist) or "Ustasha" (fascist) had deep resonance in families with ties back to a bloodstained land. But the postwar generations had little time for these old-country battles. The children and grandchildren of Slavic and Italian immigrants were more interested in driving their girlfriends up the hill at the north end of town to request the latest rock 'n' roll hits on the weekend teen radio special "Hilltop Rendezvous." Long lines of Chevys waited while radio host "Tex" Lefebvre stood outside CFCL radio and television station taking the requests from the fans of C&W, rock 'n' roll, and French hit parades.

The rise of the Hilltop Rendezvous coincided with the steady decline of the dance-hall tradition in Timmins. Conrad Lavigne, owner of the Pav and CFCL radio, inadvertently hastened the demise of the historic dance hall when he brought the first television station to the region. The Saturday night tradition of dancing was replaced by a new tradition—watching hockey broadcasts from the Forum in Montreal or Maple Leaf Gardens in Toronto.

When the Pav shut its doors for the last time in 1962, many people believed that it was television that had killed the great dance hall. Few in the younger generation even noticed. The local dance-band heroes had been replaced by the hit parade heroes of the Hilltop Rendezvous. These teens were a different breed than the young folk growing up in the pre-war years. Their parents didn't want them carrying the "badge of ignorance" (the miner's trusty silver lunch pail). For the first time it was possible for the children of working-class parents to get a university education.

As the young folk went off to universities and jobs in the South, the ethnic makeup of Timmins began to change. By the mid-1960s, immigration had tapered off as "New Canadians" flocked mainly to the urban centres in the south. To be sure, there were new families coming into the region, but they tended to be either from other parts of the North or from the mining regions of Quebec. Timmins, which had always had a large francophone population, became increasingly a community defined by its French and English (including anglicized descendants of other nationalities) character.

Throughout the 1950s and 1960s a slow but steady bleeding off of families of Slavic descent occurred. Many of them went to the Ontario car plants of Windsor or Oshawa or the mills of Hamilton. Throughout the fruit belt south of Toronto today, families with Croatian and Ukrainian names trace their roots not to the old country, but to the narrow streets of Schumacher.

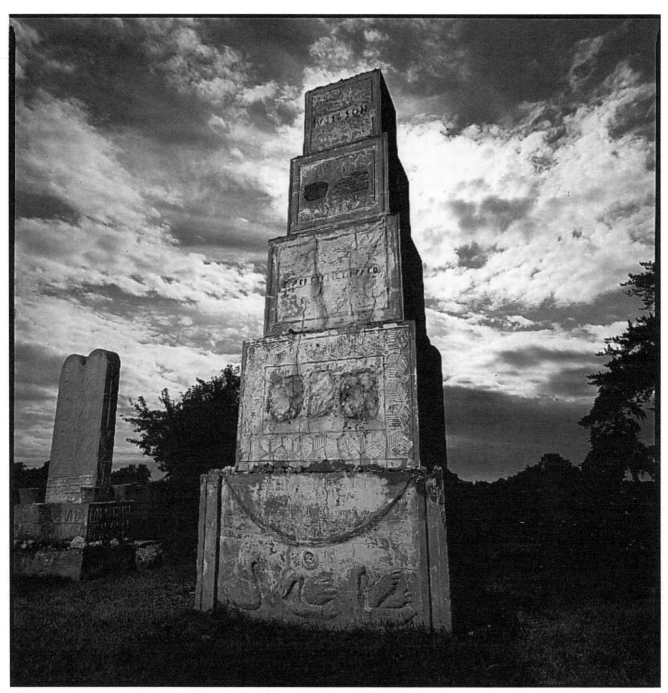

Wilson grave ■ Timmins Cemetery

16 The Birth of the New Dragon

I HAVE JUST A FEW MEMORIES of the early 1960s—watching Razzle Dazzle with my sister, sitting on our grandmother's beaten-up old chesterfield; sitting in my mother's kitchen on a gloriously bright spring morning while Gale Garnett sings "We'll Sing in the Sunshine" on the radio. And I remember the parties in the rec room of our brand-spanking-new split-level house on Spruce Street.

The year must be 1966 and I'm a four-year-old picking through the morning-after debris in the rec room with my faithful toy monkey Ringo and my dirty old purple blanket. The coffee table and bar are littered with empty bottles. A polished-off Texas mickey of rye sits in the corner, propped against the panelling. A bloated piece of lime floats in a half-empty glass of flat coke and rum. The room is filled with the strong smell of stale cigar smoke.

Perhaps like most people, I look upon these memories as valuable pieces of brain-recorded tape. Every now and then I play them over in my mind just to make sure they haven't been lost. But as I get older I have come to accept that the memories of childhood are not like faithful recordings. Rather they are constructions. The faces of the folks at the party—Johnny Evans, Frank Smolarchyk, Ken Darke—have probably been enhanced through the aid of family photographs and stories. I see them mixing highballs at the bar with my old man, like a branch plant of Sinatra's Rat Pack in their black pants, white shirts, and fancy ties. And the women—all cat-eyed glasses and beehive hairdos.

The historian in me has cross-examined these memories many times and has begun to doubt the veracity of the youngster. Surely, somewhere along the way, cultural distortion has crept in. Other influences, like movies, TV shows, and family lore, have probably made these memories more colourful than they would otherwise have been.

But I am very sure about my memories of Ken Darke. Ken was the one who smoked cigars. He had a Playboy calender in his office and a narwhal tusk on the wall (all very impressive for a young lad). Ken was the first adult who ever asked me my opinion as if it mattered.

I have vivid memories of when Ken's son, eleven-year-old David, died—run over by a truck near the Aunor Mine on the Porcupine backroad. David was killed on a humid summer afternoon. I was outside playing Green Berets with my friends when the news hit our house. As

The biggest ore strike since gold was discovered more than 60 years ago in Canada has stampeded speculators to the snowbound old mining city of Timmins, Ontario... The richness of the copper is so great that samples were reportedly flown out of the country to be assayed.

—New York Herald Tribune, April 11, 1964

the family gathered indoors to deal with the news, I stayed outside running with the neighbourhood gang until darkness came, bringing with it a powerful and violent summer storm. As the rain pelted the windows and the thunder broke I stood in the living room feeling the heavy weight of a dark emotional storm I only barely understood. Every summer since, when a heat wave ends in a powerful storm, I find myself thinking of that night.

The smell of cigar smoke, though, brings with it positive memories. It makes me think of the parties. As a boy I never thought much about the reasons for the parties, or about how we had just made the monumental move from sharing my grandmother's cramped little miner's house in the old quarter of town to a brand new split-level house in a newer part of town. The house came with new furniture, sparkling new appliances, and a fresh-off-the-lot 1966 Pontiac Delta 88.

Ken Darke was the reason for all this change. Having sunk one single drill hole in the muskeg of Kidd Township, he turned the history of the Porcupine upside down. His drill hole made fortunes for some and brought ruin to others.

■ ■ ■

When Ken Darke arrived in Timmins in 1959, the community was in need of a spectacular roll of the dice. It had been twenty years since the last wave of mining discoveries, and the clock was running out on many of the local gold mines. Between 1956 and 1968, eight of the twelve gold mining operations in the region shut down permanently. The big mining companies had written the Porcupine off as a spent force. Families were moving out and the area's biggest employer, Hollinger, was getting set to break the news that its large mine was facing closure. Unless someone came up with a big discovery, the Porcupine was facing a long, slow death.

Ken Darke wasn't interested in discovering another gold mine. The twenty-six-year-old geologist from Trail, B.C., was banking on the possibility that the region could be home to a profitable base-metal operation. Ken arrived in the Porcupine as the front man for a small exploration division of Texas Gulf Sulphur Company. Along with Ed Holyk, vice-president of exploration (based in New York) and geophysicist Hugh Clayton, Darke was in the Porcupine looking to map a series of magnetic anomalies.

Each of the three Timmins brokerage houses had large rooms with ticker tape, girls marking the blackboards, plus 50 or more chairs for customers and hanger-ons. The brokerage houses were jammed from early morning until long after the tapes were stilled. Radio station CKGB had announcer Dan Kelly broadcasting live from one office, just as if the stock market was a baseball game.

—Gregory Reynolds, "Some Rush," *HighGrader Magazine,* Christmas 1996

One of the most interesting targets identified during their helicopter flyovers was a magnetic anomaly in Kidd Township. Rights to the land, however, were tied up by three different landowners and the property seemed off limits. Unable to sit and wait, the team moved on to other exploration projects in Alaska, south Texas, and the Hualapai Mountains of Arizona. Over the next few years Ken mapped out a soda-ash mine in Wyoming and worked on the property that was eventually to become Nanisivik Mines on Baffin Island.

On one flight to the Arctic the plane crashed and Ken was trapped in the wreckage with a broken back. Ken never gave the accident a second thought. As soon as he could walk again, he was back in the field. In 1962 he returned to Timmins to conduct more magnetic flyovers of Kidd Township. The aerial readings indicated that something very interesting might lie beneath this otherwise unimpressive piece of moose pasture.

By mid-1963 Darke had finished with his work in Baffin Island and was itching to get down to exploration of the Kidd property. But by that time Texas Gulf Sulphur had cold feet. Texas Gulf was a conservative company and its board of directors was balking at the cost of this new and aggressive exploration policy. Holyk informed Ken that the company was going to close its Toronto office and was cutting off all Canadian exploration except for the work being done on Baffin Island. No expenditures above $5,000 could be taken without specific company authorization.

Ken argued with Holyk about need to take a shot at the Kidd anomaly. Holyk pointed out that with the loss of budget, a drilling program wasn't possible. Ken then offered to carry out the project on his own time—cashing in on vacation time that the company owed him. Ken would hire the crew himself, and to avoid alerting head office Holyk could slip him money left over from the Baffin Island project.

It was a hard sell. Texas Gulf had two good reasons to give up on the Kidd property. First, mining giant Inco had already taken a look at the anomaly and written it off as worthless, and, second, the company had not secured the property rights from the various landholders. Ken was insistent and Holyk finally gave him the green light. It was clear, however, that there wasn't the time or money for anything more than a cursory look.

The other major problem Ken had to overcome was undertaking a drill program that wouldn't trigger speculation and imitation stakers. Timmins moved and jumped to the rumour mills of mineral exploration.

The discovery of the mine that became known as Kidd Creek... aroused the imaginations and suspicions and frequently the greed of tens of thousands of people. Ultimately, it resulted in the shareholders of one company making one billion dollars in capital gains; it allowed dozens of hot-shot unethical promoters to make millions of dollars selling worthless stock; it caused thousands of gullible market gamblers to lose their shirts.

—Morton Shulman,
The Billion Dollar Windfall

At the centre of the action was the local penny-stock market centred in the town's three brokerage offices. My father worked at one of them. It seemed as though everybody played the penny stocks. It was the lottery, the favoured big game of chance played by widows, working men, and the wealthy. The penny-stock mills ran on rumours. Any new drilling program that attracted attention was bound to result in numerous competitive drill operations trying to cash in on the excitement.

To avoid a rush on the Kidd region, Ken brought in a Quebec-based drilling company and forbade any of the men from leaving the camp for any reason. The first test drill (known as Kidd 55-1) came on Friday, November 9, 1963. Mining companies often have to drill fifty or a hundred holes before being convinced they have a mineable ore body. Ken hit the motherlode with a single hole. René Gervais, the drill foreman, could see the glimmer of metals as the core was being pulled from the ground. Gervais, who had drilled the rich Quemont copper body for Noranda twenty years earlier, knew right away that he was standing on top of a geological marvel. The 655-foot drill-run cut through high-grade values of copper, zinc, and silver all the way. A mining company considered it impressive if over six hundred feet of drilling it hit twenty feet of ore averaging grades of 2 to 3 per cent copper. The first Kidd drill core contained over six hundred feet of solid ore. In one 120-foot section, the grade was a spectacular 18 to 20 per cent copper and 20 to 30 per cent zinc.

With this single test hole completed, Ken Darke quickly moved to cover his tracks. A helicopter from McIntyre Mine had already flown over while the drilling was being carried out. It was followed by an Inco exploration plane. Ken was worried about being seen a second time at the Kidd 55-1 target, so he moved the entire crew to the opposite end of the township. He had them set up camp in exactly the same order as the first drill camp so that a pilot taking a second flight over might mistake it for the original location. Ken had the original site carefully cleaned up and all tractor marks hidden by branches.

Within days the top executives from Texas Gulf had flown in from New York. The drill core was shipped to Salt Lake City, Utah, to be assayed. On the basis of this single drill core, there was certainly no way to accurately guess how big the ore body was or wasn't, but Texas Gulf knew the potential was extraordinary. Its executives knew that if word got out about the find, they could come up the losers in a free-for-all staking frenzy.

The company had to move quickly but quietly. On the legal front it needed to secure title to the property. The only problem was that, having already drilled on the site, the company was aware of the potential value of the property, whereas the property owners were not. (That problem later led to a major court battle between the property owners and Texas Gulf.) The company would have to carry out an intensive staking program to secure the property and all potentially useful land without alerting the local prospecting community.

In a town that lived on mining rumours, this was not an easy task. At one point, Ken was stopped on the street by a local stock salesman who seemed to know the exact grades of silver in the core. It was information that no one on the local level could have any access to—unless, of course, they had an aunt working in the telephone exchange who made a point of listening in to all calls being placed by prospectors and geologists to head office. To prevent other confidential news from leaking out via nosy phone operators, Ken started sending all new information to head office by mail. He then set up a secretive staking program to secure the ground for Texas Gulf. At the same time he began to carry out an even more secretive staking program for himself and two other partners—real estate agent Neddo Bragagnola and my father, John.

■ ■ ■

In the years following the Kidd Creek discovery, Ken Darke's decision to double-deal on his superiors cast a shadow over his impressive discovery—a discovery that would keep the town of Timmins alive until well into the next century.

Ken was well aware of this shadow and tried always to limit its spread. Ken's version of the story, told just before his death, follows the version given in Morton Shulman's book *The Billion Dollar Windfall*, in which hot-shot young Neddo Bragagnola got wind of the staking operation and threatened Darke with the prospect of a competitive staking rush unless Darke cut him in on the deal.

Bragagnola was the son of an Italian miner who had died of silicosis. Shulman painted him as a man with his ear to the ground for any rumour of mineral potential. It was this ear to the ground that supposedly brought him in contact with Ken's attempt to secretly secure all the ground in the Kidd Township area before news leaked out about the drill results.

According to Ken, Neddo was onto the staking program. After meeting with Neddo in my father's office at the stock exchange, Ken decided to limit the possible damage Neddo might do as a competitor by offering to go into a silent partnership with him. The three men pooled resources and Darke provided the information on where to stake. It was land that didn't interfere with Texas Gulf's operation, but it positioned them to cash in on the claim-buying frenzy that was sure to hit once the drill results were made public.

My father says the idea for a parallel staking program came from Ken himself. John Angus had been friends with Ken Darke since Ken first arrived in town. It was my father's job, as the disseminator of good deals and long shots at one of the local brokerage offices, to know the various players in the exploration game. Ken Darke, for his part, was a big fan of penny-stock gambling.

On Monday, November 12, 1963, just after Kidd 55-1 was drilled, Ken walked into my Dad's office at T.A. Richardson's, in the heart of Timmins's small but busy financial district, and casually pointed over to the calender. "Mark this day down in your calender, John, it's going down in history." John Angus had heard a lot of big boasts since first joining the brokerage business at age seventeen. Back then, with no prospects for a university education, he had jumped at the chance of going to work in mining stocks when a high-school teacher had proposed the opportunity to him in the school hallway. By the time he was twenty-five he was branch manager. And now, after nineteen years of hearing wild promises and being told about "sure things," he was looking at the prospect of a major discovery.

Ken knew that the impressive grades from the Kidd drill core would unleash a staking bonanza. In the mining game, all too often the big returns aren't made by the mines, but by the speculators who flip every available piece of property in the vicinity.

Ken took my father aside and said, "Let's make some money." John Angus suggested bringing in Neddo Bragagnola (whom Darke didn't know at the time) because neither Darke, as a geologist, nor Angus, as an employee of the stock exchange, was in a position to sell the claims. Neddo was an aggressive young salesman who could make them all a lot of money.

Texas Gulf executives didn't know about Ken's side deal, but then many of them were busy making their own. For five months the company kept the results of Kidd 55-1 secret while the company secured

rights to the land. All the while, executives and their family members were buying up as much stock as possible in anticipation of the major boost the stock would take once the results were announced. Their activities led to the intervention of the U.S. courts and questions about the strength of insider-trading laws in North America.

■ ■ ■

By the beginning of April 1964, rumours were flying that something very big had been discovered in the Porcupine. New York newspapers were openly speculating about a major nickel or copper discovery outside of Timmins. Around the beer parlours of the Porcupine the air was abuzz with rumours and speculation. The talk was in the air at the Maple Leaf Hotel one afternoon when a dirt-poor Maritimer came in looking for a bottle of beer. The only problem was, he was five cents short on a forty cent bottle. The bartender, Gaeten Lepine, eyed the stranger up and down—a skinny vagrant holding a beat-up guitar case.

"Do you sing with that thing," asked Gaeten, "or do you just use it to carry your clothes?"

The stranger said he knew a few songs.

How many?

Twenty-three hundred, all off by heart.

"Well," said Gaeten, "sing me a few songs and I'll cover the nickel."

The stranger got up on the stage and sang two songs—"Pick Me up on Your Way Down" and the Hank Snow classic "I've Been Everywhere."

The vagrant certainly had been everywhere. Tom Connors had been on the road since being nabbed by the Children's Aid with his teenage mom when he was a toddler. Tossed in various orphanages and foster homes, he managed to run away as a young teen to work on the coal boats. After that he criss-crossed the country doing odd jobs, picking up country and western songs along the way.

Tom sang so well for his five cent audition that the bartender went and called the owner, Pete Kotze. Over a few more beers and a few more songs, Kotze offered Connors a room in the hotel upstairs. If the crowd liked him on Friday night, Kotze would keep him on for another week. That week stretched into fourteen straight months of gigs running six nights a week. In that period, the Maple Leaf Hotel was renovated three times to make room for the crowds that were coming out in droves to hear Connors.

Tom Connors was a one-man band—using his cowboy boot to stomp a heavy backbeat on a wooden board at his feet. "Stompin' Tom" Connors was also taken by the lore and culture he picked up in the Porcupine nightlife. The crowds coming into the bar heard more than Hank Williams and Ferlin Husky tunes. They heard songs about lumberjacks, pretty Northern mill daughters, and Hollinger miners blowing up card cheats.

When the McIntyre Mine was hit by a devastating underground fire in 1965, Tom put the struggle to music. Local radio station CKGB was quick to pick up on the Tom Connors phenomenon. They recorded the song as a single, and in 1965 Tom Connors outsold the Beatles in the Porcupine at a rate of twenty to one. All for a song about miners fighting a deadly underground inferno.

■ ■ ■

But the deadly gas kept rising
in the McIntyre high
'Til it seeped through the walls
and the fire doors
of the Hollinger Mine nearby
For nearly a thousand miners
there was no work below
And the word came from the office,
"Boys we'll have to let you go,
there's a fire way down in the mine."

© 1965 Crown Vetch Music

As word began to spread about a rich copper find out in Kidd Township, Tom Connors got together with local Member of Parliament Murdo Martin and over a number of drinks wrote the anthem "The New Dragon Mine." The song was another hit single. By 1966 Stompin' Tom Connors was ready to take on the rest of Canada. Although much of his first album was about life in the northland, he took the lessons from the Porcupine—to write songs about local people and issues—and began writing songs about all of rural Canada.

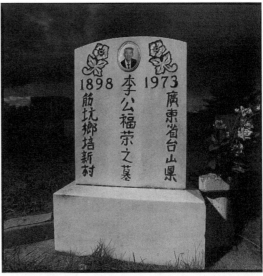

Grave of Li Gongfu, born in Peixin Village, Guangdong Province ■ Timmins Cemetery

■ ■ ■

Soon enough, the rumours of the "New Dragon"—the find was originally named for the Chinese year of the Dragon—began to turn the North American markets upside down. Then, on April 26, 1964, company officials released the official news that an ore body containing at least twenty-five million tons of copper/zinc ore had been discovered. This announcement touched off the biggest flurry of stock-trading in the history of the Toronto Stock Exchange. Within days the hotels of Timmins were filled to overflowing as more than five thousand prospectors and stock hustlers moved in to share in the wealth.

In no time at all more than one hundred companies were selling claims and shares in properties, most of them not even remotely connected to Kidd Creek Township. Inco, which had already dismissed the original Kidd anomaly as worthless, was back on the scene looking to make up for the lost bonanza. One penny-stock company sold Inco the drilling rights to a property that was later revealed as the site of the Timmins airport. When told that there was no way they could drill the airport, Inco unsuccessfully appealed to the Ontario Department of Mines.

The rush was more than a mining rush, it was a media rush. U.S. and Canadian newsmen flocked north looking to peddle stories of the land of opportunity and long-shot heroes, and Neddo Bragagnola was touted as the boy wonder of the great copper rush. The media wrote about Neddo's seeming sixth sense for mineral discoveries, about how he had taken a $7,000 investment in land near the site and turned it into a possible $2,000,000. What the media didn't know was that Bragagnola's sixth sense came from having an inside partner.

Bragagnola was just one of many colourful promoters who took to the media in the Porcupine. Penny-stock king John Doyle flew in on a private jet, as did Earle Glick. They set up hospitality suites at local hotels and carried on for the benefit of journalists. Murray "the Pez" Pezim (who later made his name in the 1981 Hemlo rush) was also on the lookout for a big play. Lyle Smith used the rush to push Genex Mine, a dead-dog property west of Timmins, into the hottest stock in Canada. Indeed, journalist Gregory Reynolds points out that during the government inquiry into stock manipulation tied to the Kidd Creek rush, Smith showed up during a break in the hearings and sold Genex to four witnesses.

But none of the promoters or hucksters could hold a candle to Viola MacMillan, the Queen Bee of Canadian mining. Viola MacMillan, the flamboyant head of the Ontario Prospectors Association, was in Timmins within days of the Texas Gulf announcement. Viola quickly took the limelight away from everyone, including Texas Gulf, when she dropped the bombshell announcement that her company, Windfall Oils, was in possession of four claims in Prosser Township that Texas Gulf had failed to properly stake. Not only that, she maintained that the claims contained a major magnetic anomaly. It seems a young lumber contractor, Don McKinnon, who had been paying close attention to Texas Gulf's secret staking campaign, had quickly snapped up the claims along with his partners Fred Rousseau and John Larche. (Larche and McKinnon later made mining history with the discovery of the massive Hemlo gold deposit near Marathon, Ontario.)

Viola had purchased the Prosser claims and Windfall stock suddenly shot up as penny-stock players turned their attention to that company. Ken Darke, who had written off the anomaly as worthless, decided to make some easy money by selling Windfall stock short. Drilling was carried out at the site over the first four days of July 1964. If the core hit copper or zinc it would have been apparent to even an untrained geologist. Viola's husband George, however, quickly hurried the core off site without allowing anyone to see it. When pressed about what he found, the tight-lipped MacMillan said that more tests were needed.

Word was soon spreading through the mouths of reputable mining people that Windfall had encountered impressive metal grades. In fact, the word going around Toronto's Bay Street was that the drill core was identical to the Texas Gulf drill core. Stock prices continued to climb, and Ken Darke was now sitting on 45,000 shares that he was selling short in anticipation that the MacMillans would be coming clean with negative drill results.

Over the next week the MacMillans refused to say what they had found. Speculation continued to flourish. When word hit the Timmins brokerage offices that the respected Bradley brothers (owners of a drilling company in Rouyn-Noranda, Quebec) had inside information that Windfall had indeed hit a major ore zone, even the sceptics jumped on board. In a single day Ken Darke threw caution to the wind and began buying back Windfall stock. And while Ken was struggling to get on board the good ship Windfall, Viola MacMillan was working to sell off as many shares as she could. Within a month the stock had jumped from $.68 a share to $5.65.

The Windfall saga became the main international story of the rush. Most of the Timmins betting money bypassed the sure thing (Texas Gulf) and gambled heavily on the long-shot juniors, most notably Windfall. But as the days went on and no drill results were posted, the Toronto Stock Exchange came under increasing pressure from investors and regulators to force MacMillan to make public the results of the drilling. A meeting was held with Viola and representatives of the Toronto Stock Exchange and the Ontario Securities Commission. Despite the threat that Windfall stock would be suspended from trading, Viola stood her ground. "This is like a wildfire," she told them. "Releasing information would create a holocaust."

Even the august regulators of the Toronto Stock Exchange had fallen under the snake-charming spells of the Queen Bee. After his meeting with MacMillan, John Campbell, director of the Ontario Securities Commission, ended up buying Windfall shares. His wife Bunty was also buying up Windfall based on MacMillan's direct advice. After nearly a month of suspense the bubble burst with the announcement that Windfall had drilled hundreds of feet of worthless graphite.

Grace Hounslow
Died age 4, 1930

Stocks plummeted and many people lost their savings. The fallout of the Windfall disaster was not unlike the fallout after the Bre-X scandal hit the news in 1997. Stung investors demanded a major investigation. The government brought in a special commission (the Kelly Commission) to examine the laws and practices surrounding penny-stock speculation. The result was that the once colourful Toronto Stock Exchange was purged of its penny-stock operators (they moved to Vancouver). Viola, the Queen Bee, eventually went to jail for wash-trading. In the United States, the FBI targeted the inside trading practices of the Texas Gulf executives.

Ken Darke, who made a fortune and lost a good part of it to Windfall, then joined his partner Neddo in a new venture going after a major copper discovery in New Guinea. The property was a bust and the two partners had a falling out over the lost money. The situation worsened when the tax man came after the partners for money they thought was protected under capital gains allowances.

By that time my father had got out of the penny-stock game. He took his share of the money and invested it in a university education. He was forty when he went back to school. Our family continued to live in Timmins for a few years while he shuttled back and forth between university, teachers' college, and graduate school. Eventually he took a job in Toronto and we moved south to be with him.

When I moved back north in 1990 my father gave me one piece of advice. "Don't play the penny stocks," he said. "You know enough about mining to get into trouble and not enough to make any money."

■ ■ ■

I interviewed Ken Darke in 1998. He was living in the house my parents had built with their Kidd Creek earnings. The man who had given the Porcupine a second lease on life had fallen on hard times, both physically and financially. He was dying from cancer. The only mention he made of his illness was to complain that his eyes had been affected and he couldn't read the new geophysical data coming out from the Shining Tree area west of Timmins. Ken believed that another Kidd Creek could be found in the region. He clearly wanted to be part of the hunt, but it was not to be.

Our visit was cut short by the arrival of a home-care nurse. When I was on my way out the door, Ken's wife stopped me and showed me the rec room. It seemed so small, so modest. It was hard to believe that this was the room where all dreams seemed possible when Ken's crowd was young and the riches were there for the taking. Ken died a year later.

Ken may have died broke but his Texas Gulf discovery transformed Timmins. When the mine opened in 1966 it quickly set a new standard for wages and mining practices in the region. The Kidd Creek ore body, originally estimated at 25 million tonnes, blossomed at depth into a known 147 million tonnes (with the deposit's bottom still not found). The ore, containing elements of copper, zinc, palladium, cadmium, and silver, was recognized as one of the greatest underground mining deposits in the world. The high-paying jobs at Kidd Creek Mine were augmented by the building of a massive refinery and smelter, which would eventually take stock from mines around the world.

The ascendancy of Kidd Creek helped offset the slow but steady decline of gold production in the region. Although the region has maintained a generally healthy exploration industry, it has only two operating gold mines (Dome and Hoyle Pond) remaining—which means that the community is even more reliant on the decreasing ore reserves at Kidd Creek. With the decline in underground production has come a typical struggle to transform the community's base into a service economy. Some thirty years ago, it was a given that any boy who quit school could get a job in the mines. Today's youth will more than likely have to settle for low-paying service-sector jobs.

Gone forever are the parochial limitations of the one-industry town, but gone along with that too may be some of the very factors that helped define the textured identity of the Porcupine. Culture in the region was always influenced by the four distinct variables of work (mining and logging), ethnicity, landscape, and isolation. Clearly, in the thirty-some years since Kidd Creek opened, many of these variables have been altered or lost. Until the early 1970s, for instance, the community was relatively isolated, with just one English-language television station and only two English-language radio stations. Today the community is plugged into the same multi-channel universe and World Wide Web shared by the rest of the world.

The changing pattern of demographics in Canada has also had a major effect. The community, like other Northern regions, has ceased to be a destination for immigrants, who have turned away from the frontiers. Incoming populations now tend to congregate in a few large urban centres. The influences exerted by a continual influx of young (and socially hungry) families were a strong part of what made the Porcupine an exciting "frontier." Today's population pattern tends to be a matter of emigration. Young and working families are more likely to move out of the region than into it.

Despite these changes, the community retains a fascinating local identity—even though, like other regional-based cultures, the Porcupine can no longer take the vitality of this identity for granted. The struggle in the coming century will be to find ways of maintaining the characteristics of the multi-ethnic frontier community in the face of an increasingly homogeneous and interconnected consumer culture. But even now a more basic struggle is going on: the need to find another Kidd Creek for a community that is still largely dependent on the wealth of underground resources. If another Kidd Creek is not found, an even more fundamental issue will revolve around the viability of the Northern community itself.

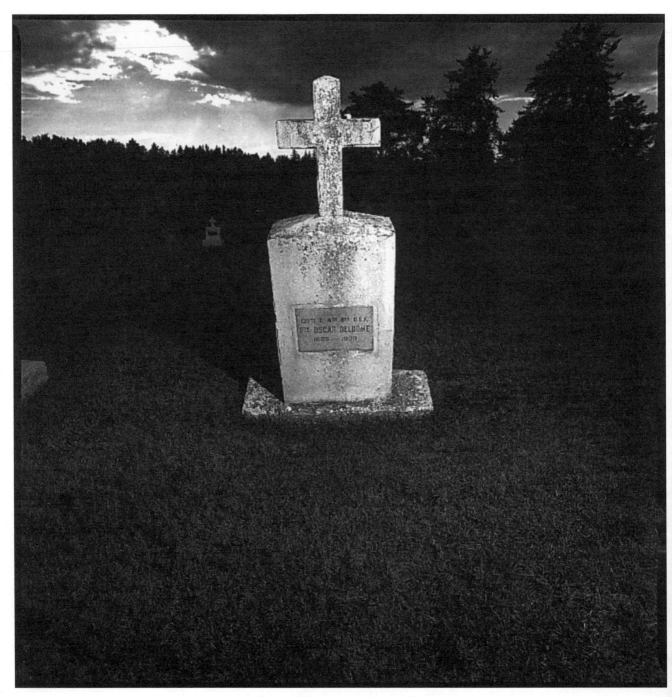

Grave of Oscar Delorme ■ Timmins Cemetery

Conclusion

THIS BOOK ENDS WHERE IT BEGINS—in the graveyard. I've made the trip to Timmins to check a few outstanding details for the book. On the drive out to the cemetery I tell myself that I will only stay for a few minutes—gather up the final strands and move on to other business. But this is the story I've been telling myself for years—as if I could somehow take the faces and neatly consign them to a box labelled "finished business."

Having checked the necessary spellings and dates, I take the time to "visit" among the rows. It's a ritual in which I've taken part every year since I can remember.

At the grave of Emilio Mion someone has placed fresh lilacs. The twenty-seven-year-old mucker was blown up in the Vipond Mine in 1929. If he had a wife, she would be nearly one hundred years old; any children would have to be at least seventy. And yet after all this time, someone still cherishes the memory of young Emilio.

Further along, I notice a bouquet at the graves of Frank and Mary Hrovat. This handsome young Croatian couple died within a week of each other in 1937. Their gravestone portrait has always fascinated me, so much so that last year I looked up their obituary on microfiche at the local library. According to a small write-up in a March 1937 issue of the *Daily Press*, I learn that thirty-five-year-old Frank had been consigned to the sanatorium in Gravenhurst. His lungs were shot and he was no longer able to work. Thirty-three-year old Mary was left at home with a five-year-old son. When she died of a sudden illness, the shock of her death and the separation from the young son was too much for poor Frank. He died within days.

Whatever became of the boy was not stated. I've looked up the name Hrovat in a number of community phone books in Northeastern Ontario but have not found it. Still, sixty years on, someone takes the time to make the trip north and plant flowers at their graves.

Mesmerized by the sight of these fragile offerings I am struck by the value that the immigrant culture places on remembering. Memory is not merely a private collage of experiences, it is part of a larger social whole—a sense of shared obligation and comfort. The rituals of death—the vigil, the eulogy, the gathering of a community in the fields of the dead—provide a public way of reminding people that nobody dies forgotten. The old-style cemetery with its individual markers and gravestone portraits offers families a tangible way of showing that the bonds

But you don't think you're making history when you're living day by day. It's just very uninteresting things happening all the time.

—Agnes King, Porcupine pioneer

131

of life have not been broken by death.

This notion of memory as both a public responsibility and a private source of comfort seems very much at odds with present-day materialist culture. History has lost its power to haunt, challenge, or inspire. It has been reduced to a pastiche of out-of-date fashions and supposedly narrow-minded beliefs. Popular movies and songs present us with heroes committed to breaking free of the obligations of these outmoded convictions. This "breaking free" mirrors the breaking down of regional, linguistic, and social identities by the forces of global consumer culture.

Neil Postman, in *Amusing Ourselves to Death*, points out that what is being lost is the whole notion of a common memory. "We do not refuse to remember," Postman says. "Neither do we find it useless to remember. Rather, we are being rendered unfit to remember. For if remembering is to be something more than nostalgia, it requires a contextual basis—a theory, a vision, a metaphor—something within which facts can be organized and patterns discerned."

The loss of a common story tradition or public memory has enormous implications for the social and political health of society. What I have learned from the mirrors of stone is that memory, like death, only makes sense if it is held in common. The deep roots of the story-telling tradition of a region (or nation) help to provide a context. They give us the tools that we can use to imagine alternative futures.

We now live with a material affluence that would have been unimaginable to the Hrovats or Mions. But each of us must learn, as they did, that the distance between the first date and the second date on a tombstone is not at all very long. If we let the web of long-term relationships diminish in an increasingly busy world, death and the movement of time will remain a frightening thing, a reminder of our fundamental "aloneness."

Seen in this light, the seemingly heartbreaking sentiment of the old stone markers—"Never was a father more loved," "Someday we'll understand," "We will meet again"—speaks to a belief in the future that is beyond the scope of a consumer-driven culture. How many of us can dare hope that seventy years after our death someone will take the time to bring flowers to our stones or tell a young generation what our lives meant?

Already the elders are passing over to the other side and the young ones are struggling to take our place. But as long as there is memory, as long as the stories are told, this movement can be a marvellous thing to behold.

Emilio Mion
Killed in the Vipond Mine, 1929

Notes

Part I: The Road to Emmaus

The story of Don Pecore meeting the missionary priest comes from the interview with Jack Pecore (see List of Interviews).

1. Relics of the Pioneers

Details on the early settlement of the Porcupine come from interviews with Eva Derosa, John Campsall, Jack Andrews, Ben Beauchamp, the Davis sisters (Neva Lane, Mrs. Hilda Arnold), and the Russell sisters (Mrs. Calvary, Mrs. Dysert).

The 30 per cent accident rate per year comes from Nancy Forrestell, "You Never Give Up Worrying."

Details about the Russell family and the two-year-old girl in the fire come from interviews with the Russell sisters. The details about Bob Weiss being burned in the shaft come from Eva Derosa. The story of Herb Wilson, John McCambridge, and Sam Crawford surviving at the bottom of a shaft during the fire comes from *The Globe and Mail* (Toronto), July 12, 1951.

2. North of Murphy Township

For information on the strike I am indebted to Peter Vasiliadis, "Dangerous Truth." Vasiliadis also provides analysis on the role of the hiring "gatekeeper" in various ethnic communities. The details about Mayor Wilson's experience in the street battle come from The Globe (Toronto), Dec. 5, 1912.

Information on the outlaws north of Murphy Township comes from the interview with Jack Pecore, and other interviews with Bob Miner and Ernie White.

Period newspaper articles in *The Globe and Mail* and the *Cobalt Nugget* filled out other details about the strike.

The use of multi-ethnic workers to prevent worker solidarity was known as the "Rockefeller Formula." For more information on this, see Swift, *The Big Nickel*. As well, the efforts of the Great War Veterans Association in undermining the Western Federation of Miners in Northeastern Ontario was chronicled in Angus and Griffin, *We Lived a Life and Then Some*.

Information on the ethnic makeup of the Porcupine workforce and the high turnovers comes from Gaudreau, "Les Ouvriers-Mineurs de Timmins (1915-1940)."

3. The Short Unhappy Life of Natasia Balduick

Natasia Baldiuck's story comes from an article in *The Porcupine Advance*, Wednesday, July 9, 1924; also, interviews with Lempi Mansfield and Eva Derosa.

The story of Mike Volni and John Petric convicted of "brutal assault" of mucker shift boss John McCormick comes from *The Porcupine Advance*, Nov. 15, 1916. John Primak, charged with double murder in the Dome mine, comes from The Porcupine Advance, March 19, 1924. The story of Mike Kulick and his wife comes from *The Porcupine Advance*, Feb 3, 1927.

4. Joe Basill Gets Whacked

For "The cops called high-grading Ontario's biggest crime," and "cancer eating at the provincial economy," see "High-Grading: Our Most Costly Crime," *Canadian Business*, September 1948; and "Cancer Eating at the Economy of Northern Ontario," *The Toronto Star*, Dec. 3., 1963.

Information on high-grading prices comes from articles in *The Toronto Star*, *Canadian Business*, and *The Globe Magazine*. The story of the killing of David Palmer and Frank DeLuca comes from research conducted by William Miller and written up in his "Highgraders Get Murdered." For "Detroit boys put the word out in Timmins . . ." see Jerry Gillespie, "High-Grade Killing," *Montreal Standard*, Sept. 11, 1948. For women as high-grading runners, see Rudy Platiel, "High-Grading Is Stealing," *The Globe Magazine*, June 31, 1967.

I am particularly indebted to the information supplied by Bruce MacLeod as well as to his manuscript "Pirates in the Porcupine." MacLeod tells the story about the wife tossing evidence out an upstairs window. Information on the Annie Newman high-grade rackets comes from Dubro, *King of the Mob*. This book mentions the Rocco Perri connection to the Joe Basill killing. I also relied on Miller, "HighGrade Queen."

5. The Hollinger Fire

Sources on the Hollinger Mine come from Ross, "The Hollinger Mine," as well as the reports of the Ontario Department of Mines, particularly the reports relating to 1928-29.

Magne Stortroen's reminiscence *An Immigrant's Journal* has great details on the fire as well as descriptions of work at the Hollinger. Michael Barnes's book *Timmins* also has some good information. For information regarding the political backlash amongst the workforce I relied on accounts from the local press.

6. Joe and Lola

This chapter was based on stories told to me by my aunts and uncle. One exception is the story about Joe working underground and unbolting some timbers without a wrench. My grandfather never told that story; an old McIntyre miner related it to an uncle of mine who was on one of his first shifts underground.

Allegations about shift bosses occasionally demanding the "rights" to a pretty wife in exchange for a job emerged during interviews with mining widows done by the United Steelworkers in the 1970s and early 1980s. Veterans of the Kirkland Lake gold camps have told me similar stories. A miner in Sudbury also told me a similar tale.

Part II: Strangers and Memory

7. Burning Crosses and Red Co-operatives

The main historical document on the Workers' Co-op comes from Vasiliadis, "The Truth Is Sometimes Very Dangerous." I also used the reminiscence by Nelma Sillanpaa, "Under the Northern Lights," and Eckland, "Builders of Canada."

Information on the conflict at the Workers' Co-op also comes from articles in *The Porcupine Advance.*

I tracked the short history of the KKK in the Porcupine through *The Porcupine Advance* (beginning in February 1927). The newspaper also aided with numerous stories about conflicts with the Finnish community, particularly Rev. Jones and the formation of the Finnish Church.

The story of Atbi Siren comes from the *Advance,* as does the information of street battles with Ukrainians. An article dated Aug. 31. 1931, describes the demonstrations being ringed with children to stop police advances. The story of francophone school children being brought out to jeer "Red" demonstrators comes from MPP Gilles Bisson, who was told this by his father, Aurele.

The details of the Workers'/Communist party activities in demonstrations in Rouyn and Kirkland Lake come from articles in the Advance, which names Ukrainian activist N. Trachuk as being a major organizer.

Information on conflict within the Ukrainian community in the North was aided by an interview with J.J. Billoki, who grew up as a white Ukrainian in Sudbury.

8. The Weekly Matinee

Much of the information in this chapter comes from the weekly crime reporting in *The Porcupine Advance*. The story of Mati Aho and the Latour sisters comes from a piece in the *Advance*, March 9, 1939.

9. The Night in Moneta

This chapter was greatly aided by DiGiacomo, "They Live in the Moneta." The story of R.J. Ennis confronting McIntyre miners about anti-Italian activities also comes from DiGiacomo's essay.

Newspaper accounts in both the *Advance* and *Daily Press* filled in details about street fights and troubles. The story of Tops Tellino comes from the June 13, 1940 issue of *The Porcupine Advance*. For "Their social halls were seized . . ." see "Ukrainians Ask Council to Aid Having Bans on Their Group Lifted," *The Porcupine Advance*, June, 17, 1940.

As well, I relied on a number of newspaper articles outlining efforts by various ethnic organizations to display their loyalty to the war effort.

10. Henry and the High-Graders

The story of Henry Kelneck's underground meeting with local high-graders comes from his son Ike Kelneck. According to Ike Kelneck, Henry was hired to work on the sample gang and while on the job was approached and asked to double-knot high-grade bags so that they could be stolen. Ike says that while his father knew saying no was a very risky business, Henry always refused to take part in the high-grading rings.

Other information on the dance scene in the North comes from interviews with Emma (Ciotti) Pierni and Eddie Duke; and from Reynolds, "Dancing at the Pav." Information on working conditions for area miners comes from Stortroen, *An Immigrant's Journal*.

11. The Paymaster Disaster

I am indebted to the suggestions made by Mr. Albert Ristimaki of South Porcupine for details regarding this accident. Newspaper accounts from the *Daily Press* and *Advance* filled in details, as did the inquiry results from the Ontario Mining Association Committee in Barton and Jones, *Annual Report of the Technical Silicosis Research Committee*.

12. Breathing the Powder

Over the last ten years I have amassed a number of files and studies on the use of aluminum powder. A short synopsis of sources comes from interviews done over the last ten years with Homer Seguin, Michael

Farrell, Felix Brezinski, Sandra Rifat, and Gary Hyrtsak. Information on aluminum powder comes from various medical journals, some of which are listed in the Bibliography. As well, I had a number of correspondences between W.B. Dix, head of the McIntyre Foundation, and the Ministry of Labour.

For "By the late 1920s, nearly 20 per cent of the underground workforce was suffering...", see Forrestell, "You Never Give Up Worrying."

Information on the experiment at the Queen Alexandra Sanitorium in London, Ontario, comes from a letter from D.W. Crombie to C. Gibson, Secretary of the Technical Silicosis Research Committee, June 2, 1943. For "The McIntyre Foundation offered the use of its miracle cure as "available to mankind..." see *Annual Report to the Technical Silicosis Committee of the Ontario Mining Association*, June 1943. A number of articles in *The Porcupine Advance* (Nov. 4, 1937 and May 16, 1940 among them) also spelled out the tone of the McIntyre Foundation's research.

The story about the worker who pumped powder down the drain comes from an interview with Gertrude MacDonald, 1998. The Rifat study can be found in *The Lancet*, Nov. 10, 1990.

I am indebted to the large dossier of files and correspondence from Moses Sheppard, USWA staff rep in Thunder Bay (formerly staff rep in the Porcupine). Sheppard made me aware of the use of the experimental vole vaccine. According to the 1943 *Annual Report to the Technical Silicosis Research Committee of the Ontario Mining Association*, two hundred patients in four provincial sanitoriums were subjected to the experimental vole vaccine. Other than the eight initial subjects mentioned in this chapter, we do not know if the project was limited to miners or included other members of the population infected with tuberculosis. The report simply states that the work was done in consultation with the Ontario Mining Association's Technical Silicosis Research Committee.

The information on the average life expectancy of Porcupine men comes from a field study I did with my daughter Mariah of three Porcupine graveyards: Timmins, Tisdale, and Dead Man's Point. We gathered five hundred names in a cross-section of areas covering the period 1916-45. In the end I concentrated on the 360 or so names in the period between 1916 and 1940. The anglo names do probably include some people of other ethnic origins whose names may have been anglicized. I did not include deaths of children under the age of thirteen years in the averaging of death ages because I wanted to assess deaths from mine-related exposures as accurately as possible.

In the francophone and anglophone categories, we noticed a wide array of ages of death (early teens to late nineties). This was probably indicative of a variety of work environments for both francophones (logging, mining, carpentry, farming, merchant) and anglophones (mining, surface work, professions, merchants, logging, farming). The vast majority of Slavic men, however, were directly involved in underground gold production. The Slavic categories showed almost no fluctuation in death patterns. Of the forty-seven case samples, not a single male had reached the age of fifty-eight.

13. Death by a Thousand Cuts

The story of Auguste Salminen comes from a *Porcupine Advance* story, May 27, 1937. The story of Pete Procopio was brought to my attention by Draper, *Porcupine Camp Tisdale Township*.

Much of the information on the death of gold miners comes from a long-standing interest in this subject. I have done numerous interviews with widows, activists, and even nurses in the Haileybury sanitorium on the subject. Among these interviews are Homer Seguin, Ed Vance, Carrie Chenier, Shirley Picard (co-founder of the widow's action group VOME), Jenny Gyokery, and Don Taylor.

Information on the cost of living for silicotic miners on pensions comes from the 1954 study, USWA, "A Supplementary Submission Dealing with the Health and Living Conditions of the Timmins Miners."

Information on the wage drop experienced by silicotic miners who were given compensation comes from the 1954 Steelworkers' submission to the "Special Committee appointed by the Ontario Legislature to Inquire into Problems of the Gold Mining Industry in Ontario."

As well, I made use of hundreds of file cases from the Steelworkers' Lung Cancer Project. From a large database I compiled the five hundred outstanding industrially related mining illnesses found in the Porcupine as of 1988.

For the McIntyre Foundation quote, "For the past 27 years, with perhaps one questionable case..." see Newkirk, "Standard Practices and Procedures for the Application and Assessment of Aluminum Prophylaxis." The information regarding the "Ontario government assessment listing 279 cases" comes from correspondence from J.O. Roos, Senior Medical Consultant, Ministry of Labour, to Moses Sheppard, Sept. 20, 1990.

PART III: In Search of the Synagogue

Eddie Duke has helped me greatly to learn more about the Jewish community of Northern Ontario. My father, John Angus, also supplied some good details. Various newspaper accounts of Jewish public events helped round out the perspective.

14. The Mystery of Bill Barilko

The story of miners coming off shift was inspired by a quote from Bill Miner in Roberts, *A Miner's Life*. I was aided by Jelbert, "Searching for Bill Barilko," and by Duplacey and Romain, *Images of Glory: The Toronto Maple Leafs*.

15. Battle at the Broulan Reef

Information on the changing pressures on the logging companies and changes in the logging workforce come from an interview with union organizer Johnny Leblanc. Information on the changes being brought in by Hollinger come from the excellent manuscript by C. Bruce Ross on the Hollinger. I was greatly aided by the collection of *Hollinger Miner* magazines loaned to me by Mr. W.T. "Red" Phillips of Timmins. For "Veteran drillers resented having to handle their own mucking work ..." see Drifting and Raising Practice at Kerr-Addison Gold Mines, Mining in Canada," Sixth Commonwealth Mining and Metallurgical Conference, 1957.

The Mine Mill-Steel wars in the North are something I have been researching for some time. Thanks also go to research work done by Rick Stowe in his radio documentary "The Battle Within."

Interviews with Mine Mill-Steel activists from the period rounded out the perspective, in particular: Mike Farrell, Jack Rahaula, Don Taylor, and J.J. Billoki. Mike Solski's book on Mine Mill was also of great interest.

Information on tension among miners about changes in drilling and mucking operations comes from a report submitted by staff at Kerr Addison mine and included in *Mining in Canada*, a book prepared by the Sixth Commonwealth Mining and Metallurgical Congress, 1957.

Information on the two strikes comes from *Daily Press* coverage. I was aided in my research on the Broulan Reef strike by James-Chètalat, "Alice's Daughters." Wayne Roberts's oral history with Bob Miner was also helpful.

Information about the tension between ethnic alliances and the francophone workers in deciding union affiliation comes from Vasiliadis, *Dangerous Truth*. Information on the DPs and the splits in the Croatian community comes from a number of anecdotal stories I picked up over the years. Details on the Porcupine Miners Club and the Johnny Papalia connection come from Humphries, *The Enforcer*.

Information on Hilltop Rendezvous comes from Fruitman, "The Hilltop Rendezvous."

16. Birth of the New Dragon

Primary written information came from Shulman, *Billion Dollar Windfall*; Lafoli, *Claims*; and Reynolds, "Some Rush."

I relied on family information, including stories told by my mother and father. The interview with Ken Darke rounded out the details, particularly the information that Inco had taken a look at Kidd Creek and that Darke had to use his vacation time to convince the company to go ahead with the drill program.

Information on Tom Connor's rise to stardom comes from Tom's autobiography *Before the Fame* and from Fruitman, "Stompin' Tom: Birth of a Legend."

Bibliography

Books and Publications

Angus, Charlie, and Brit Griffin. *We Lived a Life and Then Some: The Life, Death, and Life of a Mining Town*. Toronto: Between the Lines, 1996.

Angus, Charlie and Susan Meurer, eds. *Carved from the Rock: The Miners' History Project*. Toronto: United Steelworkers of America, 1995.

Barnes, Michael. *Fortunes in the Ground*. Erin, Ont.: Boston Mills Press, 1986.

———. *Timmins: The Porcupine Country*. Erin, Ont.: Boston Mills Press, 1991.

Barton, A. and Jones W. Campbell. *Annual Report of the Technical Silicosis Research Committee*. Ontario Mining Association, June 25, 1940.

Bradwin. Edmund. *The Bunkhouse Man*. Toronto: University of Toronto Press, 1972.

Connors, Tom. *Before the Fame*. Toronto: Viking Press, 1995.

DiGiacomo, James Louis. "They Live in the Moneta: An Overview of the History and Changes in Social Organization of Italians in Timmins, Ontario." Working paper no. 2. Toronto: York Timmins Project, York University, 1982.

Draper, Keith. *Porcupine Camp Tisdale Township*. South Porcupine, Ont.: self-published, 2000.

Duplacey, James and Joseph Romain. *Images of Glory: The Toronto Maple Leafs*. Toronto: McGraw Hill-Ryerson, 1990.

Dubro, James and Robin Rowland. *King of the Mob: Rocco Perri and the Women Who Ran His Rackets*. Markham, Ont.: Viking Press, 1987.

Eckland, William. *Builders of Canada: History of the Finnish Organization of Canada 1911-1971*. Toronto: Finnish Organization of Canada, 1987.

Gilchrist, Gilbert, H. *As Strong As Steel*. Sudbury, Ont.: United Steelworkers of America, 1999.

Girdwood, Charles, Lawrence Jones, and George Lonn. *The Big Dome.* Toronto: Cybergraphics Company.

Humphries, Adrian. *The Enforcer: Johnny Pops Papalia, a Life and Death in the Mafia.* Toronto: Harper Collins, 1999.

Irwin, D.A. *Annual Report to the Technical Silicosis Committee.* Ontario Mining Association, May 1942.

James-Chètalat, Lois. "Alice's Daughters." Unpublished manuscript, 2000.

Jones, Lawrence and George Lonn. *Historical Highlights of Canadian Mining.* Toronto: Pitt Publishing, 1973.

Ketchnie, Margaret and Marge Reitsma-Street, eds. *Changing Lives: Women in Northern Ontario.* Toronto: Dundurn Press, 1996.

LeBourdais, D.M. *Metals and Men: The Story of Canadian Mining.* Toronto: McClelland and Stewart, 1957.

Lefoli, Ken. *Claims: Adventures in the Gold Trade.* Toronto: Key Porter Books, 1987.

Robert, Wayne. *A Miner's Life: Bob Miner and the Union Organizing in Timmins, Kirkland Lake and Sudbury.* Hamilton, Ont.: McMaster University, 1977.

Ross, Bruce C. "The Hollinger Mine." Unpublished manuscript, Timmins, Ont.

Shulman, Morton. *The Billion Dollar Windfall.* Toronto: McGraw Hill, 1969.

Sillanpaa, Nelma. *Under the Northern Lights: My Memories of Life in the Finnish Communities of Northern Ontario.* Hull, Que.: Canadian Museum of Civilization, 1994.

Sixth Commonwealth Mining and Metallurgical Congress. *Milling in Canada,* 1957.

Sixth Commonwealth Mining and Metallurgical Congress. *Mining in Canada,* 1957.

Smith, Phillip. *Harvest From the Rock: A History of Mining in Ontario.* Toronto: Macmillan of Canada, 1986.

Solski, Mike and John Smaller. *Mine Mill: The History of the International Union of Mine, Mill and Smelter Workers in Canada since 1895.* Ottawa: Steel Rail Publishing, 1985.

Stortroen, Magne. *An Immigrant's Journal.* Cobalt, Ont.: Highway Book Shop, 1982.

Swift, Jamie. *The Big Nickel: Inco at Home and Abroad.* Toronto: Between the Lines, 1977.

Tataryn, Lloyd. *Dying for a Living: The Politics of Industrial Death.* Ottawa: Deneau and Greenberg, 1979.

Van Paassen, Pierre. *To Number Our Days.* New York: Scribners.

Vasiliadis, Peter. "The Truth Is Sometimes Very Dangerous: Ethnic Workers and the Rise and Fall of the Workers Cooperative in the Porcupine Camp." Working Paper no. 3. Toronto: York Timmins Project, York University, 1983.

———. "Dangerous Truth: Interethnic Competition in a Northeastern Ontario Gold Mining Community." Doctoral Thesis. Vancouver: Simon Fraser University, December 1984.

Articles and Reports

Angus, Charlie. "Dust to Dust: Gold Miners and Their Families Await Answers on the Link between Aluminum Dust and Alzheimer's Disease." *This Magazine*, November 1993.

Canada. *Royal Commission of Inquiry into Industrial Relations in Canada* (The Mather Commission). May 1919; Microfilm 1981.

CIMM Bulletin. "The Ecstall Story." Vol.67, no. 745 (May 1974).

Gaudreau, Guy. "Les Ouvriers-Mineurs de Timmins (1915-1940): Les Canadiens-Francais, Mais Surtout Les Autres." Lecture delivered to Laurentian University, Sudbury, 1988.

Forrestell, Nancy, "You Never Give up Worrying," essay, mimeo.

Fruitman, Steve. "Stompin Tom: Birth of a Legend." *HighGrader Magazine*, vol.3, issue 1 (January/February 1997).

———. "The Hilltop Rendezvous." *HighGrader Magazine*. vol. 2, issue 3 (May/June 1997).

The Hollinger Miner, various issues 1949-65.

Kennedy, M.C.S. "Aluminum Powder Inhalations in the Treatment of Silicosis of Pottery Workers and Pneumoconiosis of Coal Miners." *British Journal of Industrial Medicine*, 13, 85 (1956).

MacLeod, Bruce. "Pirates in the Porcupine." Unpublished manuscript.

McIntyre Foundation. "Equipment and Procedure to Disperse Aluminum Powder." Mine document found at Paymaster Mine, South Porcupine, Ont. Date of origin unknown.

Miller, William. "Highgraders Get Murdered: Reviewing the Palmer and DeLuca Killings." *HighGrader Magazine*, vol. 3, issue 5 (September/Octover 1997).

———. "Highgrade Queen." *HighGrader Magazine*, vol. 7, issue 2

(March/April 2001).

Newkirk, T.E. "Standard Practices and Procedures for the Application and Assessment of Aluminum Prophylaxis to Prevent the Development of Silicosis." McIntyre Research Foundation, April 1972.

Ontario, Advisory Council on Occupational Health and Safety. *Second Annual Report*. Toronto, April 1, 1979 to March 31, 1980.

———. "Advisory Memorandum 79-1V Concerning Policy and Principles or Using Prophylactic Agent in the Workplace and in Particular Aluminum Inhalation Therapy in the Ontario Mining Industry." Toronto, Jan. 15, 1980.

Ontario, Department of Mines. *Annual Reports 1912-62*.

Ontario Mining Association Committee. "Investigations Regarding the Safety of Hoisting Equipment and Hoisting Practice in Ontario Mines." Toronto: Legislative Assembly of Ontario, 1949.

Jelbert, Austin. "Searching for Bill Barilko." *HighGrader Magazine*, Summer 1999.

Pirie, Kathryn. "When a Place Is No More." *HighGrader Magazine*, vol. 1, issue 2 (March 1995).

Platiel, Rudy. "High-Grading Is Stealing." *The Globe Magazine*, June 31, 1967.

Reynolds, Barbara. "Dancing at the Pav." *HighGrader Magazine*, May/June 1995.

Reynolds, Gregory. "Some Rush." *HighGrader Magazine*, vol.2, issue 6 (Christmas 1996).

———. "Master of All: Noah Timmins Builds an Empire." *HighGrader Magazine*, vol. 3, issue 3 (May/June 1997).

———. "The Hollinger Houses." *HighGrader Magazine*, vol. 3, issue 4 (July/August 1997).

———. "No Long Goodbyes: Closing the Hollinger Mine." *HighGrader Magazine*, vol. 3, issue 5 (September/October 1997).

———. "The Rinkmen: Outdoor Rinks in the Porcupine." *HighGrader Magazine*, vol. 7, issue 2 (March/April 2001).

Rifat, Sandra, M.R. Eastwood, Crapper McLachlan, and P.N. Corey. "Effect of Exposure of Miners to Aluminum Powder." *The Lancet*, Nov. 10, 1990.

Stone, Phil. "Highgrading: Our Most Costly Crime." *Canadian Business*, September 1948.

United Steelworkers of America. "A Supplementary Submission Dealing with the Health and Living Conditions of the Timmins Gold Miners." Presentation to the Special Committee Appointed by the Ontario Legislature into the Socio-Economic Problems of the Gold Mining Industry in Ontario. December 3, 1954.

———. "A History of Steelworkers Action for Occupational Health and Safety." Brief to the Royal Commission on the Health and Safety of Workers in Mines in Ontario. February 1976.

Correspondence and Notes

Exchange of letters between W. B. Dix, President of McIntyre Foundation, and Dr. Jan Muller, Ministry of Labour, between July 21, 1983 and April 10, 1985.

Letters from W.B. Dix, President of McIntyre Foundation to Warren Holmes, Manager of Pamour Porcupine Mines, June 21, 1984 and June 26, 1984.

Exchange of letters between Moses Sheppard and Dr. Charles Stewart of the Workers' Compensation Board, January 9, 1989 to August 15, 1989.

File notes from the Lung Cancer Project plus other outstanding cases related to industrial disease in the Porcupine up to 1988.

Newspapers

The Porcupine Advance, The Daily Press (Timmins), *The Golden Citizen, The Cobalt Nugget, The Globe and Mail* (Toronto), *The Toronto Star, The Northern Miner.*

List of Interviews

Interviewed by author

J.J. Billoki, July 8, 1994
Bill Boychuk, March 28, 1998
Clarence Brazier, March 31, 2001
Felix Brezinski, Nov. 25, 1994
Carlo Cattarello, March, 27, 1998
Carrie Chenier, March 2000
Ken Darke, June 26, 1998
Eddie Duke, 1996, 2000
Michael Farrell, Feb 24, 1994
Jenny Gyokery (Warzecha), June 19, 1994
Ike Kelneck, February 1996
Johnny Leblanc, June 1998
Gertrude MacDonald, June 2, 1998
W.T. (Red) Phillips, March 28, 1998
Shirley Picard, Nov. 26, 1994
Emma (Ciotti) Pierini, March 27, 1998
Evelyn Rymer, June 27, 1998
Homer Seguin, Oct. 22, 1992
Don Taylor, Aug. 13, 1994
Ed Vance, Nov. 5, 1992

Interviewed by John Campsall

Ben Beauchamp, May 1, 1974

Interviewed by Porcupine Historical Society

Dorothy Senja, April 5, 1976

Interviewed by Ruth Reid

Eva Derosa, March 1, 1974

Self-interview

John Campsall, Oct. 9, 1974

Interviewed by Magne Stortroen

Jack Andrews, June 17, 1975
Davis sisters (Neva Lane/Mrs. Hilda Arnold), Jan. 29, 1975

Leo Delvillano, Sept. 3 1975
Hamer Disher, June 1, 1974
Minnie Gram (Levinson), Feb 4, 1976
Laura Helin, April 13, 1975
Agnes King, Jan. 28, 1975
Gladys Kitchen, May 7, 1975
Uly Levinson, Feb 4, 1976
Lempi Mansfield, Sept. 24, 1975
Petronella Maxwell (Smith), Feb. 28, 1975
Bob Miner, Feb. 10, 1976
Jack Pecore, Oct. 30, 1975
Russell sisters (Mrs. Calvary and Mrs. Dysart), July 6, 1974
Lee Saunder, June 20, 1977
Elizabeth Townsend, April 13, 1975
Ernie White, Oct. 20, 1975

Interviewed by Rick Stowe

Robert "Bob" Carlin, Oct. 8, 1987